The National Self-Portrait Collection of Ireland

VOLUME I – 1979-1989 SARAH FINLAY

UNIVERSITY OF LIMERICK PRESS

THE NATIONAL SELF-PORTRAIT COLLECTION OF IRELAND Volume I – 1979-1989

Edited by SARAH FINLAY © Texts copyright Sarah Finlay, 1989

Design and typography by JOHN O'REGAN © Design copyright John O'Regan, 1989

Photography by DENIS MORTELL

First published 1989 by UNIVERSITY OF LIMERICK PRESS, Plassey Technological Park, Limerick.
Published to coincide with the opening, on September 12, 1989, of the National Self-Portrait Collection of
Ireland touring exhibition in the National Gallery of Ireland. Distributed by Gandon Editions Dublin.

BRITISH LIBRARY CATALOGUING IN PUBLICATION DATA

The National Self-Portrait Collection of Ireland.
 1. Irish self-portrait paintings
 I. Finlay, Sarah
 757'.09415

ISBN 0 9503427 6 9 clothbound edition ISBN 0 9503427 7 7 paperback edition ISSN 0791-2250

All measurements in centimetres, height precedes width.

Abbreviation: C.E.M.A.: Council for the Encouragement of Music and the Arts

front cover: John Shinnors, Self-Portrait, 1965 (detail), oil on canvas
back cover: Conor Fallon, Self-Portrait, 1985, steel
frontispiece: Dairine Vanston, Self-Portrait, 1948-86, watercolour and gouache on paper

Yevgeny Yevtushenko, *The Face Behind The Face.* Translated by Arthur Boyars and Simon Franklin. First
published in Great Britain by Marion Boyars Publications Ltd, 1979. Copyright.

Designed and produced on an ... Apple Centre, Dublin.
Text in 9.5pt Univers Light ... with headings in
Univers Bold Condensed ... Ryan, Gandon
Editions Dublin; output by ...

Colour separations by ... Huntsman Velvet.
Printed by Nicholson & Bass, Belfast.

H50 090 923 3

£14.50

Hertfordshire
COUNTY COUNCIL
Community Information

13 MAR 2004

– 9 MAR 2001
Renewed by phone
27th *Mar*
10/12

28 MAR 2002

27 APR 2000 26 OCT 2002
18 MAY 2000 15 MAY 2003

23 SEP 2000 19 JUN 2003
28 NOV 2000
– 9 JAN 2001 26 NOV 2003
3. *April 2004*

L32a

Please renew/return this item by the last date shown.

So that your telephone call is charged at local rate, please call the numbers as set out below:

	From Area codes 01923 or 0208:	From the rest of Herts:
Renewals:	01923 471373	01438 737373 757
Enquiries:	01923 471333	01438 737333 FIN
Minicom:	01923 471599	01438 737599

L32b

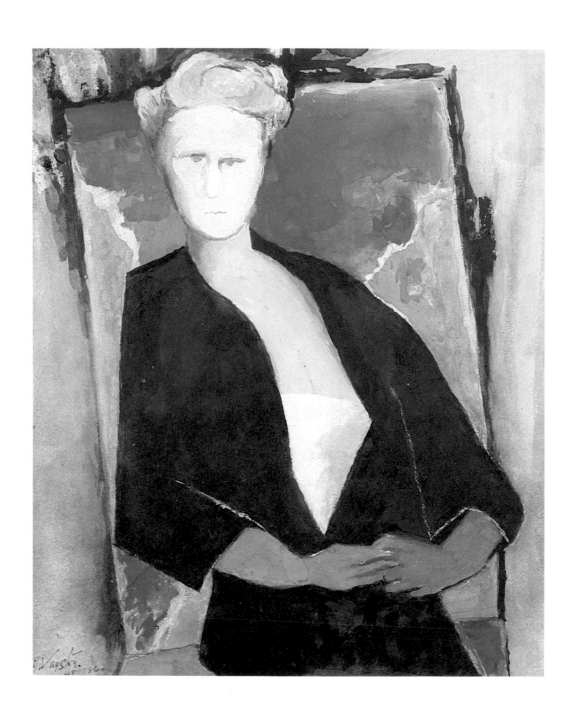

Contents

Foreword

The idea of a self-portrait collection is not new: indeed the world's greatest collection, housed in the Uffizi Gallery in Florence, was commenced by Cardinal Leopoldo de Medici in the seventeenth century. The plan for Ireland's National Self-Portrait Collection grew from the 1977 purchase by the University of Limerick (then the National Institute for Higher Education, Limerick) of fifteen self-portraits from the late John Kneafsey.

In 1982 the National Institute for Higher Education appointed a Board of Trustees composed of the Director of the National Gallery of Ireland, the Keeper of the Royal Hibernian Academy of Arts and the Director of the Arts Council under the Chairmanship of the President of the University. The Board was charged with the establishment of the national collection and its maintenance.

Each year since then the Board has invited a small number of Ireland's most distinguished artists to add their self-portrait to the collection. The Board has not established guidelines that might artificially inhibit, but has sought to bring together a collection which reflects the spectrum of the visual arts on the island. Over the years further additions will be carefully introduced and the self-portraits of noted deceased artists will be acquired as they become available.

In addition to establishing a valuable and well-documented national reference collection, the process serves to recognise formally many of Ireland's leading artists in their lifetime. This first volume records the works in the Collection in 1989. The Board of Trustees has decided that another volume should be published in 1999 and subsequent volumes at intervals of a decade thereafter.

Praise and appreciation are richly deserved by artists who contributed and the many who have worked in building the Collection. The Board of Trustees, Raymond Keaveney, Adrian Munnelly and James Nolan, and their predecessors Homan Potterton and Colm O'Briain, have undertaken the difficult task of deciding on those artists who should be invited to contribute, while the Curator, Patrick F. Doran, and the Secretary to the Board, Anne Sadlier, have worked with dedication and energy over the years in bringing the Collection together. Sarah Finlay has been responsible for compiling this volume and also for arranging the associated exhibitions in close collaboration with the officers and staff of the National Gallery and other galleries. To these the Board extends its admiration and gratitude.

Edward M. Walsh
Chairman, Board of Trustees

The Origins and Development of the National Self-Portrait Collection

In 1977 Thomas Ryan, now President of the Royal Hibernian Academy of Arts, made it known that his friend John Kneafsey, who was about to leave Limerick to retire to Co Wicklow, was willing to sell a group of self-portraits of Irish artists which he had collected over the years. John Kneafsey, Manager of the Limerick office of the *Irish Independent*, was a notable and enthusiastic collector in many fields and a dedicated organiser of art exhibitions and musical events, who had served for a number of years as Chairman of the Limerick Art Society. He had formed his collection of fifteen self-portraits by commissioning them from artists whose work was being exhibited in Limerick and by requesting Thomas Ryan to approach other artists whose work he admired. This collection was bought by the then NIHE Limerick on Mr Kneafsey's retirement. The acquisition of this collection prompted the idea of a National Self-Portrait Collection in the mind of Dr Edward Walsh who subsequently formed the Board of Trustees to bring the concept to fruition and to manage the collection.

Both the Kneafsey Gallery and the National Self-Portrait Collection were officially opened on March 6, 1982. The opening exhibition consisted of the original nucleus of the Collection and a group of thirteen self-portraits by artists who had been invited to contribute. In addition to these works there was a small but significant exhibition of self-portraits on loan from the Crawford Municipal Art Gallery, Cork, the Municipal Art Gallery, Limerick, the National Gallery of Ireland and the Ulster Museum. By their kindness and generosity these institutions helped to make the opening a most successful occasion.

Since then the Collection has been enriched by the annual addition of a number of works, the yearly average being fourteen. As the years pass, the range of media in which the self-portraits are executed and the variety of approaches adopted by the artists greatly enhance the imaginative breadth of the Collection. Still only in its infancy, the Collection already numbers 130 works. Not all of these are on display as generally each artist is represented by only one work.

The first additions to the original Kneafsey Collection were chosen from among Members and Associates of the RHA. In subsequent years members of Aosdána, specifically those who had an interest in portraiture, newly elected Members and Associates of the Royal Hibernian Academy and of the Royal Ulster Academy were invited as well as a number of other artists whose work was, in the opinion of the Board of Trustees, worthy of inclusion in the Collection.

The Collection has both an artistic and a historical element. Its artistic importance is dealt with in the main text of the catalogue. The historical significance of the Collection cannot but grow with time. Here is a unique grouping of the self-portraits of Irish artists – and of artists who have lived and worked in Ireland – which allows the viewer to study how these artists saw themselves at a particular time and in a particular place. While portraiture, in Vasari's words, shows man's desire to ensure the survival of his image,

there is no such certainty about the self-portrait. Some artists paint their own image again and again throughout their lives; others rarely, if ever, do so. Many find the self-portrait a difficult and demanding exercise, sometimes made even repugnant by the prospect of having to study with concentration their own face. Both the individual self-portrait and the collection of self-portraits acquires, with time, an archival quality not obvious to those living in the last decades of the twentieth century.

Not all artists invited to contribute a self-portrait respond immediately or at all. Some may take years to respond. When one learns to accommodate oneself to the artistic time-clock the result can be a succession of pleasant surprises. Artists suddenly make it known that they have finished their self-portrait or are about to do so. The imminent arrival of a new work brings its own excitement and its own rewards.

In helping to put the Collection together the greatest reward of all has been the pleasure of meeting many of the artists. Invariably courteous, friendly and hospitable they have allowed me the opportunity to enter their studios, to see their work in progress, to listen to their comments on their own work. This has not only been an expansion of experience but a privilege which is deeply appreciated.

Dr Patrick F. Doran
Curator

Preface

To confront one's image is a difficult task.
To record it is to state assertively
'I am, and this is how I see myself.'

Artists have been making this claim for centuries.*
Their reasons for doing so have ranged from
the desire for profound self-analysis to
the striving for a lifelike image or
the investigation of an artistic problem.

A self-portrait is a purely personal commitment.
No concessions need be made when artist and subject are one
– the viewer and the viewed.
The public, when invited, is witness to an intimate discovery.

To view this collection is to meet with a great variety of people.
The visitor is naturally drawn.
Glances are exchanged; dialogues develop.
Relationships thus formed are unique.

*Ludwig Goldscheider in his book *Five Hundred Self-Portraits* traces the first self-portrait to
Old Kingdom Egypt. More generally, self-portraiture is believed to have emerged as an independent
art form in Renaissance Europe.

Note to the Reader

Most of the artists in this Collection used a mirror to obtain an impression of their features. In the flattened mirror image, 'reality' is reversed; the right-handed artist paints with the left hand. The three-quarter view, which predominates, allows the artist's eyes to move from mirror to canvas while the head remains fixed. The full-frontal view has been made possible by the advent of photography.

The quotations used throughout this catalogue are the artists' own words.

'Selected Exhibitions' listed for each artist include, where possible, the artist's first one-person exhibition as well as shows for which a catalogue was produced.

'Collections' listed have been limited to five and are generally public and Irish, for reasons of accessibility.

Bibliographic references, listed in chronological order, are included only when they provide information beyond what is given here.

Acknowledgements

I would like to thank the following people who, in various ways, have contributed to this catalogue:

Bruce Arnold, Anne Blayney, Anne Crookshank, Julian Campbell, Katie Donovan, Janet Drew, Arthur Duff, Mary Fitzgerald, Patricia Flavin, Richard Hurley, Brian Kennedy of the Ulster Museum, Adrian le Harival, Elizabeth Le Jeune, John Logan, Marguerite MacCurtin, Ciaran MacGonigal, Rosemarie Mulcahy, Edward Murphy and the staff of the Library at the National College of Art and Design, Robert O'Byrne, Paul O'Reilly, Hélène O'Shaughnessy, Angela Rohan, Mary Stratton-Ryan, Wanda Ryan-Smolin, Derek Shortall, Ann Stewart, Taylor Galleries, Diane Tomlinson, Robert Towers, John Turpin, Sam Walshe, Paul Whelan

Jim Allen

Jim Allen is a print-maker and painter who has concentrated more recently on drawing. His subject-matter, which runs in series, dictates his choice and handling of media. A collection of beach stones is delicately rendered in colour aquatint; he adopts a clear and precise etching technique to represent a building or an interior; his detailed drawings describe the different foliage in a garden. The recent nude studies in coloured pencil are perhaps the most atmospheric of all. In these the figure is seen as part of an interior, sometimes barely outlined, at other times generously shaded in coloured pencil. The tones are soft and the mood is calm.

His pencil-drawn self-portrait is similar to the nude series in its style and composition. Here Allen places himself in an interior. Behind his head, one of his paintings, featuring an empty room with large French windows, is reminiscent of the space in which his nudes are located. Reflected in the picture-glass, and indicated by the grey vertical and horizontal elements, is the window at the other side of the room. The linear drawing style of his face contrasts with the finely hatched and smudged areas of the background, indicating Allen's varied and skilled use of the medium.

Born in Lurgan, Co Armagh, 1941. Studied at Belfast College of Art and Design and Brighton College of Art. Member of the Royal Ulster Academy. Lives and works in Belfast.

Selected Exhibitions	1972 The Room Gallery, Greenwich, London
	1975 Upper Street Gallery, London
	1976 Tom Caldwell Gallery, Belfast
	1980 *The Corner of My Eye: Four print poems by Jim Allen and Michael Longley*, Ulster Museum, Belfast
	1988 *Nudes in Interiors*, On the Wall Gallery, Belfast
	Exhibits at the Royal Ulster Academy.
Collections	Armagh County Museum
	Arts Council/An Chomhairle Ealaíon, Dublin
	Arts Council of Northern Ireland, Belfast
	Queen's University, Belfast
	Ulster Museum, Belfast
Selected Bibliography	Kenneth Jamison, 'Painting and Sculpture' in *Causeway: The Arts in Ulster*, ed. Michael Longley, Arts Council of Northern Ireland, Belfast, and Gill and Macmillan, Belfast, 1971
	Mike Catto, *Art in Ulster: 2*, Arts Council of Northern Ireland and Blackstaff Press, Belfast, 1977

Self-Portrait, 1989. Coloured pencil on paper, 76 x 56.5.
Signed: 'James Allen '89'.

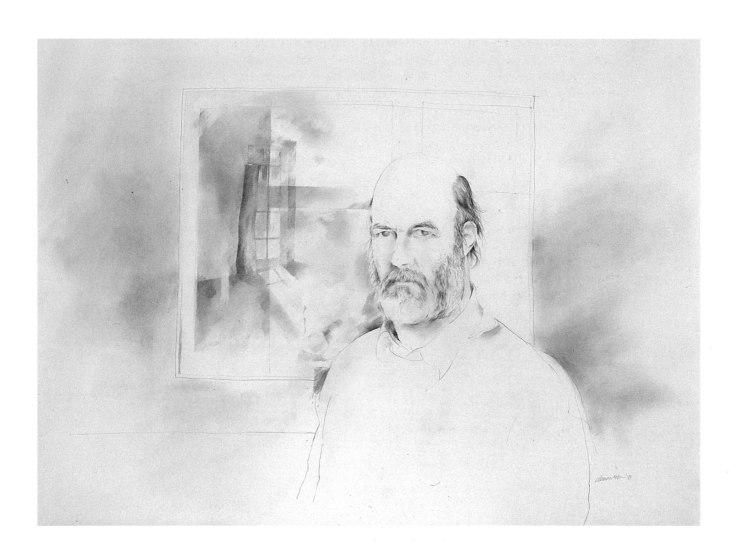

Michael Ashur

In his paintings Michael Ashur presents a vision of the universe which is, for most people, both invisible and inaccessible. With his vast, dark painted galaxies, based on telescopic views and photographs of space, he wishes to extend and enhance common perceptions of creation. They intentionally suggest exploration and progress and 'put our everyday problems in perspective'. In recent years, the explosive nebulae of the self-portrait have given way to the more controlled energy of perfectly formed crystals and prisms. These shapes rest on perspectival grids which, having drawn us into the picture, recede into the infinite space beyond. Ashur's method of working is slow but meticulous. Using an airbrush, he applies very thin layers of acrylic paint, thereby achieving the paradoxical realism of what many have described as his "science fiction" images.

His self-portrait is clearly representative of his main body of work, although the inclusion of a figure is a new departure. Here he assumes the role of interpreter, placing himself in front of one of the expansive galaxies of his paintings. He holds up a prism with which he hopes 'to bring the light of the universe' to the viewer. His facial features are realistically rendered in finely stippled brushwork which contrasts with the hazy effect of the airbrush technique used to depict the galaxies in the night sky behind and the diffused rays of the prism. His white suit, also spray-painted, offers a foil to the dark background. On his lapel is a pin which bears the emblem of the Contemporary Irish Art Scociety. This portrait is a striking example of Ashur's sophisticated painting technique.

Born in Dublin, 1950. Studied at the National College of Art, Dublin. Lives and works in Dublin.

Selected Exhibitions	1974 David Hendriks Gallery, Dublin
	1977 Gallery Von Bartha-Lonn, Göteborg, Sweden
	1980 Arts Council of Northern Ireland Gallery, Belfast
	1981 International Festival of Painting, Cagnes-sur- Mer, France
	1988 Riverrun Gallery, Limerick

Collections	Arts Council/An Chomhairle Ealaíon, Dublin
	Hugh Lane Municipal Gallery of Modern Art, Dublin
	Radio Telefís Eireann, Dublin
	University College Dublin
	Wang Ireland Ltd, Dublin

Selected Bibliography	Emmanuel Kehoe, 'The sky's no limit', *Sunday Press*, July 1, 1979
	Brian Fallon, Michael Ashur: 'Astrodome Views' in *Contemporary Irish Art*, ed. Roderic Knowles, Wolfhound Press, Dublin, 1982
	Pierre Van Osselaer, catalogue introduction, David Hendriks Gallery, Dublin, 1987

Self-Portrait,1982. Acrylic on canvas, 76 x 61.
Signed: 'Ashur '82'.

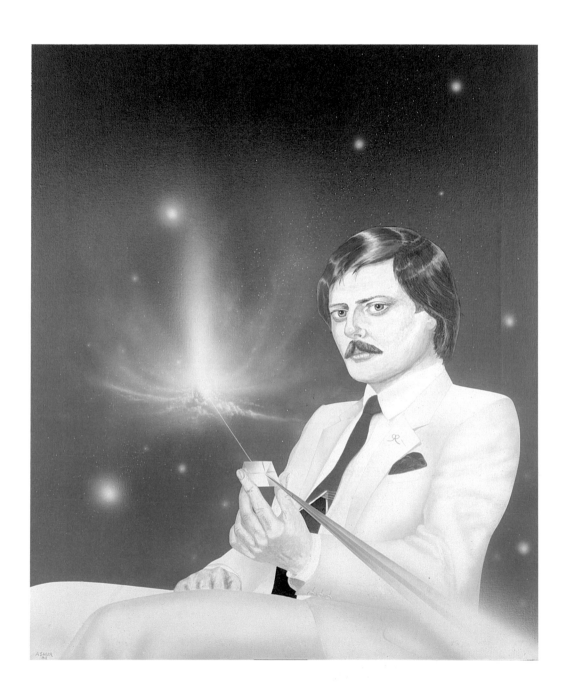

Brian Ballard

Brian Ballard began his artistic career in the late 1960s as a landscape painter. In his early work he focused on individual elements – a tree or a hedge, for example – and simplified or stylised their forms, interspersing them with a filtered light. Gradually, the light became the focal point and, by the early 1970s, was reduced to hard-edge vertical strips of pure acrylic colours. Ballard later returned to a more figurative mode, exploring the classical themes of landscape, still life and the nude. He continues to paint these subjects, adopting an increasingly brighter palette and a freer and bolder painting technique.

Ballard's self-portrait may be seen in the context of work dating from the mid-1980s and reveals the essence of his approach to painting. The face is modelled by light, indicated by a lively use of white. In parts of the painting the white paint is worked wet-on-wet onto the darker colours beneath, producing a Giacometti-like grey and a range of muted browns – tones which dominate Ballard's paintings of the time. His roughly delineated features suggest a slightly uneasy expression. The framing device – an easel perhaps – which is barely visible behind the sitter's head, hints at the rectangular shapes of subsequent still lifes. The energetic brushwork, applied in contrasting linear strokes, is typical of Ballard's recent painting.

Born in Belfast, 1943. Studied at Belfast College of Art and Liverpool College of Art. Member of the Royal Ulster Academy. Lives and works in Belfast.

Selected Exhibitions	1970 David Hendriks Gallery, Dublin
	1974 Tom Caldwell Gallery, Belfast
	1983 Tom Caldwell Gallery, Dublin
	1986 Grafton Gallery, Dublin
	1988 Kerlin Gallery, Dublin
	Exhibits at the Royal Ulster Academy.
Collections	Arts Council/An Chomhairle Ealaíon, Dublin
	Arts Council of Northern Ireland, Belfast
	Crawford Municipal Art Gallery, Cork
	Guinness Peat Aviation, Shannon
	Ulster Museum, Belfast
Selected Bibliography	Mike Catto, *Art in Ulster: 2*, Arts Council of Northern Ireland and Blackstaff Press, Belfast, 1977
	Louis A. Muinzer, 'Brian Ballard, Tom Caldwell Gallery, Belfast, 17 Feb-13 Mar, 1987', exhibition review, *Circa*, no. 33, March-April 1987
	Frances Ruane, *The Allied Irish Bank Collection: Twentieth Century Irish Art*, Douglas Hyde Gallery, Dublin, 1986
	Sean McCrum, catalogue introduction, Solomon Gallery, London, 1988

Self-Portrait,1984. Oil on canvas, 50 x 39.5.
Signed: 'Ballard '84'.

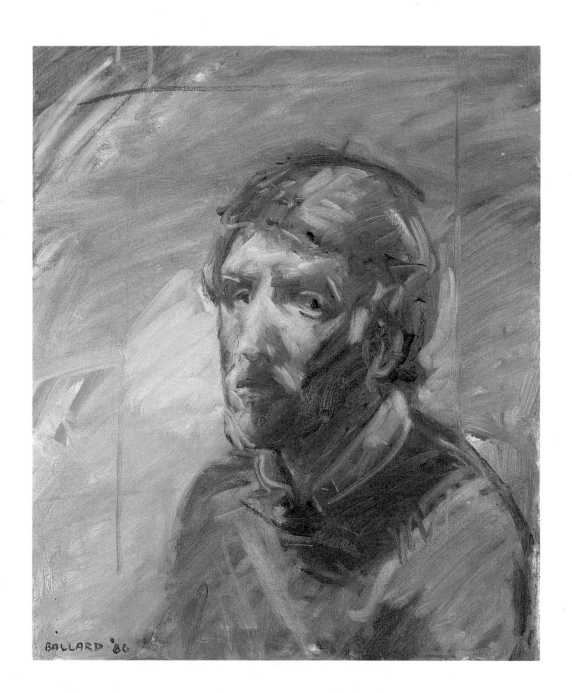
BALLARD '86

Moyra Barry

Moyra Barry belonged to a generation of talented Irish women artists – Evie Hone, Grace Henry, Sarah Purser and Mary Swanzy amongst them – who, at the beginning of this century, studied and worked abroad, while maintaining strong links with their native country. Having completed her studies at the Slade School of Fine Art in London, she travelled to Quito in Ecuador where she taught painting and drawing for a short period. She returned to Dublin to continue the successful artistic career she had begun as a student in the Royal Hibernian Academy Schools. She spent much of her time drawing and painting rare plants and flowers in the Botanic Gardens, which has resulted in a collection of paintings noted for their sensitive handling and delicate colouring.

Barry also painted landscapes, cityscapes and a series of self-portraits. The portrait in this collection is not dated but shows a woman somewhat older than the one portrayed in *Self-Portrait in the Artist's Studio* in the National Gallery of Ireland, which was painted in 1920 when the artist was thirty-four. In contrast with the sad, wistful stare of the earlier painting, she has in this piece a more self-assured, if serious, look. Here the atmosphere is outdoor and summery, as opposed to the relatively dark interior study. The bright palette and light touch – and more obviously the floral pattern of her dress – are reminiscent of her flower studies.

Born in Dublin, 1886. Studied at the Royal Hibernian Academy Schools, Dublin and the Slade School of Fine Art, London. Died in Dublin, 1960.

Collections	Crawford Municipal Art Gallery, Cork
	Limerick City Gallery of Art
	National Gallery of Ireland, Dublin
	Ulster Museum, Belfast
Selected Exhibitions	1932 Angus Gallery, Dublin
	1943 Victor Waddington Galleries, Dublin
	1975 *Flower Paintings from the Permanent Collection*, Ulster Museum, Belfast
	1982 *Moyra Barry 1886-1960*, Gorry Gallery, Dublin
	1989 *Irish Paintings*, George Gallery, Dublin
	Exhibited regularly at the Royal Hibernian Academy.
Selected Bibliography	Blaithín O Cíobháin, 'Impressions: Moyra Barry Rediscovered', *Irish Press*, September 24, 1982
	Adrian le Harival and Michael Wynne, *National Gallery of Ireland: Acquisitions 1982-1983*, National Gallery of Ireland, Dublin, 1984
	Brian Kennedy, 'Women Artists and the Modern Movement, 1943-49' in *Irish Women Artists from the Eighteenth Century to the Present Day*, National Gallery of Ireland and the Douglas Hyde Gallery, Dublin, 1987

Self-Portrait. Oil on canvas, 36 x 31.
Unsigned.
Purchased from Gorry Gallery, Dublin, 1982.

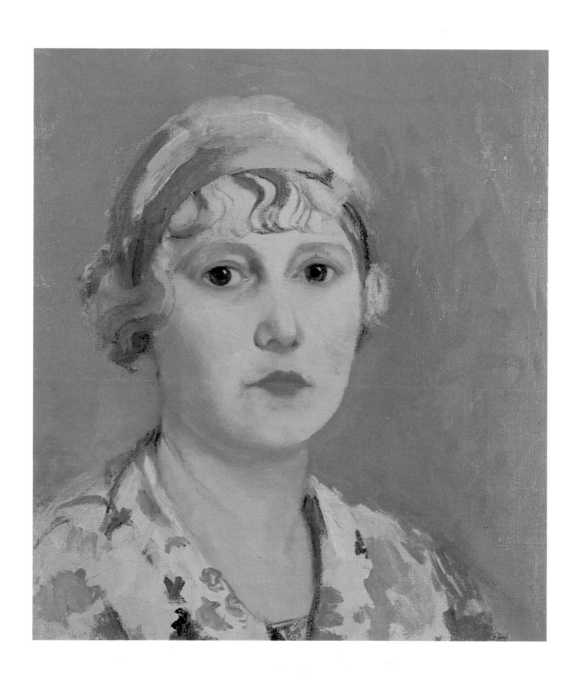

Pauline Bewick

Pauline Bewick's principal medium is watercolour, which she uses in a tight controlled manner to depict fine detail or more loosely to create atmosphere ánd mood. In the stylised paintings of the early 1950s, she depicts the life of a carefree art student in Dublin. Flamboyant watercolours of crowded social gatherings record her stay in London, where she worked as an illustrator for BBC Television. Since the early 1970s, when she moved to the countryside, her images have been concerned with the female experience of life. Woman is depicted alone, with child, naked, resting, reading, often outdoors, sensuously allied to nature. These harmonious compositions, in which animal, plant and female form merge freely together, are in direct contrast to the paintings which reflect the harsher aspects of nature: its ugliness, its cruelty and its bleakness.

The decorative element is central to Bewick's work, as is evident in her self-portrait. Here each leaf, flower and strand of hair is part of a fluent, ornate rhythm. Sometimes, an apparently decorative motif can have an even more basic role to play: the sprig of fuschia which trails elegantly across her face subtly conceals the fact that the artist had misjudged the length of her nose and painted it too long. With this portrait, Bewick wished to create an effect whereby the viewer is looking through the paper on which she is drawing – hence the poised pencil in her right hand and the transparent rectangle which delicately veils her figure, exposing only her eyes and forehead. Through the studio window we can glimpse the mountains and fields which have provided the setting for many of her paintings since the 1970s.

Born in Northumbria, England, 1932. Studied at the National College of Art, Dublin. Member of the Royal Hibernian Academy. Member of Aosdána. Lives and works in Co Kerry.

Selected Exhibitions	1957 Clog Gallery, Dublin
	1959 Parkway Gallery, London
	1965 Dawson Gallery, Dublin
	1980 Taylor Galleries, Dublin
	1986 *Paintings by Pauline Bewick from 2-50 years*, mid-term retrospective touring exhibition, Guinness Hop Store, Dublin
Collections	Arts Council/An Comhairle Ealaíon, Dublin
	Arts Council of Northern Ireland, Belfast
	Crawford Municipal Art Gallery, Cork
	Office of Public Works, Dublin
	Radio Telefís Eireann, Dublin
Selected Bibliography/ Sources	Roderic Knowles ed., 'Pauline Bewick: The Elemental', in *Contemporary Irish Art*, Wolfhound Press, Dublin, 1982
	James White, *Pauline Bewick: Painting a Life*, Wolfhound Press, Dublin, 1986
	David Shaw-Smith, *A Painted Diary – Pauline Bewick*, television documentary, RTE, 1985
	Frances Ruane, *The Allied Irish Bank Collection: Twentieth Century Irish Art*, Douglas Hyde Gallery, Dublin, 1986

Myself with fuscia. Watercolour and pencil on handmade paper, 58 x 79.5.
Signed: 'Bewick Oct. 1983'

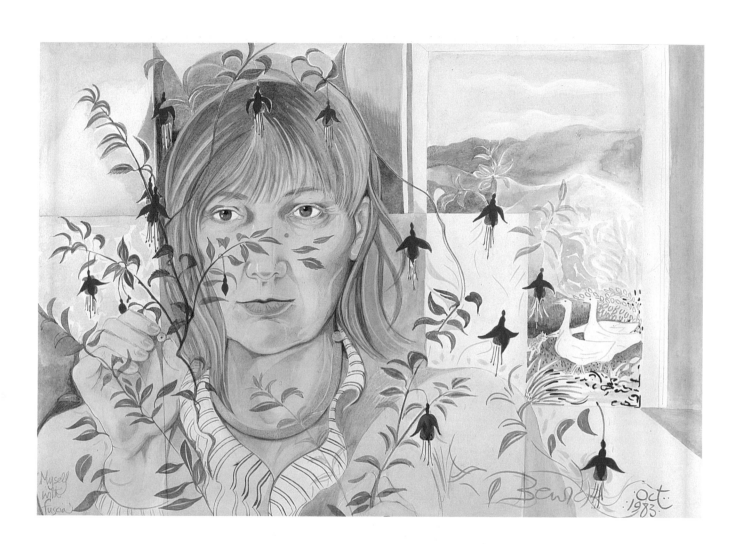

Myself
with
fuscia

Bewick Oct 1983

Basil Blackshaw

The world of hunting and wildlife in which Basil Blackshaw grew up and to which he has returned has become the subject-matter of many of his paintings. A dog or a horse assume monumental stature in a six-foot tall canvas. His grey misty landscapes are those he knows well – the area of the Lagan Valley, for example, near his homeland in Boardmills, County Down. Choosing Colin Mountain as a central motif, he has been able to experiment with form and colour in a highly concentrated and disciplined manner. More recently he has selected individual elements of the natural environment – a leaf, a flower or a tree for example – and featured each in giant canvases. In these, as in all of his paintings, he captures and distils the essential form and mood of his subject-matter.

Blackshaw is also a successful portrait painter. In a direct but gentle way, he manages to convey the core of his sitters. His self-portrait, which he has approached with characteristic probity and lack of pretension, was executed in the early I980s, at a time when Blackshaw was dissatisfied with his painting in general. According to the artist 'this portrait was an attempt to take an honest look without any preconceived ideas of what a portrait should look like and so it is significant, having been made at the beginning of this way of seeing things'. He is without ostentation. His gaze is direct and scrutinising. The sensitive scumbling, which exposes the layers of paint or raw canvas beneath, seems an appropriate technique for such a revealing self-image.

Born in Glengormley, Co Antrim, 1932. Studied at Belfast College of Art. Member of the Royal Ulster Academy. Associate of the Royal Hibernian Academy. Member of Aosdána. Lives and works in Co Antrim.

Selected Exhibitions	1961 C.E.M.A. Gallery, Belfast 1974 *Retrospective Exhibition*, Arts Council of Northern Ireland Gallery, Belfast and Watergate Gallery, Washington D.C. 1983 *Six Artists from Ireland: An Aspect of Irish Painting*, travelling exhibition organised by the Arts Council/An Chomhairle Ealaíon and the Cultural Relations Committee, Department of Foreign Affairs, Dublin 1987 David Hendriks Gallery, Dublin 1988 *Rosc '88*, Guinness Hop Store, Dublin
Collections	Arts Council/An Chomhairle Ealaíon, Dublin Arts Council of Northern Ireland, Belfast Herbert Art Gallery and Museum, Coventry Trinity College, Dublin Ulster Museum, Belfast
Selected Bibliography	Mercy Hunter, 'Basil Blackshaw' in *The Irish Imagination 1959-1971*, published in association with *Rosc '7l*, Municipal Gallery of Modern Art, Dublin,1971 John Hewitt, *Basil Blackshaw Retrospective*, catalogue introduction, Arts Council of Northern Ireland, Belfast, 1974 Kenneth Jamison, catalogue introduction, Tom Caldwell Gallery,Dublin,1975 John Hewitt, *Art in Ulster: 1*, Arts Council of Northern Ireland and Blackstaff Press, Belfast, 1977 Liam Kelly, 'Basil Blackshaw', in *Six Artists from Ireland: An Aspect of Irish Painting*, Arts Council/An Chomhairle Ealaíon and the Department of Foreign Affairs, Dublin, 1983

Self-Portrai, 1982. Oil on canvas, 50 x 40.
Signed: 'Blackshaw '82'.

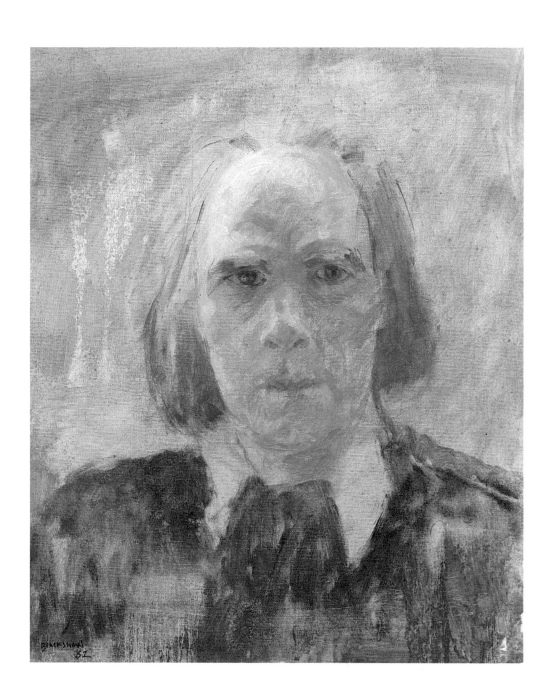

Vivienne Bogan

Vivienne Bogan's self-portrait, in its juxtaposition and layering of various images and media, is typical of her work. Here she combines brown paper, fabric, thread, spray-painted handmade paper, pastel and coloured pencil. In other compositions she has used feathers, pieces of wood and watercolour. She finds inspiration for her subjects in the natural environment or specific events in her life. Certain symbols recur, such as the rose or the vertical bars.

Her self-portrait contains both these and other autobiographical elements. She describes it as `a brief profile of my life at the time – religion, state of mind, needs and hopes'. The pale pink roses which surround her figure are an explicit reference to her femininity. The use of the stitch as a structural element has a similar function. The artist's vest reflects a more personal aspect of her character. It is, in her own words, `something that has been there, hidden, close to me – as if symbolic of a need for viewers to see beyond the face, to progress to the skin level and deepen to a hidden self, wishing to be revealed'. Its soft texture contrasts with the stiff surface of the handmade paper beneath. The linear bars, behind which can be glimpsed a fragment of Arabic script, are another familiar motif. They relate to a verse from the scriptures of her Baha'i faith which invokes the image of a bird entreated to break through the bars of its cage to attain spiritual freedom. As is often the case with Bogan's work, the layers are at once actual and metaphorical.

Born in Limerick, 1951. Studied at the School of Art and Design, Limerick Technical College and the Vrije Academie, Holland. Lives and works in Co Tipperary.

Selected Exhibitions	1981 Yerevan, Soviet Armenia
	1982 *Belltable Foursight*, Arts Council touring exhibition
	1983 *Watercolours and Drawings*, Project Arts Centre, Dublin
	1986 Grafton Gallery, Dublin
	1988 *Hidden Words*, Riverrun Gallery, Limerick
Collections	Allied Irish Bank, Dublin
	Arts Council/An Chomhairle Ealaíon, Dublin
	Guinness Peat Aviation, Shannon
	Musée des Beaux-Arts, Quimper, France
	University of Limerick
Selected Bibliography	Anon., *Watercolours and drawings*, catalogue introduction, Project Arts Centre, Dublin, 1983
	Gerry Dukes, *Hidden Words*, catalogue introduction, Riverrun Gallery, 1988
	Vivienne Bogan, *Belltable Foursight*, artist's statement, Belltable Arts Centre, Limerick, 1982

Self-Portrait, 1987. Mixed media on paper, 64 x 94.
Signed: 'Vivienne Bogan '87'.

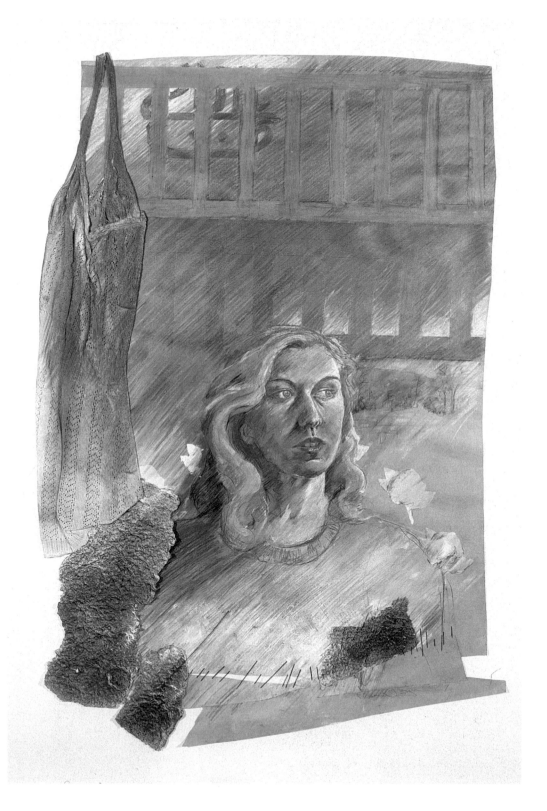

Brian Bourke

Brian Bourke has always had a remarkable facility with line. This is as evident in his paintings and painted sculpture as it is in his drawings and etchings. Over the years he has dealt extensively with a number of figurative themes: Bavarian and west of Ireland landscapes, portraits of J., Don Quixote, and Sweeney. His portraits from the late 1960s are painted in the manner of the late Italian Renaissance. The figure is shown as a head and shoulder study resting on a large rectangular block of colour. In these, as in most of his paintings, the subject-matter is framed by a circle or sometimes a square within a circle. This has the effect of highlighting the image and relieving the usual squareness of a painting. The bronze heads, painted with lively hatched brushstrokes, are a natural progression from these portraits.

Bourke has painted many self-portraits. These include depictions of himself nude with an umbrella, wearing a top hat or a helmet, or seated at an easel or alongside Don Quixote. The humour and self-mockery of these earlier works has given way to a more sombre mood in this self-portrait, hinted at by the death-mask image. The two drawings are based on a plaster cast of the artist's head. Turned towards the viewer, they are separated from him in their sightlessness. The title, *Memento Mori* – remember that you must die – is ambiguous. The casts are obviously made from life and drawn with characteristic vigour, using variously hatched lines and coloured pencil. They share with all of Bourke's graphic work a strong sense of volume and line.

Born in Dublin, 1936. Studied at the National College of Art, Dublin, St Martin's School of Art, London and Goldsmith's College, London. Member of Aosdána. Lives and works in Co Galway.

Selected Exhibitions	1971 *The Irish Imagination 1959-1971*, in association with *Rosc '71*, Municipal Gallery of Modern Art, Dublin 1981 *Self and Don Quixote*, Taylor Galleries, Dublin 1985 *Out of the Head*, Arts Council/An Chomhairle Ealaíon touring exhibition 1988 *Rosc '88*, Guinness Hop Store, Dublin 1988-9 *Brian Bourke: Paintings, Drawings and Sculpture 1963-1988*, Heinz Building, Galway and Royal Hospital, Kilmainham, Dubllin
Collections	Arts Council/An Chomhairle Ealaíon, Dublin Arts Council of Northern Ireland, Belfast Hugh Lane Municipal Gallery of Modern Art, Dublin Uffizi Gallery, Florence – Self-Portrait Collection Ulster Museum, Belfast
Selected Bibliography	Patrick Gallagher, 'Brian Bourke', in *The Irish Imagination1959-1971*, published in association with *Rosc '71*, Municipal Gallery of Modern Art, Dublin, 1971 Roderic Knowles, ed., 'Brian Bourke' in 'The Artist and Don Quixote' in *Contemporary Irish Art*, Wolfhound Press, Dublin, 1982 Henry J. Sharpe, 'Brian Bourke' in *Making Sense: Ten Painters 1963-1983*, exhibition catalogue, Project Arts Centre, Dublin, 1983 Brian Bourke, *Out of the Head: Artist's Response, 6*, Arts Council/An Chomhairle Ealaíon, Dublin, 1985 Kieran Corcoran, *Brian Bourke: Paintings, Drawings and Sculpture, 1963-1988*, catalogue essay, Galway, 1988

Momento Mori. Pencil and coloured pencil on paper, 51 x 71.
Signed: 'March '84 Brian Bourke'.

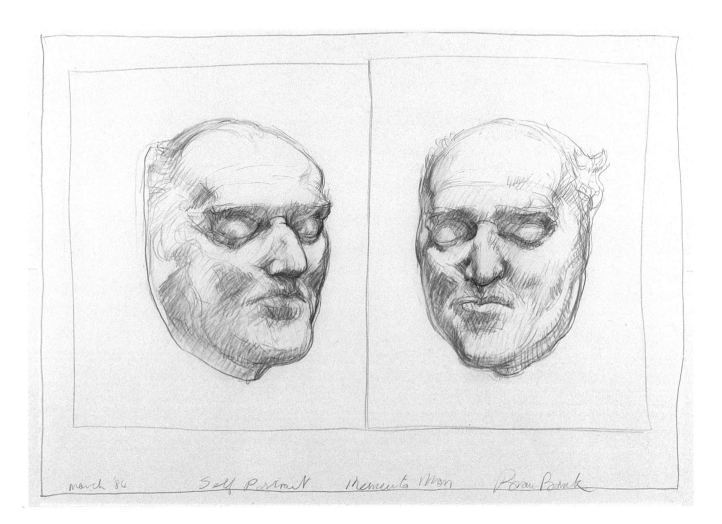

march 86 Self Portrait Memento Mori Brian Bourke

Howard Bowen

Howard Bowen began his artistic career as a graphic designer in New York. In 1942 he was conscripted into the army and was drafted to Europe the following year. During the three years he spent there, he made numerous drawings and paintings of his surroundings in Belgium, Holland and Germany. Although conditions were far from pleasant, this experience instilled in Bowen a love of travel which lasted throughout his life and which provided him with the source for many of his paintings. Returning to America in 1946, he concentrated mainly on portraiture. He made frequent trips to Mediterranean Europe, where he painted almost exclusively in watercolour. In 1967 he moved to Killaloe in Clare from where he continued to paint portraits and to travel. His atmospheric paintings of the Clare landscape belong to this period.

His self-portrait, painted in oils, possesses the clarity and brightness of his watercolours. The head is emphasized by its detailed rendering and generous use of paint. In contrast, he paints his sweater in a roughly applied dry-brush technique. The areas of blank canvas lend an unfinished look to the piece and further accentuate the head. As an experienced and skilled portraitist, Bowen here displays his ability to convey a sense of character in a direct and informal manner.

Born in St Louis, Missouri, USA, 1916. Studied at Washington University School of Fine Arts. Died in Killaloe, 1984.

Selected Exhibitions	1955 Cooling Galleries, London
	1968 Goodwin Gallery, Limerick
	1986 Gorry Gallery, Dublin
Collections	Kopnopka Museum, Krakow
	University of Limerick
	The White House, Washington

Self-Portrait. Oil on canvas on board, 43 x 34.5.
Signed: 'Howard Bowen'.
On loan from Mrs Mary Bowen.

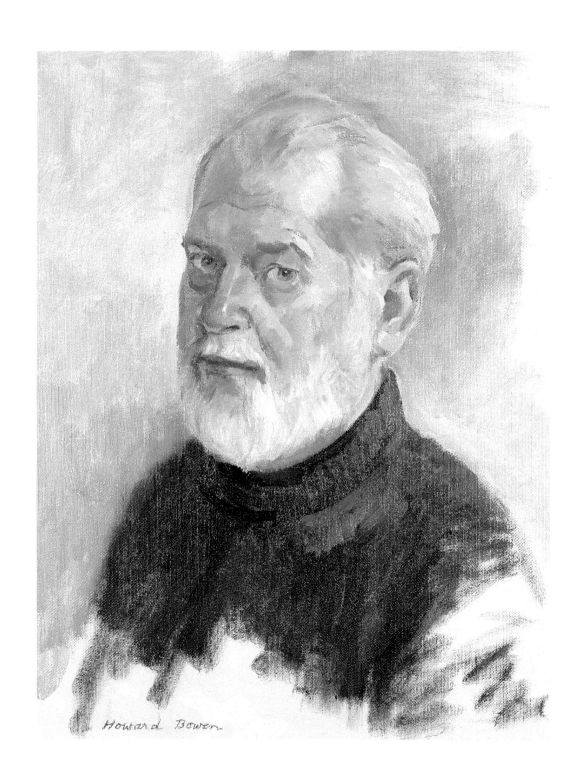

Howard Bowen

Muriel Brandt

Having attended night-classes at the Belfast College of Art, Muriel Brandt went on to study architecture and specialise in mural painting at the Royal College of Art in London. Apart from a few religious commissions which she received on her return – including a series of large-scale paintings for Adam and Eve's Church in Dublin – she worked on a small scale, painting portraits and landscapes in oil and watercolour. She is perhaps best known for her studies of children. In these she captures a bright-eyed innocence of youth which lacks the self-conscious stiffness often displayed by the adult sitter. The strong lines, pale colours and simple rounded faces of her earlier portraits in particular suggest the influence of Stanley Spencer, her teacher at the Royal College of Art.

In her own portrait, drawn when she was in her late forties, the artist emphasises the structure of the face, modelling it with a clearly defined use of line and tone and an effective highlight of white chalk. The impact is immediate. Here Brandt has exaggerated her features slightly, making her jawline and chin seem harsher than they were in reality. This tendency towards caricature is evident in many of her adult portraits. The dynamic double portrait of the Countess of Longford, which hangs in the National Gallery of Ireland, has similarly attenuated, angular features.

Born in Belfast, 1909. Studied at Belfast College of Art and the Royal College of Art, London. Member of the Royal Hibernian Academy. Died in Dublin, 1981.

Selected Exhibitions	1964 Dawson Gallery, Dublin
	1970 Dawson Gallery, Dublin
	1975 *Irish Art 1900-1950*, in association with Rosc Teoranta, Crawford Municipal Art Gallery, Cork
	Exhibited regularly at the Royal Hibernian Academy
Collections	Butler Gallery, Kilkenny
	Crawford Municipal Art Gallery, Cork
	National Gallery of Ireland, Dublin
	National Museum of Ireland, Dublin
	Waterford Municipal Art Collection, Garter Lane Arts Centre
Selected Bibliography	Hilary Pyle, 'Muriel Brandt' in *Irish Art 1900-1950*, published in association with Rosc Teoranta, Crawford Municipal Art Gallery, Cork, 1975
	Homan Potterton and Michael Wynne, *The National Gallery of Ireland, Acquisitions 1981-82*, National Gallery of Ireland, 1982

Self-Portrait, 1954. Pastel on paper, 32 x 21.
Signed: 'Muriel Brandt'.
Original Kneafsey Collection.

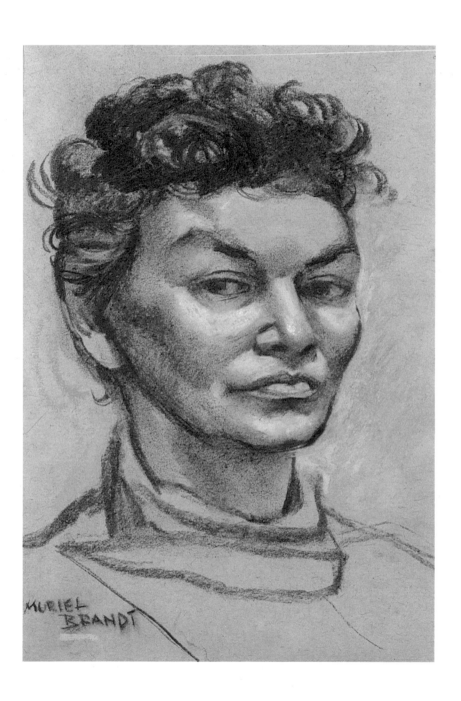

Deborah Brown

Deborah Brown is best known for her sculpture. Yet the first ten years of her artistic career were devoted to painting. In the 1950s, having seen the work of the abstracts in Paris, she experimented with their approach to painting. By the mid-1960s, she had begun to explore the sculptural possibilities of painting, attaching paper and papier mâché relief forms onto the canvas. The translucence of the more durable medium of fibreglass subsequently became an attraction; thus the jagged-edged free-standing forms emerged. More recently, she has returned to the figure, using papier mâché and wire to create life-size tableaux which are theatrical in their gestures and settings.

Her self-portrait, painted in 1986, relates to this recent sculptural development. At the time when it was painted, she was working on a series of sculptures based on goats to be seen around Cushendun in County Antrim and so she thought it would be appropriate to portray herself looking at one of these animals. Her attitude is serene and contemplative; the relationship is clearly between the artist and her subject-matter. In sculpting the goats, she models the basic shape in wire, and covers it thinly in papier mâché. The translucent quality present in these sculptures – and more notably in the fibreglass forms – is recreated in the portrait by the loosely applied overlapping layers of watercolour. Brown's interest in sculptural form is evident in this painting. The fluid handling of paint and subtle tonal range is reminiscent of her last series of public paintings, executed in the mid-1960s for the interior of the Ferranti building in Manchester.

Born in Belfast, 1929. Studied at Belfast College of Art, the National College of Art, Dublin and in Paris. Lives and works in Belfast.

Selected Exhibitions	1951 C.E.M.A. Gallery, Belfast
	1962 Arts Council Gallery of Northern Ireland, Belfast
	1977 David Hendriks Gallery, Dublin
	1982 *Deborah Brown: a selected exhibition of works completed between 1947 and 1982*, Arts Council of Northern Ireland Gallery, Belfast; Orchard Gallery, Derry; Hugh Lane Municipal Gallery of Modern Art, Dublin
	1984 *Rosc '84*, Guinness Hop Store, Dublin
Collections	Arts Council/An Chomhairle Ealaíon, Dublin
	Arts Council of Northern Ireland, Belfast
	Hugh Lane Municipal Gallery of Modern Art, Dublin
	Radio Telefís Eireann, Dublin
	Ulster Museum, Belfast
Selected Bibliography	T.P. Flanagan, 'Deborah Brown: an appreciation', *Threshold*, no. 22, 1969
	Dorothy Walker, 'Deborah Brown' in *The Irish Imagination 1959-1971*, published in association with *Rosc '71*, Municipal Gallery of Modern Art, Dublin, 1971
	Mike Catto, *Art in Ulster: 2*, Arts Council of Northern Ireland and Blackstaff Press, Belfast, 1977
	Anne Crookshank, *Deborah Brown: a selected exhibition of works completed between 1947 and 1982*, catalogue essay, Arts Council of Northern Ireland, Belfast, 1982

Self-Portrait, 1986. Watercolour and pencil on paper, 60 x 79.
Signed: 'Deborah Brown '86'.

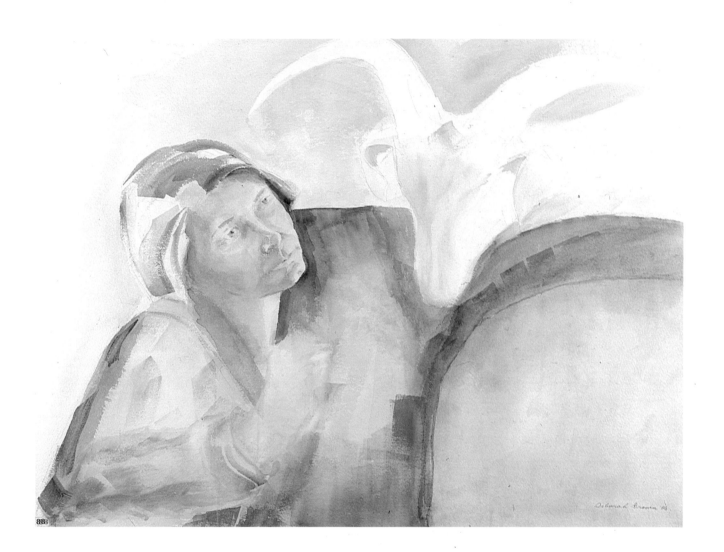

Gerarld Bruen

Gerald Bruen spent almost ten years of his early adult life in London, where he worked as a graphic artist. On his return to Ireland, he concentrated on painting and drawing, specialising in portraits and landscapes. For many years he acted as an advisor to the Department of Education, developing and promoting the teaching of art in schools. In recent years he has returned to landscape painting in watercolour. Coastal and river scenes predominate. The translucency of water is achieved through loosely overlapping layers of paint. Darks and lights are contrasted and visual detail is kept to a minimum.

Bruen, like many others represented in this collection, studied art in an environment in which the tradition of portraiture and figure painting predominated. His interest in physiognomy, allied to what he himself calls 'a good feeling for form', has resulted in his becoming a successful and popular portraitist. This is one of his early self-portraits, painted when he was forty. Like many others, it was painted 'on the spur of the moment, primarily as an exercise in the genre of portraiture'. Bruen describes it as 'somewhat trivial'. The dark hat, which throws most of his face into shadow, gives a sense of drama to the painting. The cropping of the hat on all sides seems to bring his figure closer to the viewer. His sideways look is slightly aloof.

Born in Poona, India, 1912. Studied at the Metropolitan School of Art, the National College of Art and the Royal Hibernian Academy Schools, Dublin, and the Central School of Arts and Crafts, London. Member of the Royal Hibernian Academy. Lives and works in Dublin.

Selected Exhibitions	1975 Cork Arts Society Gallery
	Exhibits regularly at the Royal Hibernian Academy.

Collections	Butler Gallery, Kilkenny
	Crawford Municipal Art Gallery, Cork
	Waterford Municipal Art Collection, Garter Lane Arts Centre

Self-Portrait, 1952. Oil on board, 36 x 26.
Signed: 'Bruen'.

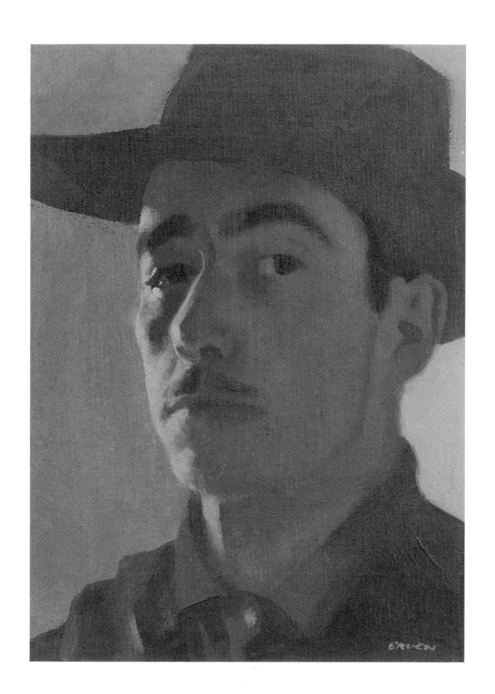

Aengus Buckley O.P.

Aengus Buckley successfully integrated a theoretical and a practical interest in art. He went to Rome in the mid-1930s to teach aesthetics at the Dominican University. During the ten years he spent there, he became increasingly interested in the art of the Italian Renaissance. This finally led to his decision to study fresco painting with Angelo Landi, then an almost lone exponent of the Roman fresco tradition. Buckley returned to Ireland and painted his first fresco in St Saviour's, the Dominican church in Sligo. This, like the rest of his painted works – both religious and secular – relies for its impact on simplicity of composition and clarity of content.

Buckley's self-portrait provided him with an opportunity to convey an intimacy not easily attained in his large-scale work. It was executed in Rome when the artist was thirty-two years old. He has painted in tempera, influenced, no doubt, by the early Italian Renaissance tradition. However, his choice of linen rather than a wooden panel as a painting surface, is unusual. Buckley believed serenity to be one of the most essential qualities in a work of art. His own portrait is a remarkably serene painting, restrained both in its mood and handling of paint. He gradually builds up the tones to give substantial volume to the head which is brightly lit from one side. The roughly painted areas of the hair and ear contrast with the finer details of the facial features. This is a gentle painting which reflects the artist's compassionate character.

Born in Cork, 1913. Studied at the Crawford School of Art, Cork and the Accademia di Belle Arti, Rome. Died in Cork, 1978.

Commissions Ennistymon Parish Church, Co Clare
 Galway Cathedral
 St Saviour's Dominican Church, Limerick
 St Saviour's Dominican Church, Waterford
 University of Limerick

Selected Bibliography Brian McLaughlin, 'In pursuit of an Irish art form', *Irish Press*, May 9, 1978

Self-Portrait, 1945. Tempera on linen, 32 x 29.
Signed: 'A. Buckley OP Rome '45'.
Original Kneafsey Collection.

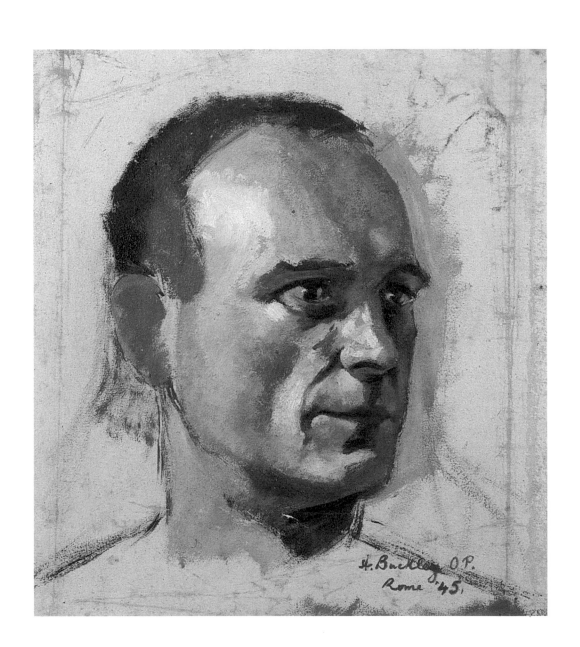

H. Buckley O.P.
Rome '45.

Robin Buick

In 1983 Robin Buick gave up his career as a computer analyst so that he could devote himself fully to sculpture. Since this time he has gained considerable skill and confidence working from the figure in bronze and terracotta. A year spent at the New York Academy of Art (1987-88), where he studied artistic anatomy, has furthered his understanding of the nude. Rodin, whose work Buick first came across in illustration in 1967, has been a constant source of inspiration: 'It is the expressive way in which he uses the human form and the subtle sexuality between his figures that fascinates me.' Buick's own female nudes, elegantly S-shaped, in terracotta and bronze, possess the classical beauty of Rodin and the rich sensuality of Clodion, the late eighteenth-century French sculptor, whom he also admires.

In his portrait busts Buick takes a more direct approach to his subject-matter. By focusing on a physical likeness, he can then emphasize certain aspects of the sitter's character. In his self-portrait he concentrates more on the surface texture and less on the precise visual detail. He enjoys the way in which the bronze 'has a life of its own', reflecting the light variously, and it is this expressive potential which he is keen to exploit further.

Born in Ballymena, Co Antrim, 1940. Self-taught artist. Associate of the Royal Hibernian Academy. Lives and works in Dublin.

Selected Exhibitions	1979 Lad Lane Gallery, Dublin
	1981 Stone Gallery, Galway
	1983 Apollo Gallery, Dublin
	1985 Grafton Gallery, Dublin
	1988 New York Academy of Art, New York
Commissions	Dublin Corporation
	Institute of Chartered Accountants, Dublin
	Nixdorf Computer International Ltd, Dublin
Selected Bibliography	Aidan Dunne, 'Byzantium', *Image*, April 1986

Self-Portrait, 1974. Bronze, height 32.
Signed: 'R Buick 1974'.

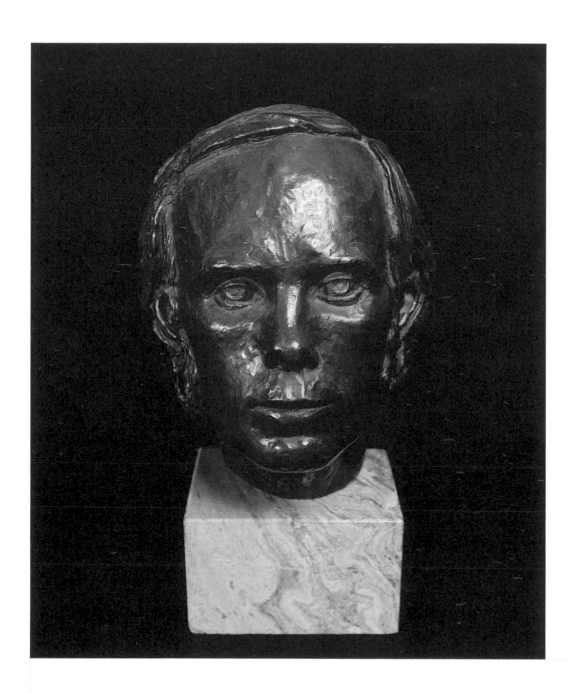

Augustus Burke

Like many Irish artists of his generation, Augustus Burke both studied and worked for many years outside his native country. Little is known of his training, although he spent some time studying formally in London. He also lived in Brittany and Antwerp for a brief period in the 1870s. Landscapes predominate from this time on. Strong contrasts of light and shade distinguish the Breton domestic scenes and landscapes. The same location and method of painting were adopted by Burke's students, Walter Osborne and Joseph Malachy Kavanagh, whom he taught when Professor of Painting at the Royal Hibernian Academy Schools in the early 1880s. Burke painted the countryside of Wexford and Connemara in subdued greens and is perhaps best known for his impressionistic studies of cattle.

Burke was also well-respected as a portrait painter. The self-portrait in this collection reveals his sensitive approach to the genre. He turns, almost hesitantly, towards the viewer. His head, in three-quarter view and lit from one side, is further highlighted by the traditional dark background. The glazed paintwork is smooth. The flesh tones in particular are skilfully rendered. Judging from a charcoal drawing of the artist made by Sir Alfred Grey in 1873 – now in the National Gallery of Ireland – he is probably in his late forties in this self-portrait.

Born at Knocknagua, Co Galway, c.1838. Studied in London. Member of the Royal Hibernian Academy. Died in Florence, 1891.

Selected Exhibitions	1971 *Irish Art in the 19th Century*, Crawford Municipal School of Art, Cork 1980 *The Peasant in Nineteenth Century French Art*, Douglas Hyde Gallery, Dublin 1984 *The Irish Impressionists: Irish Artists in France and Belgium, 1850-1914*, National Gallery of Ireland and Ulster Museum, Belfast Exhibited regularly at the Royal Academy and the Royal Hibernian Academy.
Collections	Hugh Lane Municipal Gallery of Modern Art, Dublin National Gallery of Ireland, Dublin
Selected Bibliography	Cyril Barrett S.J., 'Augustus Burke' in *Irish Art in the 19th Century*, Crawford Municipal School of Art, Cork, 1971 Julian Campbell, *The Irish Impressionists: Irish Artists in France and Belgium, 1850-1914*, National Gallery of Ireland, 1984 Mary Stratton, *The Life and Work of Augustus Nicholas Burke RHA 1838-1891* (unpublished source)

Self-Portrait. Oil on canvas, 30.5 x 26.
Signed and inscribed on reverse: 'A. Burke RHA. Painted by himself.'
Purchased from Gorry Gallery, Dublin, 1988.

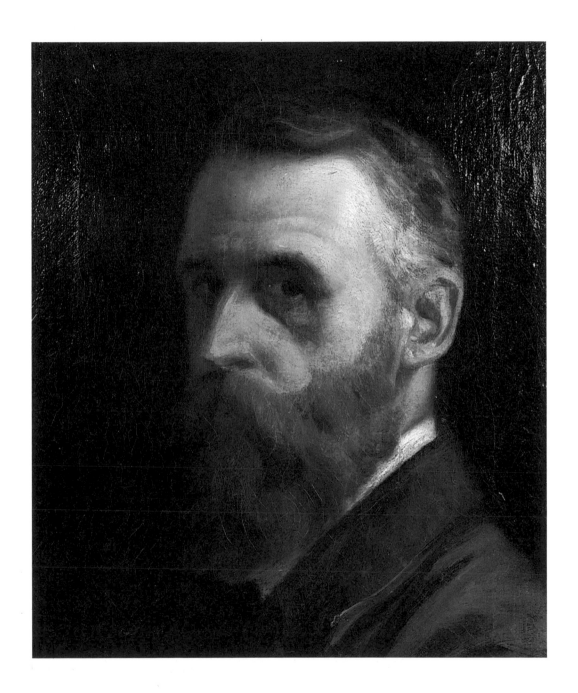

John Butts

John Butts was part of a significant development in landscape painting in Ireland in the mid-eighteenth century. As is the case with many artists of the period, little of his work has survived. Apart from the self-portrait, there are only two other works known to be his. One, in the National Gallery of Ireland, is a view of trees above a valley, sensitively rendered in crayon, ink and wash on paper. The other is a rocky landscape in oils, painted with a broad and lively technique, indicating a Flemish influence. Other works attributed to him are stylistically similar to those of his better-known contemporary, George Barret. Aged about thirty, Butts came to Dublin from Cork and worked as a theatrical scene-painter. He is reputed to have taught James Barry, a more flamboyant and successful painter than Butts ever was – although Barry stresses that Butts was the first person to encourage and inspire him to paint.

His almost hand-sized self-portrait is not unusual in the context of mid-eighteenth-century Irish painting. Robert Hunter, a fashionable portrait painter of the time, painted several small half-length and full-length portraits and John Trotter, Hunter's son-in-law, also painted small full-length group portraits. Butts' portrait, more crudely painted than his other few known works, is perhaps more of interest as a likeness of the man and a record of the period than a fair example of his work.

Born in Cork, c.1728. Worked as a scene painter with Crow Street and Smock Alley theatres, Dublin. Died in Dublin, 1764.

Collections Cork Public Museum
 National Gallery of Ireland, Dublin

Selected Bibliography Anthony Pasquin, *Memoirs of the Royal Academicians and an Authentic History of the Artists of Ireland*, London, 1976, reprinted with an introduction by R.W. Lightbown, London, 1970
 James Barry, *The Works of James Barry*, ed. E. Fryer, 2 vols, London, 1809
 Anne Crookshank and the Knight of Glin, *The Painters of Ireland c.1660-1920*, Barrie and Jenkins, London, 1978

Self-Portrait. Oil on canvas, 19.5 x 13.5.
Inscribed on reverse: 'John Butt of Corke Landscape painter, by himself.'
On permanent loan from the Cork Public Museum.

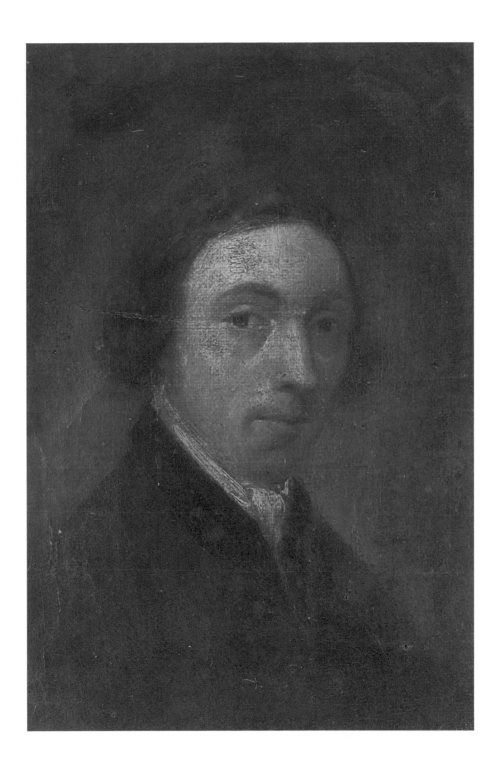

Christopher Campbell

Christopher Campbell is a little-known artist who seems to have been overshadowed artistically by his younger brother, the sculptor, Laurence Campbell. Most of his known work can be dated to a brief period during the early 1930s, shortly after he left the National College of Art in Dublin. He studied under Patrick Tuohy, whose sensitive line and assured handling of paint Campbell admired and emulated. His varied themes include portraits, nude studies, religious scenes, landscapes and fantastical compositions. His strength of design is particularly evident in the stained glass schemes which he is thought to have completed when working in the Harry Clarke Studios. Unlike Clarke's figures which are elegant and ethereal, Campbell's are stocky, sinewy types, and his subject-matter – for the most part religious – is treated in a Blakean manner.

Campbell painted and drew many self-portraits during the l930s. The three-quarter length view is one more associated with the tradition of European portraiture of the sixteenth and seventeenth centuries than that of our own age. The artist is smartly dressed and adopts a striking pose. His hands are carefully placed one over the other. Such emphasis on gesture and general appearance distracts somewhat from a frowning and intense facial expression. Campbell the colourist is revealed here; the blue of the waistcoat complements the orange shirt-sleeves. His figure, like those of his stained glass cartoons, is firmly outlined in black. In contrast, his face and hands are sensitively modelled by a subtle use of tone, suggesting the influence of Tuohy. Campbell's academic approach is evidenced by the grid, most visible on the left-hand side, which he has used as a guide for his drawing.

Born in Dublin, 1908. Studied at the Metropolitan School of Art, Dublin. Died in Dublin, 1972.

Selected Exhibitions	1976 Neptune Gallery, Dublin
	1977 Octagon Gallery, Belfast
	1980 *Irish Art 1943-1973*, in association with Rosc Teoranta, Crawford Municipal Art Gallery, Cork
	1982 *The Irish Revival*, Pyms Gallery, London
	Exhibited regularly at the Royal Hibernian Academy
Collections	Hugh Lane Municipal Gallery of Modern Art, Dublin
	Ulster Museum, Belfast
Selected Bibliography	Bruce Arnold, catalogue introduction, Neptune Gallery, Dublin 1976
	Cyril Barrett S.J., 'Christopher Campbell' in *Irish Art 1943-1973* published in association with Rosc Teoranta, Crawford Municipal Art Gallery, Cork, 1980

Self-Portrait, 1939. Pencil, crayon and watercolour on paper, 48 x 27.
Signed: 'Christopher Campbell May 7, 1939'.
Original Kneafsey Collection.

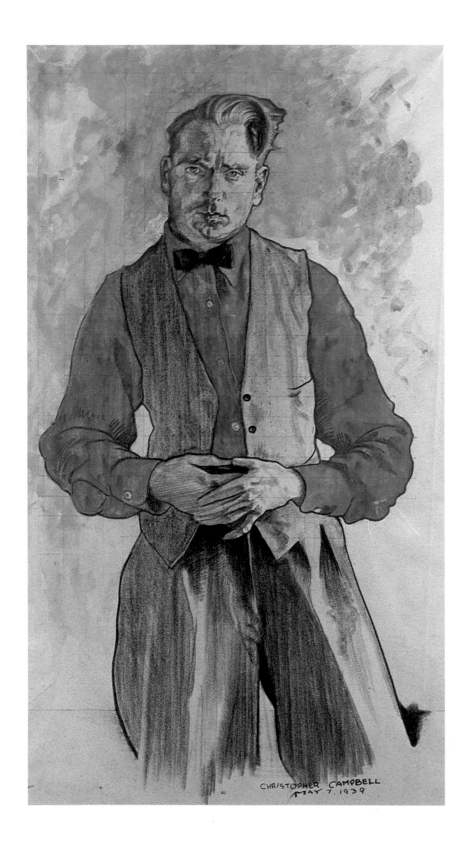

CHRISTOPHER CAMPBELL
MAY 7. 1939

Desmond Carrick

Desmond Carrick likens his painting to 'the pages of a diary'. Primarily a landscapist, he records the places he visits, both in Ireland and abroad. His choice of location is dictated by colour, the primary concern in his painting. He likes the pink skies and the burnt yellow ferns of late winter in Ireland. Summer in France or Spain offers yellows and purples, which are a particular favourite.

His self-portrait was painted in Nerja in southern Spain where he spends part of each summer. He places himself in front of a beach scene, in which he also features as a small figure, his back to the viewer, sitting working at his easel. The choice of this colourful setting was, he felt, far more attractive than 'the grey and black voids of academic works' which tend to isolate the sitter. He applies the paint in short, thick brushstrokes, allowing the tones beneath to show through. Violet predominates and unifies the composition, complemented by the warmer yellow ochre of the sand. Working mostly from dark to light, he attains a characteristic shimmering effect. The horizon is low. His own figure looms large in front of those on the beach. He looks straight out and slightly above the eye level of the viewer. Both the lively brushwork and bright palette give the painting an airy, spontaneous quality.

Born in Dublin, 1928. Studied at the National College of Art, Dublin. Member of the Royal Hibernian Academy. Lives and works in Dublin, Spain and France.

Selected Exhibitions 1959 Ritchie Hendriks Gallery, Dublin
 1963 Ritchie Hendriks Gallery, Dublin
 1982 Robinson Gallery, Dublin
 1986 James Gallery, Dalkey, Co Dublin
 1988 James Gallery, Dalkey, Co Dublin
 Exhibits regularly at the Royal Hibernian Academy.

The Painter at Nerja (Malaga). Self-Portrait, 1981. Oil on board, 60 x 44.
Signed: 'Carrick'.

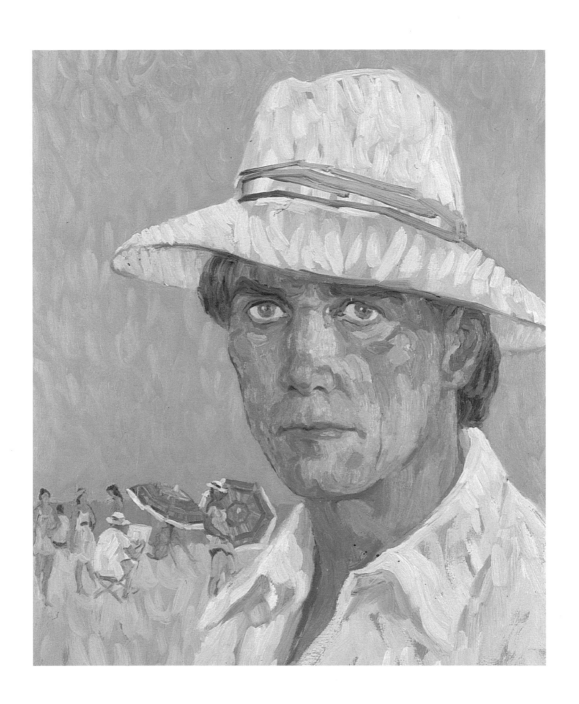

Taylor Carson

From an early stage in his career, Taylor Carson has been studying and painting the human figure. As war artist for the United States Air Force in Northern Ireland from 1943-45, he recorded the life of the men at the airbase. Spending the following year in America, he established himself as a portrait painter. He has continued to paint portraits, as well as landscapes and figure studies in oil, watercolour and pastels. Best known for his character studies, he manages to convey a personality by capturing a glance or a gesture.

This study in pastel is his second self-portrait. The first was painted in oils in 1946 after his visit to America. His use of black paper is most effective. It is as if his face, spotlit, is emerging from a dark background. Here he draws in a denser, more concise manner than usual. In parts the paper shows through, giving volume to the head. Carson exaggerates the naturally occurring green of the flesh tones which, applied also to the hair, lend a vibrancy to the portrait.

Born in Belfast, 1919. Studied at Belfast College of Art. Member of the Royal Ulster Academy. Lives and works in Co Donegal.

Selected Exhibitions 1947 Feragil Gallery, New York
 1948 Russell Button Gallery, Chicago
 1953 Combridge Fine Arts Gallery, Dublin
 1980 Bell Gallery, Belfast
 1989 James Gallery, Dalkey, Co Dublin
 Exhibits regularly at the Royal Ulster Academy and the Royal Hibernian Academy.

Self-Portrait, 1985. Pastel on paper, 25.5 x 20.
Signed: 'Taylor Carson'.

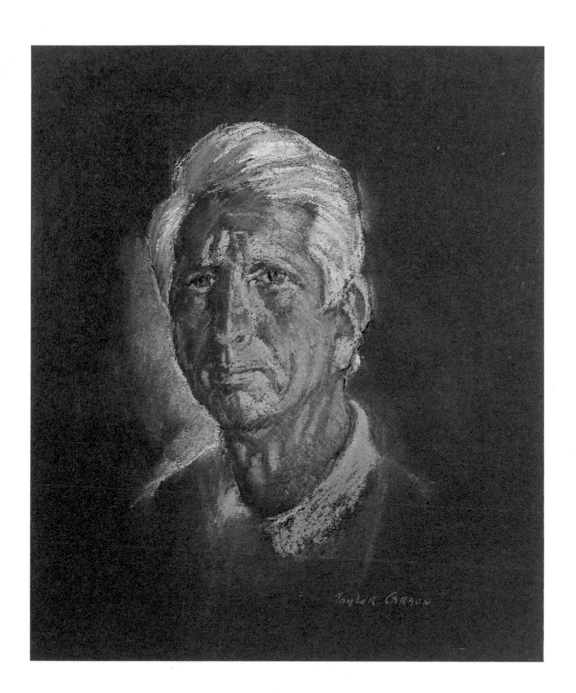

Taylor Carson

Barry Castle

Barry Castle attended the National College of Art in Dublin for a brief period in the early 1950s but did not paint again until 1969. She describes herself as a 'Sophisticated Primitive' which, she explains, is 'a self-taught artist who, through the creation of images altered by experimentation in scale, perspective and colour, brings the world to life in an entirely idiosyncratic way'. Her paintings are full of private jokes and personal symbols, yet do not exclude the viewer because of this. Her fantastical figures become intertwined, as in a medieval manuscript, with weird creatures, sometimes half-human. Religious themes are treated in a highly imaginative manner, often with reference to early Christian mythology. Compositions are tightly knit with a strong decorative element. Unity of design is further emphasized when the artist extends her painting onto the frame.

For Castle, painting a self-portrait was quite an unsettling exercise: 'Having prided myself on my lack of vanity, I was incapable of including my wrinkles – so I painted the puppet to bear them for me. If you look closely her face is like crazy paving'. The small puppet is surrounded and cushioned by the animals and oval-faced figures of Castle's paintings. Her pose is one of acceptance: her hands, outstretched, are ready to receive. She stares straight out, while Castle as the giant puppeteer covers one half of her face and can hardly bear to look. The typically smooth surface is achieved by fine stippling of numerous layers of oil paint on board. With a thin red line, concealed in parts by a profusion of leaves, Castle creates the illusion of a frame within a frame and so continues to challenge common perceptions of what a painting should look like.

Born in Dublin, 1935. Studied at the National College of Art, Dublin. Lives and works in the Alpes Maritimes, France and in London.

Selected Exhibitions	1974 Portal Gallery, London
	1980 Portal Gallery, London
	1984 *Conversations with Myself*, Portal Gallery, London
	1986 *Philip and Barry Castle*, Cork Arts Society, Cork
	1986 *Philip and Barry Castle*, Taylor Galleries, Dublin

Selected Bibliography /Sources	*20th Century British Naive and Primitive Artists*, Astragel Books (Architectural Press), London, 1977
	Portal Painters: A Survey of British Fantasists, Alpine Fine Arts Collection Ltd, New York, 1982
	David Shaw-Smith, *Life Without Shadows*, documentary film, RTE, 1985
	Pauline Bewick, 'Her technique is perfection', *Sunday Tribune*, March 30, 1986

Self-Portrait, 1987. Oil on board, 90 x 68.
Signed: 'BC 87'.

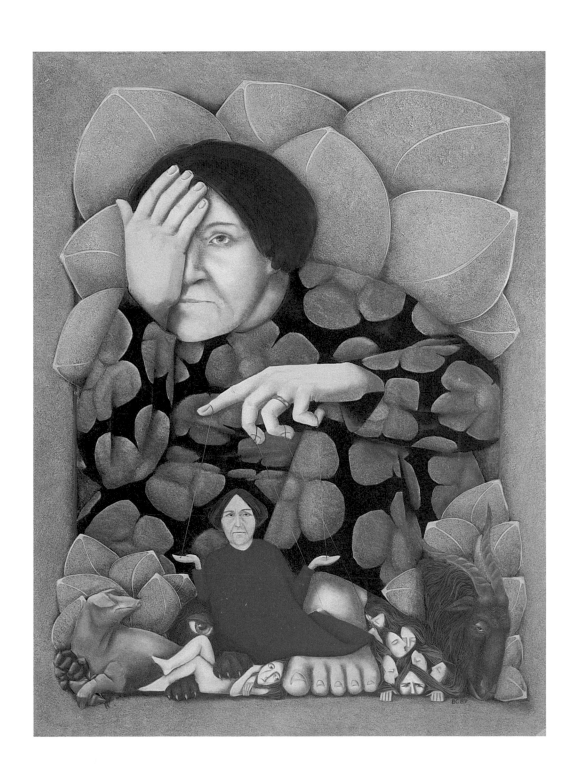

Carey Clarke

Carey Clarke paints in a very realistic style. Yet his work goes far beyond the limits of literal description. He employs a sophisticated technique and a sensitive response to light to create the mood or atmosphere of an image. In a quiet, understated way Clarke conveys the essential character of a person, a place, or a group of objects. Light is reflected in the surfaces of a still life; it models and explores the detailed forms of a portrait or landscape. His handling of paint and his approach to composition are always fresh and original.

In his self-portrait Clarke wished to examine the colour of each facet of his head under specific lighting conditions. It would seem to be a night painting, lit artificially. The contrasting flesh tones clearly define the head. In the tradition of the High Renaissance, Clarke places himself against a solid dark background. Such a device brings his figure forward and forces the viewer to focus completely on the main subject-matter.
He repeats the brown of the background in the stripe of his shirt, thereby attaining the harmony which he seeks in all of his paintings. There is a contained stillness in the portrait which holds the attention of the viewer. The artist feels that it is a good likeness 'but somehow makes me look worried'.

Born in Donegal, 1936. Studied at the National College of Art, Dublin. Member of the Royal Hibernian Academy. Lives and works in Dublin.

Selected Exhibitions	1966 Molesworth Gallery, Dublin
	1972 Winged Arts Gallery, Sedona, Arizona
	1983 Royal Academy Summer Exhibition, London
	1986 International Contemporary Art Fair, London
	1987 Grafton Gallery, Dublin
	Exhibits regularly at the Royal Hibernian Academy.
Collections	Aer Lingus, Dublin
	Radio Telefís Eireann, Dublin
	Telecom Eireann, Dublin
	Trinity College, Dublin
	Ulster Museum, Belfast
Selected Bibliography	Frances Ruane, catalogue introduction, Grafton Gallery, 1987
	Aidan Dunne, 'Carey Clarke's exciting nuts and bolts', exhibition review, *Sunday Tribune*, November 22, 1987

Self-Portrait 2, 1981. Oil on canvas, 50.5 x 45.5.
Signed: 'Carey Clarke'.
One of two portraits by the artist in the Collection.

Simon Coleman

Simon Coleman studied under Seán Keating and Maurice MacGonigal, whose teaching placed great emphasis on life drawing and painting. Coleman continues this tradition, painting in oils and watercolours, mostly to commission. As well as portraits, he likes to paint still lifes, flower studies, landscapes, seascapes and agricultural scenes. His main concern is to represent the subject-matter in as lifelike a fashion as possible: 'I have photographic vision which compels me to be accurate in drawing always.'

Coleman believes that 'portraiture is always suspect as a likeness' in that it cannot represent someone as accurately as a photograph. The necessity to produce a photographic likeness is not implicit in self-portraiture, which may account for the looser, more abstract style of painting which he adopts here. He varies his paint surfaces, using broad brushstrokes to depict his own figure and a palette knife for the background. He places himself against a two-toned backdrop, contrasting the dark red of his sweater with the dark green of the drape behind. This results in a livelier composition than the more traditional monochrome background. The angle of vision, which is slightly upward, creates a striking effect.

Born in Duleek, Co Meath, 1916. Studied at the Metropolitan School of Art, Dublin. Member of the Royal Hibernian Academy. Lives and works in Co Meath.

Selected Exhibitions	1948 Victor Wadddington Galleries, Dublin Exhibits regularly at the Royal Hibernian Academy.
Collections	Butler Gallery, Kilkenny Hugh Lane Municipal Gallery of Modern Art, Dublin Limerick City Gallery of Art Ulster Museum, Belfast

Self-Portrait, 1981. Oil on canvas, 50 x 34.
Signed: 'Simon Coleman R.H.A'.

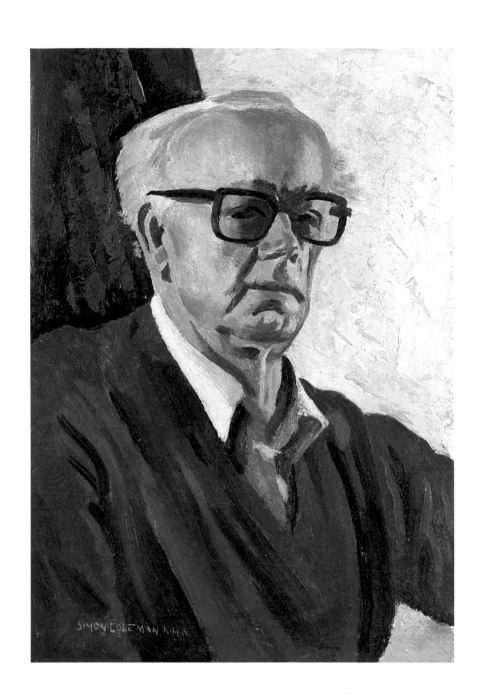

George Collie

George Collie was one of the most sought-after and prolific portrait painters of his time. After studying in Dublin, London and Paris, he returned to Dublin to teach at the National College of Art. Later he opened his own school and studio in Schoolhouse Lane which he ran successfully for over thirty years. He operated an *atelier libre* which allowed students to take classes during the day or evening as they wished. His own output included numerous portrait commissions from church and civic dignitaries as well as from private individuals.

Unlike many artists who practised self-portraiture as an exercise in portrait painting, Collie, constantly busy with commissions, had no such need. The image here is typically strong and clear. He paints himself from the front and stares directly at the viewer. The draped or coloured background is a popular device, employed by portrait painters since the Renaissance, and one which Collie used successfully for many of his commissioned works. As always, pictorial unity is a priority; the varying shades of grey, most intense in the drape and bow-tie, harmonise the composition.

Born in Carrickmackross, Co Monaghan. Studied at the Metropolitan School of Art and the Royal Hibernian Academy Schools, Dublin; the Royal College of Art, London; the Académie de la Grande Chaumière and the Académie Colarossi, Paris. Member of the Royal Hibernian Academy. Died in Dublin, 1975.

Selected Exhibitions	Exhibited regularly at the Royal Hibernian Academy.
Collections and Commissions	Cathedral of St Patrick and St Felim, Cavan Hugh Lane Municipal Gallery of Modern Art, Dublin Limerick City Gallery of Art National Gallery of Ireland, Dublin St Patrick's College, Maynooth
Selected Bibliography	Adrian le Harival and Michael Wynne, *National Gallery of Ireland Acquisitions 1984-86*, National Gallery of Ireland, Dublin, 1986

Self-Portrait, 1967. Oil on board, 40 x 32.
Signed: 'George Collie'.
Original Kneafsey Collection.

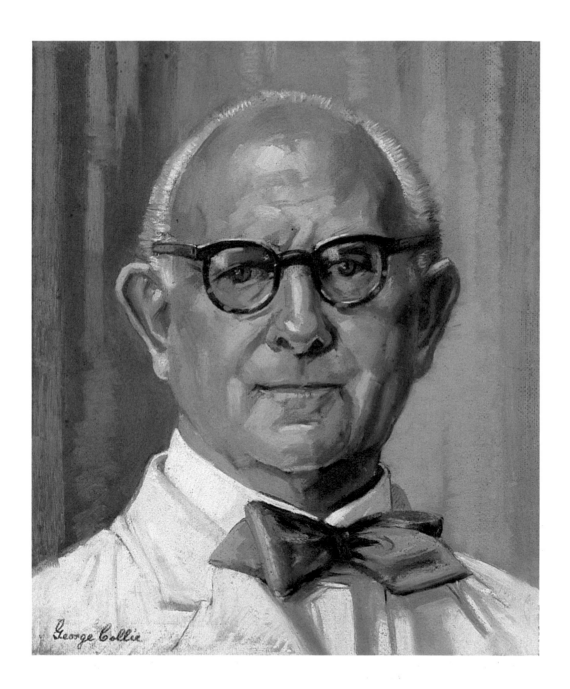

George Collie

William Conor

William Conor has been variously described as the 'Manet of Belfast', 'an Irish Daumier without the bitter satirical edge' and 'a Belfast Dostoevsky in paint'. Yet his subject-matter seems more down-to-earth than that of Manet, his picture of poverty less depressing than Daumier's and his paintings more cheerful than Dostoevsky's novels. To bring the comparisons closer to home, Conor was more like an urban Seán Keating or a Belfast equivalent of Harry Kernoff. He drew and painted the world he knew best: that of working-class Belfast. With compassion and good humour, he depicted crowds of chubby-cheeked children, "shawlies", mill girls, shipyard workers and women at their domestic chores. Despite periods spent in America, London and Paris – where he worked in André Lhote's studio – both the style and subject-matter of his pictures remained unchanged.

Conor's self-portrait, executed when he was eighty years of age, offers a glimpse of this gentle, unassuming character. His expression is alert, his mouth open as if he were caught in mid-sentence. Here one can observe his curious use of pastels, whereby he attained a variety of grainy textures by scraping or rubbing away areas of the pigment and then ironing the reverse side of the drawing. During his lifetime, Conor painted a number of larger, more formal self-portraits. This one, however, reveals more of his personality than any of the others.

Born in Belfast, 1881. Studied at Belfast College of Art. Member of the Royal Hibernian Academy. Past President of the Royal Ulster Academy (1957-64). Died in 1968.

Selected Exhibitions	1923 Goupil Gallery, London
	1948 Victor Waddington Galleries, Dublin
	1957 *Retrospective Exhibition*, Museum and Art Gallery, Belfast
	1968 *Conor 1881-1968*, memorial exhibition, Arts Council of Northern Ireland Gallery, Belfast
	1981 *William Conor: Centenary Exhibition*, Oriel II, Dublin
	Exhibited regularly at the Royal Hibernian Academy and the Royal Ulster Academy.
Collections	Arts Council of Northern Ireland, Belfast
	Crawford Municipal Art Gallery, Cork
	Hugh Lane Municipal Gallery of Modern Art, Dublin
	Limerick City Gallery of Art
	Ulster Museum, Belfast
Selected Bibliography	Richard Hayward, 'William Conor', *Ulster Review*, vol. 1, no. 5, October 1924
	William Conor, *The Irish Scene*, MacCord, Belfast, 1944
	Hilary Pyle, 'William Conor' in *Irish Art 1900-1950*, published in association with Rosc Teoranta, Crawford Municipal Art Gallery, Cork, 1976
	John Hewitt, *Art in Ulster: 1*, Arts Council of Northern Ireland and Blackstaff Press, Belfast, 1977
	Judith Wilson, *Conor: The Life and Work of an Ulster Artist*, Blackstaff Press, Belfast, 1981

Self-Portrait, 1961. Pastel on paper, 32 x 22.
Signed: 'Conor'.
Original Kneafsey Collection.

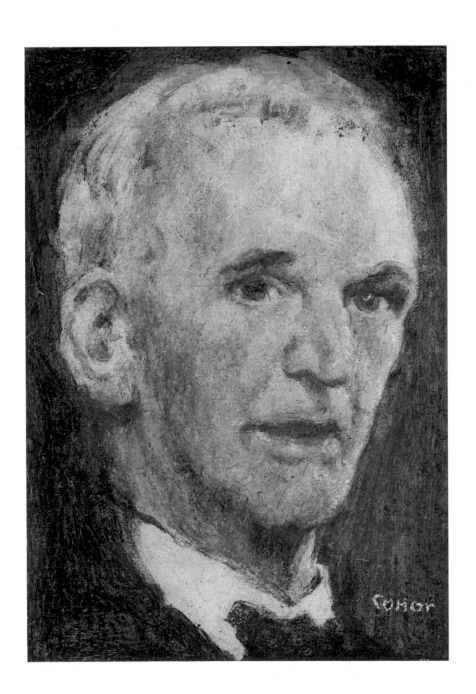

Barrie Cooke

Apart from its small size and the hard surface on which it is painted, Barrie Cooke's self-portrait has much in common with his large landscapes. The layers of thinned oil paint are loosely applied, so that the facial features seem submerged beneath a film of water. The characteristic earth colours – greens, browns and crimson – merge in parts, and the paint is allowed to drip freely downwards. Brushmarks imply spontaneity, a quality which Cooke likes to maintain in his work. Cooke rarely makes preparatory drawings; he prefers to draw with paint. His portraits and nudes are the exceptions to this rule, and even with these, he is aware of the dangers of illustration: 'You have to try to experience how that face is a landscape, a physical feature, a place.'

Nature and its regenerative process have been the main sources of inspiration for Cooke's work since he moved to Ireland in 1954. The great Irish elk, the dry grey limestone expanses of the Burren, the dense tropical rainforests of Borneo, roots, lakes, waterfalls and streams have all been studied closely over the years and have featured in large canvases and smaller charcoal drawings and watercolours. Fundamental to these images is a fluid, intuitive use of paint and a rich evocation of the natural processes of growth and decay.

Born in Cheshire, England, 1931. Studied Art History at Harvard University, Boston and attended summer schools in painting at Skowhegan College in Maine. Member of Aosdána. Lives and works in Co Kilkenny.

Selected Exhibitions	1953 Behn Moore Gallery, Cambridge, Massachusetts
	1972 David Hendriks Gallery, Dublin
	1981 *Boxes: Ten Years*, Butler Gallery, Kilkenny
	1984 *Rosc '84*, Guinness Hop Store, Dublin
	1986 Douglas Hyde Gallery, Dublin
Collections	Arts Council/An Chomhairle Ealaíon, Dublin
	Crawford Municipal Art Gallery, Cork
	Hugh Lane Municipal Gallery of Modern Art, Dublin
	Trinity College, Dublin
	Ulster Museum, Belfast
Selected Bibliography	John Montague, 'Barrie Cooke' in *The Irish Imagination 1959-1971*, published in association with *Rosc '71*, Municipal Gallery of Modern Art, Dublin, 1971
	Frances Ruane, 'Barrie Cooke: Bone Boxes' in *Contemporary Irish Art*, Wolfhound Press, Dublin, 1982
	Seamus Heaney, 'Barrie Cooke', in *Six Artists from Ireland: An Aspect of Irish Painting*, Department of Foreign Affairs, Dublin, 1983
	Aidan Dunne, *Barrie Cooke*, Douglas Hyde Gallery, Dublin, 1986
	Frances Ruane, *The Allied Irish Bank Collection: Twentieth Century Irish Art*, Douglas Hyde Gallery, Dublin, 1986

Self-Portrait, 1985. Oil on panel, 23 x 23.
Signed: 'Barrie Cooke' (on reverse).

Maud Cotter

Maud Cotter trained initially as a sculptor. As a stained glass artist, she is self-taught. Not surprisingly, it is the sculptural rather than the illustrative potential of glass which interests her. In her large abstract free-standing structures, the lines of lead are as integral to the composition as the black calligraphic markings which she paints onto the richly coloured glass. Elements of the landscape inspire many of her fluid forms. Sometimes she etches the glass so that it becomes almost clear, allowing a bright light to shine through from inside the piece. The smaller panels are more concentrated in their intensity of colour and gestural paintwork.

Cotter's decision to represent herself figuratively presented a new challenge. The basic form and design of the self-portrait, however, is consistent with the stained glass structures which she was making at the time. She has divided the portrait in two: a head piece and a lower section which may be interpreted as a torso. Originally the head consisted of a single panel. Dissatisfied with the static quality of her profile in this context, she cut up the plate and made a type of collage. What results is a section of her face, surrounded by a characteristic play of pattern and colour. Cotter likes the organic presence of what she calls this 'biomorphic detail' opening in the form of a branch at her forehead. Her head, drawn in minimum detail, looks downward and is serene. Her nose and mouth are partially obscured. The antique blue- and red-flashed glass contrast with the heavily etched areas of the face and torso, through which the light easily penetrates. Here Cotter has succeeded in integrating her own image into a representative piece of her work.

Born in Wexford, 1954. Studied at the Crawford School of Art, Cork. Lives and works in Cork.

Selected Exhibitions	1974 *Josef Albers Colour Experiment Exhibition*, Crawford Municipal Art Gallery, Cork
	1982 *Sculpture and Drawing Exhibition (S.A.D.E.)*, Crawford Municipal Art Gallery, Cork
	1983 *An Exhibition of Stained Glass, Painting and Drawing*, one-woman exhibition, Crawford Municipal Art Gallery, Cork
	1985 *Cork Art Now (C.A.N. '85)*, Crawford Municipal Art Gallery, Cork
	1986 *Cork Glass Art*, Triskel Arts Centre, Cork; Belltable Arts Centre, Limerick; Project Arts Centre, Dublin
Collections	Allied Irish Bank, Dublin
	Crawford Municipal Art Gallery, Cork
	Great American Gallery, Atlanta, Georgia
	Guinness Peat Aviation, Shannon
	University College Cork
Selected Bibliography	John Hutchinson, 'Young Artists: Maud Cotter', *Irish Times*, August 3, 1982
	Nicola Gordon Bowe, *Twentieth Century Irish Glass*, Arts Council/An Chomhairle Ealaíon, Dublin, 1983
	Nicola Gordon Bowe, *An Exhibition of Stained Glass, Painting and Drawing*, catalogue essay, Crawford Municipal Art Gallery, Cork, 1983
	Nicola Gordon Bowe, *Cork Glass Art*, catalogue essay, Crawford Municipal Art Gallery, Cork, 1986
	Francis Carr, 'Glass International', *Studio International*, vol. 199, no. 1014, 1986

Self-Portrait, 1987. Stained glass, 41 x 21.
Signed: 'Maud 87'.

John Coyle

John Coyle's self-portrait reflects one of his central themes: that of the single figure in an interior. His sitters rarely confront the viewer; their heads are turned to one side or, more often, towards the book in their lap. Sometimes they sit in front of a single coloured drape; at other times the design on a dress is played off against the pattern of a curtain or wicker-backed chair. His still lifes are simpler in composition and more direct in feeling. He isolates a bottle, a box or a piece of fruit and tries to paint each object as though he were seeing it for the first time. Here again, a book becomes a useful artistic device. Its upright opened pages surround and at the same time reflect the subject-matter of the main composition.

Coyle feels that portraits are often compositionally uninteresting: 'The demands of likeness seem to dominate everything.' He did not feel obliged to meet these demands when painting his self-portrait and so was free to experiment. In this unusual landscape format he presents an original variation on the traditional theme of the artist in his studio. He is shown full-figure, in a half-reclining position on a Victorian ship's deck-chair. He is casually dressed. A portrait sits on an easel to the right and other paintings hang on the wall. A roughly painted clothes-screen – presumably for a life model – stands in the left-hand corner. The sense of light and space is enhanced by the long mirror on the mantelpiece. Here more than usual, Coyle has sacrificed visual detail for an overall impression. The artist appears at ease in his painting environment.

Born in Glasgow, 1928. Studied at the National College of Art, Dublin. Member of the Royal Hibernian Academy. Lives and works in Dublin.

Selected Exhibitions 1979 Arts Club, Dublin
 1980 Lincoln Gallery, Dublin
 Exhibits regularly at the Royal Hibernian Academy.

Self-Portrait, 1982. Oil on board, 45 x 7l.
Signed: 'Coyle'.

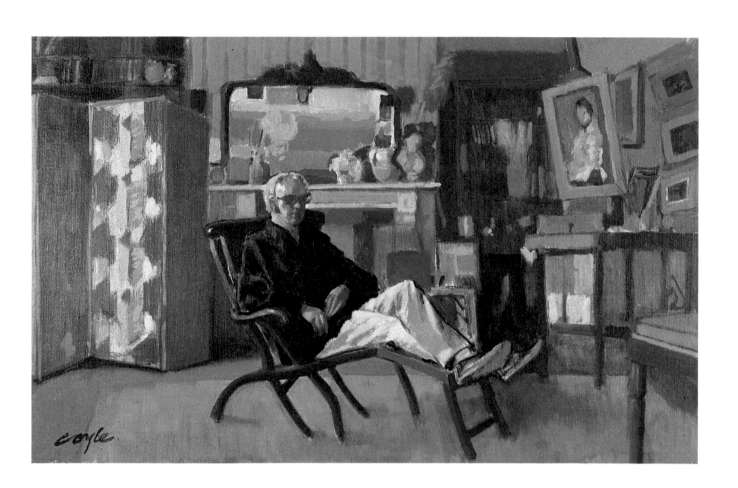

Harry Robertson Craig

Harry Robertson Craig believed that photography had a detrimental effect on painting in that it prevented artists from using their own eyes. In his own painting, he combined acute observation with technical skill to create realistic but personal impressions of people and places. His favourite genres were portraiture and landscape. Still lifes and café scenes also feature among his works. He travelled extensively in Europe and spent time painting in North Africa, preferring to keep to the coast, as he claimed 'everything looks better by the sea'. His major concern was to study and record the effects of light and weather on a scene. Although he had little regard for scientific theories about light and colour, he admired the Impressionistic interpretation of light, particularly that of Monet.

Craig's later work, which includes this self-portrait, is painted with broad, loose brushstrokes, closer in style to Monet than to the tight use of paint of his earlier years. He places himself against a large expanse of greyish-blue sky, similar to those in many of his landscapes. His face is brightly lit, his hair slightly wind-swept. There is an airy, open atmosphere which contrasts with the more frequently seen studio study. This *plein air* setting is one which Craig used to striking effect in his large-scale commissioned portraits such as that of Dan Breen in the National Gallery of Ireland.

Born in Scotland, 1916. Studied at the Dundee College of Art. Member of the Royal Hibernian Academy. Died in Portimao, Portugal, 1984.

Selected Exhibitions	1956 *Paintings of Paris by Robertson Craig*, David Hendriks Gallery, Dublin
	1959 Ritchie Hendriks Gallery, Dublin
	1973 David Hendriks Gallery, Dublin
	1986 Oriel Gallery, Dublin
	Exhibited regularly at the Guildhall Galleries, Chicago and the Royal Hibernian Academy.
Collections	Hugh Lane Municipal Gallery of Modern Art, Dublin
	National Gallery of Ireland, Dublin
Selected Bibliography	Adrian le Harival and Michael Wynne, *National Gallery of Ireland Acquisitions 1984-86*, National Gallery of Ireland, Dublin, 1986

Self-Portrait, 1981. Oil on board, 34 x 24.
Signed: 'H. Robertson Craig 1981'.
One of two portraits by the artist in the Collection.

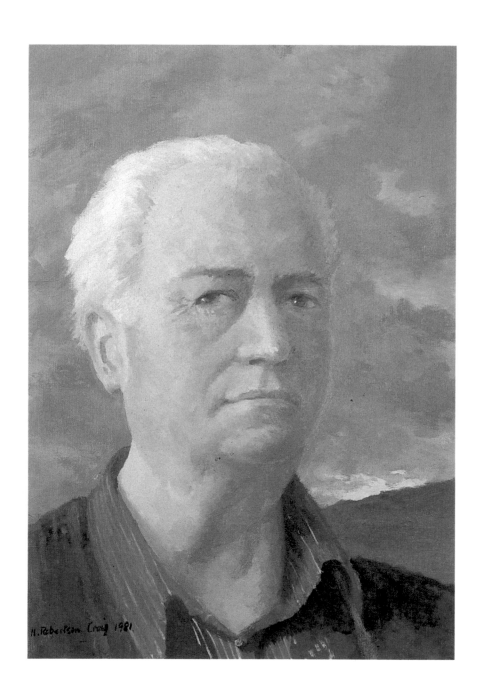

Richard Croft

Richard Croft describes his way of painting as 'funambulism' or tightrope walking. He works 'midway between abstraction and realism, swinging from one side to the other'. He paints in series; a particular still-life composition or landscape may occupy him for many years. During the 1970s his subject-matter included waterfalls, fishing boats and still lifes. More recently, he has concentrated on dolmens from County Clare and a series depicting venetian blinds. Since 1984 he has drawn his inspiration from the landscape and seascape around Dundrum in County Down where he now lives. He always begins with realistic drawings, which become increasingly abstract, until an underlying pattern predominates.

Croft resorts to portraiture on occasion 'as an academic exercise in precision'. The self-portrait in this collection – his sixth since he began to paint in 1960 – marks his decision in 1986 to give up teaching and to paint full-time. He depicts himself, almost three-quarter-length, paintbrush in hand. Outlined in black, he adopts a striking pose. It is as though he has just stopped painting and, oblivious of the viewer, is reflecting upon what he has done. Croft's interest in colour and brushwork is evident in this painting. He uses muted earth colours and applies the paint in characteristic hatched strokes. The sparsely painted white highlights have a shimmering quality. Paint thicknesses vary, allowing areas of bare canvas to show through in parts. There is, as always with Croft, a liveliness of paintwork and originality of composition.

Born in London, 1935. Studied at Bromley College of Art and Brighton College of Art. Member of the Royal Ulster Academy. Lives and works in Belfast.

Selected Exhibitions	1961 C.E.M.A. Gallery, Belfast
	1966 Arts Council of Northern Ireland Gallery, Belfast
	1971 Davis Gallery, Dublin
	1976 Tom Caldwell Gallery, Belfast
	1985 Fenderesky Art Gallery, Belfast
	Exhibits regularly at the Royal Ulster Academy, Belfast.
Collections	Arts Council of Northern Ireland, Belfast
	Crawford Municipal Art Gallery, Cork
	Oxford University
	Queen's University, Belfast
	Radio Telefís Eireann, Dublin
Selected Bibliography	Mike Catto, *Art in Ulster: 2*, Arts Council of Northern Ireland and Blackstaff Press, Belfast, 1977

Self-Portrait, 1987. Oil on canvas, 75 x 40.
Signed: 'R J Croft 87'.

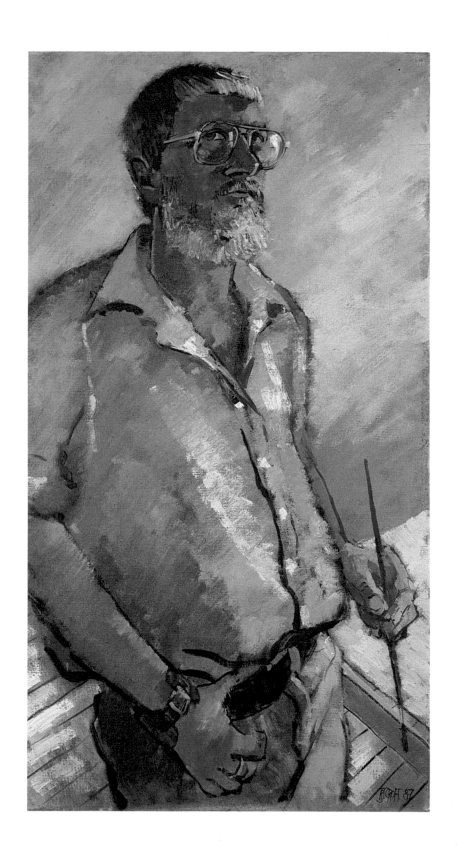

Gerald Davis

Gerald Davis is primarily a landscape painter in the Romantic Irish tradition. Joycean figures sometimes inhabit these landscapes, for which the painter, Jack Yeats, is also a direct source of inspiration. Davis paints in oils, alternating between the thickly impastoed layers on canvas, the scraped-back surface on board and the thinned paint on paper. He tends to mix his colours on the painting rather than the palette, which has a very direct impact. This is particularly evident in his paintings of Dublin's coast which feature grey expanses of sea and sand and richly coloured sunsets.

Davis' interest in the purely expressive potential of paint is coupled with his attraction for print. He has a sound working knowledge of the medium since joining the family printing business at the age of sixteen. Almost ten years later, he devised a heat-sealing method of printing which he has termed 'dallage', and has experimented with this technique – used in his self-portrait – ever since. Here he has over-printed layers of coloured foil to create an abstract composition, into which he has incorporated two photo-copied images of himself. These are taken from a poster which advertised an exhibition of the artist's work held in 1987. Davis, whose paintings may contain figurative references, is not a realistic painter. He therefore found the printed image to be an appropriate method of representation. The collage, although flat in comparison with some of his paintings, indicates his interest in textural effects.

Born in Dublin, 1938. Studied at the National College of Art, Dublin. Lives and works in Dublin.

Selected Exhibitions
1963 Molesworth Gallery, Dublin
1969 Barrenhill Gallery, Baily, County Dublin.
1974 Kenny Gallery, Galway
1980 Lincoln Gallery, Dublin
1987 *Gerald Davis – the First 25 Years*, Guinness Hop Store, Dublin

Collections
Aer Lingus, Dublin
Allied Irish Investment Bank, Dublin
Crawford Municipal Art Gallery, Cork
Hugh Lane Municipal Gallery of Modern Art, Dublin
Waterford Municipal Art Collection, Garter Lane Arts Centre

Self-Portrait, 1989. Mixed media on cardboard, 38.5 x 29.
Signed: 'Davis '89'.

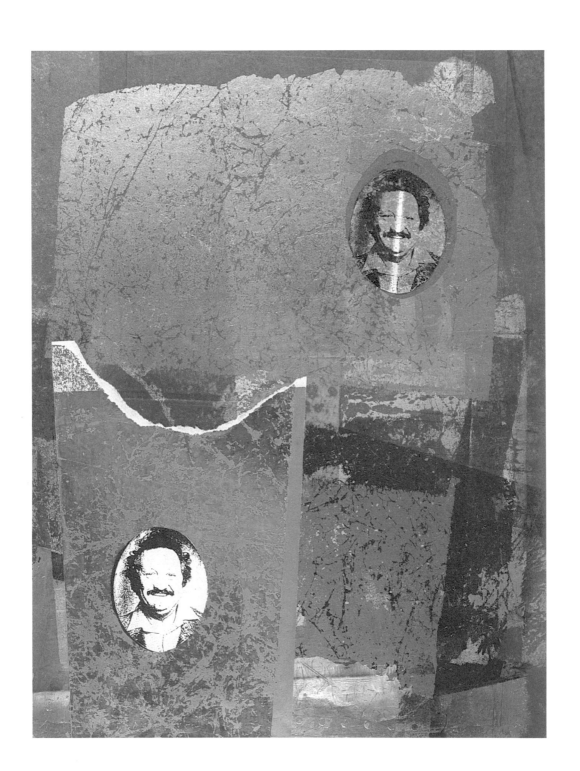

Jack Donovan

Jack Donovan sees his painting as involving 'two separate disciplines'. On the one hand, there is what he calls his 'serious work', and on the other, his portrait painting. The crowded compositions which comprise the 'serious work' are filled with simplified puppet-like figures. Faces are given a single black dot for an eye or a red line for a mouth. Bodies are often dismembered. A pair of legs hangs upside-down; an isolated head lies sideways in mid-air, as if decapitated. The ubiquitous female doll-like figure is a motif which the artist uses both to preserve the abstract qualities essential to his painting and to make reference to what he describes as 'the plaything or victim or however it is essentially most men see women if they are honest with themselves'. Magazine images, sometimes painted over, are used as a basic source for the twisted and recumbent nudes. Donovan paints thickly and rapidly. Pinks and reds predominate in both the larger figure paintings and the smaller, brightly coloured flower studies.

Donovan's portraits are painted in a much more realistic style, as is evident in the many self-portraits he has undertaken since the early 1970s. The portrait in this collection, painted at the beginning of this period, is one of his favourites. In contrast with his 'serious painting', where he uses paint and colour for their expressive qualities, in the portrait he uses paint both to describe detail *and* to express emotion. His eyes, sensitively portrayed, stare directly out. His expression is serious. He paints in oils on board, working from dark to light, which gives substance to his figure. Donovan here displays his ability to capture at once a mood and a strong physical likeness.

Born in Limerick, 1934. Studied at the Limerick School of Art and Design. Lives and works in Limerick.

Selected Exhibitions	1964 Dublin Painters Gallery
	1976 Emmet Gallery, Dublin
	1977 Belltable Arts Centre, Limerick
	1985 *Retrospective Exhibition*, Limerick Municipal Art Gallery
	1988 Taylor Galleries, Dublin
Collections	Limerick City Gallery of Art
	University of Limerick
Selected Bibliography	Roderic Knowles, 'Jack Donovan: A Sensualist View' in *Contemporary Irish Art*, Wolfhound Press, Dublin, 1982

Self-Portrait, 1977. Oil on board, 50 x 39.
Unsigned.

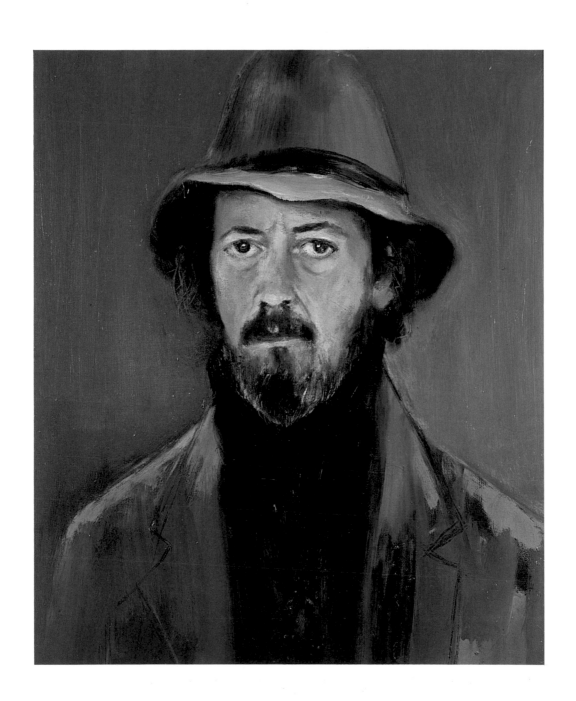

David Evans

An architect by profession, David Evans paints topographical scenes, most of which feature the architecture and landscape of Northern Ireland. In his drawings and paintings he pays close attention to detail, yet manages to convey a distinctive mood or atmosphere. Figures are often included in the composition to heighten the sense of architectural scale and function. Most of his work has been commissioned and, with the exception of some screen-prints, is executed in watercolour.

Evans' self-portrait was the first portrait he had ever painted. Here he adopts a much looser style than is typical of his work. Using a limited palette, he paints fluidly and swiftly. His features are delicately yet distinctly rendered beneath a haze of thinly applied washes. The atmosphere is almost dreamlike. He paints himself from an angle slightly above his direct line of vision and leans gently forward. This preference for the unusual angle is more pronounced in his seascapes where a beach or a boat is shown from a bird's-eye view.

Born in Belfast, 1934. President of the Royal Hibernian Academy. Lives and works in Belfast.

Selected Exhibitions
1974 Octagon Gallery, Belfast
1980 Keys Gallery, Derry
1983 Gordon Gallery, Derry
1984 Bell Gallery, Belfast
1987 *The Long Perspective*, group exhibition, Thomas Agnew & Sons Ltd, London

Collections
Arts Council of Northern Ireland, Belfast
Housing Executve, Northern Ireland
Queen's University, Belfast

Self-Portrait, 1986. Watercolour on paper, 34 x 31.
Signed: 'David Evans 86'.

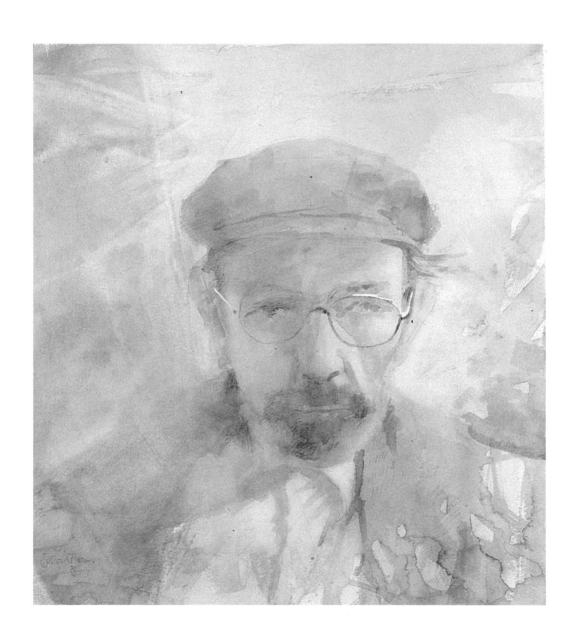

Conor Fallon

Conor Fallon finds inspiration for his sculpture in the birds and animals which inhabit the natural environment where he lives. He captures and freezes the dynamic energy of a hawk, owl or hare in simple abstracted forms which he cuts and bends from flat steel. These are animals with which he closely identifies and whose archetypal significance he can glimpse through the process of sculpture.

Fallon started out as a painter, but gradually turned to sculpture, which he exhibited for the first time in 1972. Steel, his preferred material, allows him to alter the work as it progresses; he can add or subtract by welding or cutting. Traditionally, sculptural volume is created by enclosed material mass. Fallon takes an alternative approach, allowing air and light to fill – and thus create – the spaces which he describes with thin sheets of steel. This may be seen in the self-portrait where the form is slightly flatter than usual. He is interested, he says, 'in the problems of producing a likeness without what I feel is the artificial volume of say a bronze head – I always think of the emptiness inside that metal skin'. His hair and facial features are suggested by the few empty spaces cut away from an otherwise solid sheet of steel. He emphasizes the third dimension by the angle of the ear and the protruding eyelid. The surface texture is varied. Fallon enjoys the freedom of a painter, introducing a range of tones to the piece with the vigorous markings of the axle grinder. The angle of the head and direction of the gaze create a pensive, still mood.

Born in Dublin, 1939. Self-taught artist. Member of the Royal Hibernian Academy. Lives and works in Co Wicklow.

Selected Exhibitions	1972 Newlyn Orion Gallery, Cornwall
	1975 Emmet Gallery, Dublin
	1983 *Conor Fallon: An Artist's Response*, Arts Council touring exhibition
	1983 Taylor Galleries, Dublin
	1988 *Heads*, Arts Council touring exhibition
Collections	Allied Irish Bank, Dublin
	Arts Council/An Chomhairle Ealaíon, Dublin
	Dublin County Council
	Guinness Peat Aviation, Shannon
	St Patrick's Hospital, Dublin
Selected Bibliography	Roderic Knowles, 'Conor Fallon: Archetypal Images' in *Contemporary Irish Art*, Wolfhound Press, Dublin, 1982
	Ciaran MacGonigal, *Conor Fallon: An Artist's Response*, catalogue essay, and Patrick T. Murphy, introduction, Arts Council/An Chomhairle Ealaíon, 1983
	Frances Ruane, *The Allied Irish Bank Collection: Twentieth Century Irish Art*, Douglas Hyde Gallery, Dublin, 1986
	Conor Fallon, 'Head of My Father', *Heads*, Arts Council touring exhibition, 1988

Self-Portrait, 1985. Steel, 59 x 56.
Unsigned.

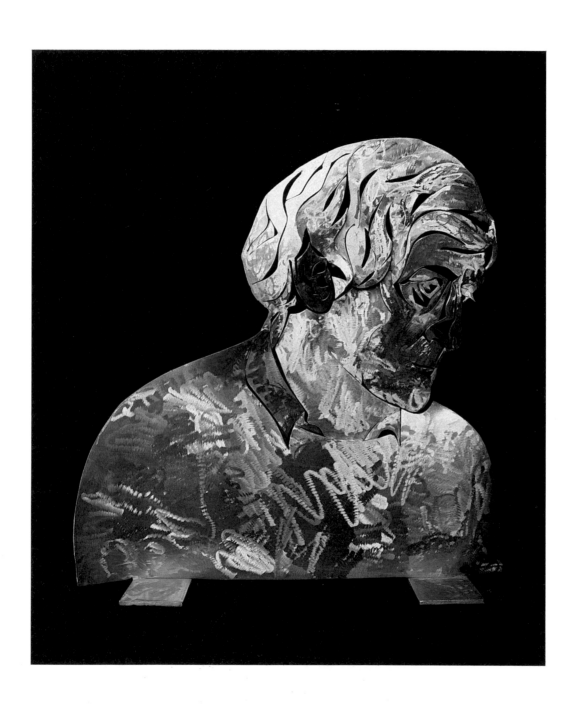

Brian Ferran

Brian Ferran's earliest paintings were landscapes. Figures and objects soon began to inhabit these views to the extent that the landscapes disappeared and only the figures remained. Drawn from Irish political history, these figures explore the interrelated themes of myth creation and the role which women have played in history. Women are seen to be 'in many ways the political manipulators ... while at the same time being able to stand removed'. References, both actual and symbolic, are made to Celtic mythology, the 1798 rebellion and the political circumstances of contemporary Northern Ireland. With the exception of a brief period of abstraction in the early 1970s, Ferran paints in a realistic style which allows him to maintain what he regards as a necessary emotional distance from his subject-matter.

Ferran has always been concerned 'to make pictures which tell a story'. More often than not the context is historical. His self-portrait is consistent with this approach. The house, now a listed building, was built by the Belfast architect, Frederick Tulloch, in 1905, and it has been Ferran's home since 1971. It is depicted in a Renaissance style roundel, acknowledging Ferran's debt to art history. Using a limited palette, he paints in an essentially realistic style, and is not afraid to leave a large part of the paper uncovered. Thus he achieves the clarity and direct quality of his images.

Born in Derry, 1940. Studied at St Mary's College of Education and St Joseph's College of Education, Belfast; the Courtauld Institute, London and the Brera Academy, Milan. Member of the Royal Ulster Academy. Lives and works in Belfast.

Selected Exhibitions	1966 Waterside Library Gallery, Derry
	1968 Queen's University, Belfast
	1973 University of Ulster, Coleraine
	1975 Tom Caldwell Gallery, Belfast
	1984 David Hendriks Gallery, Dublin
Collections	Arts Council/An Chomhairle Ealaíon, Dublin
	Arts Council of Northern Ireland, Belfast
	Crawford Municipal Art Gallery, Cork
	Queen's University, Belfast
	Ulster Museum, Belfast
Selected Bibliography	Mike Catto, *Art in Ulster: 2*, Arts Council of Northern Ireland and Blackstaff Press, Belfast, 1977
	Belinda Loftus, 'Mother Ireland and the Troubles: Artist, Model and Reality', *Circa* , no.1, November/December, 1981
	Cyril Barrett S.J., 'Brian Ferran' in *Irish Art 1943-1973*, published in association with Rosc Teoranta, Crawford Municipal Art Gallery, Cork, 1981
	Sean McCrum, 'Mourners, Marchers and Tribal Troubles', exhibition review, *Sunday Tribune*, November 6, 1983

Self-Portrait, 1984. Watercolour on hand-made paper, 57 x 76.5.
Signed: 'Brian Ferran January '84'.

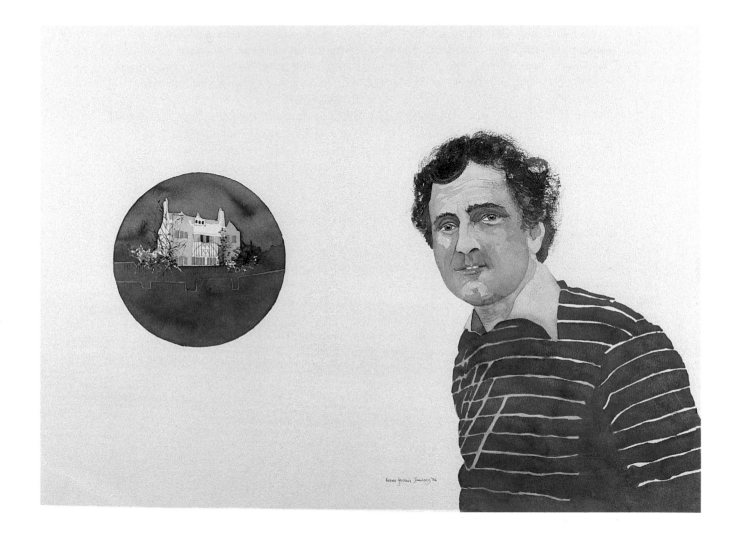

Mary Fitzgerald

Mary Fitzgerald is an abstract painter and, in the context of this collection, is unique: she is the only artist who does not represent herself figuratively. Her self-portrait is very much in keeping with the rest of her work. Its square dimensions are those used by the artist in some of her large composite pieces. In its handling of materials, the portrait reflects her central concerns. She uses a limited palette and applies the paint in layers of different thicknesses, subtly creating texture and spatial depth. Into and onto these layers she makes linear markings with graphite or charcoal. A natural tendency is to try to decipher these lines, to match them with a corresponding figurative object. Although it is possible to identify a nose and a pair of eyes – and more perhaps – such analysis denies the innate qualities of abstraction. Here the desire is to get both beneath and beyond the physical reality.

Much has been made of the influence which two years spent in Japan, studying papermaking, has had on Fitzgerald's work. Certainly, there is evidence of a commitment to mastering the craft of painting. There is also a sparse asymmetry in her linear rhythms which could be described as oriental. Sometimes she leaves large areas of the canvas untouched, contrasting the raw surface with the smooth or impastoed. Since the mid-1980s, she has grouped together square canvases in cruciform and rectangular shapes. In these, each spatial structure has its own identity, and yet clearly relates to the whole. The paintings work on many layers, from which the viewer is free to choose.

Born in Dublin, 1956. Studied at the National College of Art and Design, Dublin and Tama University of Fine Art, Tokyo. Lives and works in Dublin.

Selected Exhibitions	1982 *Painting – Drawing*, Oliver Dowling Gallery, Dublin
	1985 *Paintings*, Oliver Dowling Gallery, Dublin and Allied Irish Bank, Brussels
	1985 *Four Artists from Ireland*, Arts Councils of Ireland touring exhibition and São Paolo Bienal, Brazil
	1986 *The Drawing Room*, Oliver Dowling Gallery, Dublin
	1988 *Rosc '88*, Gunness Hop Store, Dublin
Collections	Arts Council/An Chomhairle Ealaíon, Dublin
	Arts Council of Northern Ireland, Belfast
	Contemporary Irish Art Society, Dublin
	Guinness Peat Aviation, Shannon
	Office of Public Works, Dublin
Selected Bibliography	John Hutchinson, 'Young Artists: Mary Fitzgerald', *Irish Times*, December 21, 1982
	Sven-Claude Bettinger, *Paintings*, catalogue introduction, Allied Irish Bank, Brussels, 1985
	Brian Ferran, 'Mary Fitzgerald' in *Four Artists from Ireland*, the Arts Councils of Ireland, 1985
	John Hutchinson, 'Mary Fitzgerald', *Irish Arts Review*, vol. 4 no. 2, Summer 1987
	John Hutchinson, 'Mary Fitzgerald – Oliver Dowling Gallery, Dublin', exhibition review, *Circa*, no. 43, December/January, 1989

Self-Portrait, 1987. Oil and graphite on canvas, 51 x 51.
Signed: 'Mary Fitzgerald '87' (on reverse).

Tom Fitzgerald

Tom Fitzgerald never makes traditional self-portraits. He believes that 'an artist's *oeuvre* constitutes a much more comprehensive self-portrait then any literal, visual effort'. His sculpture is firmly located in the culture and landscape of gaelic Ireland. Monuments of marble, wood and stone commemorate characters from Old Irish literature. The archaeological remains of the Clare, Limerick and Tipperary countryside have also been a rich source of inspiration for his interlocking abstract forms.

Despite its unusual figurative element, his self-portrait reflects many of the concerns of his work in general. Like the abstract 'implements' or 'devices', which derive initially from a visual or kinaesthetic experience, the self-portrait operates on a symbolic level: 'It is an attempt to create a numinous image.' The manipulation, juxtaposition and ultimate meaning of materials is a further consideration. The brittle slate pendulum, on which the artist has inscribed a simple line drawing of his face, comments on the ephemeral nature of his existence. On its reverse side is a gilded impression of his right hand. The portrait is hung so that the pendulum is at precisely the artist's own height. Here Fitzgerald reveals his accomplished technical skills and his ability to use his materials in a manner appropriate to the idea expressed.

Born in Limerick, 1939. Studied at the Limerick School of Art. Lives and works in Limerick.

Selected Exhibitions	1982 *Sculpture and Drawing Exhibition, (S.A.D.E.)*, Crawford Municipal Art Gallery, Cork
	1984 *Rosc '84*, Guinness Hop Store, Dublin
	1985 David Hendriks Gallery, Dublin
	1988 Limerick City Gallery of Art
	1988 *Olympiade des Arts*, Seoul, South Korea
Collections	Arts Council/An Chomhairle Ealaíon, Dublin
	Hugh Lane Municipal Gallery of Art, Dublin
	Limerick City Gallery of Art
	Marley Park Sculpture Garden, Dublin
	Olympic Park, Seoul, South Korea
Selected Bibliography	Tom Fitzgerald, 'Root Analogies' in *Contemporary Irish Art*, ed. Roderic Knowles, Wolfhound Press, Dublin, 1982
	Tom Fitzgerald, *Belltable Foursight*, artist's statement, Belltable Arts Centre, Limerick, 1982
	Dorothy Walker, 'Visual Aspects of Popular Culture', *Crane Bag*, vol. 8, no. 2, 1984
	Gerry Dukes, 'Opening Doors, the Portals of Discovery', catalogue introduction, David Hendriks Gallery, 1985
	Aidan Dunne, 'Artist chasing the very spirit of the land', *Sunday Press*, December 1, 1985

Self-Portrait as a Pendulum. Brass and slate, 85 x 86.
Signed: 'Tom Fitzgerald 1988' (on reverse).

Marjorie Fitzgibbon

Marjorie Fitzgibbon is best known in Ireland as a sculptor, although her initial training was as a painter. Eschewing a conventional art school education, she studied painting with Arthur Tross, a picture restorer at the Los Angeles Museum of Art. When she moved to Ireland in 1968 she began to teach herself sculpture. From the beginning she displayed a remarkable ability to capture a likeness in three dimensions and, as a result, has been commissioned to commemorate many historical, religous and literary figures. Fitzgibbon never lost her interest in painting. As in sculpture, she can create a lifelike image in paint but her primary interest is in the expressive potential of the medium. The everyday objects of her still lifes possess the calm and simplicity of Chardin. Her landscapes are freer and more impressionistic, closer in style to the abstract shimmering forms of Monet, who, along with Chardin, is an acknowledged influence.

Fitzgibbon chose to paint rather than sculpt her own portrait. In using the mirror to reflect her image, she reminds the viewer of the process involved in painting a self-portrait. Such a device, which neatly frames the artist's head, removes the viewer more than is usual from the subject. She paints here with a typically warm palette. The still life element of the mirror and the partial view of a landscape painting, which reflects the window in the room, indicate her artistic interests. The uncluttered quality of the chosen objects and the distant gaze of the artist, who seems focused on other things, make this an intimate and private self-study.

Born in Reno, Nevada, USA, 1932. Studied with Arthur Tross, picture restorer at the Museum of Art, Los Angeles. Associate of the Royal Hibernian Academy. Lives and works in Dublin.

Selected Exhibitions	1953 Wildenstein Gallery, New York
	1955 Piccadilly Gallery, London
	1969 Brown Thomas Gallery, Dublin
	1976 Tom Caldwell Gallery, Dublin
	1985 Grafton Gallery, Dublin
Collections	Imperial War Museum, London
	Maynooth College, Co Kildare
	Musée de l'Art Européene, Paris
	Papal Chambers, Vatican City, Rome
	Royal Dublin Society, Dublin
Selected Bibliography	Rebecca Schull, 'Marjorie Fitzgibbon', interview with the artist, *Irish Times*, July 20, 1973

Self-Portrait, 1986. Oil on board, 60 x 54.
Signed:'Marjorie Fitzgibbon'.

Terence Flanagan

Terence Flanagan is well aware of the illusions which paint can create. He is more concerned, however, with the physical nature of the medium: its weight, texture, consistency and the expressive potential of such qualities. In his landscapes paint describes the mood of a place rather than its detailed structure. This applies as much to expanses of dark bog painted in oil as the light-filled lake views in watercolour. He tends to work in themes: the north Donegal landscape 'with its insistence on graphic clarity'; the *Frozen Lake* series which marks his preoccupation with ice; and the splendid neo-classical mansions at Lissadel and Castlecoole.

The regions which Flanagan paints are those with which he is most familiar. He chose Lough Erne in County Fermanagh as the setting for this, the only one of several self-portraits to have been exhibited publicly. He spent much of his childhood there and was working there at the time the portrait was painted. Flanagan's understanding of water-colour is revealed in this portrait. The paint is applied sometimes wet-on-wet to give a hazy effect. In other parts – in the case of the foliage, for example – he adopts the wet-on-dry technique which gives a more defined form. He distinguishes his own figure by a slightly less fluid and more disciplined use of the medium. The naturally occurring earth colours which he uses here – umbers ochres and siennas – are his general preference.

Born in Enniskillen, Co Fermanagh, 1929. Studied at Belfast College of Art. Past President of the Royal Ulster Academy. Member of the Royal Hibernian Academy, (1978-83). Lives and works in Belfast.

Selected Exhibitions	1961 C.E.M.A. Gallery, Belfast
	1963 Ritchie Hendriks Gallery, Dublin
	1971 *A Lissadel Theme*, Municipal Gallery of Modern Art, Dublin
	1977 *T.P. Flanagan 1966-1977*, a mid-term retrospective, Arts Council of Northern Ireland Gallery, Belfast
	1988 Art Advice Ltd & Hendriks International, New York
	Exhibits regularly at the Royal Ulster Academy and the Royal Hibernian Academy.
Collections	Arts Council/An Chomhairle Ealaíon, Dublin
	Arts Council of Northern Ireland, Belfast
	Herbert Art Gallery, Coventry
	Hugh Lane Municipal Gallery of Modern Art, Dublin
	Ulster Museum, Belfast
Selected Bibliography	Kenneth Jamison, catalogue introduction, Queen's University, Belfast, 1966
	Seamus Heaney, 'Talking to T.P. Flanagan', *Irish Times*, September 21, 1967
	Seamus Heaney, 'T.P. Flanagan' in *The Irish Imagination 1959-1971*, published in association with *Rosc '71*, Municipal Gallery of Modern Art, Dublin, 1971
	Mike Catto, *Art in Ulster: 2*, Arts Council of Northern Ireland and Blackstaff Press, Belfast, 1977
	Seamus Heaney, *T.P. Flanagan 1967-1977*, catalogue introduction, Arts Council of Northern Ireland, 1977

Self-Portrait beside Lough Erne. Watercolour and pencil on paper, 56 x 76.
Signed: 'T.P. Flanagan '84'.

SELF-PORTRAIT BESIDE LOUGH ERNE. T.J.FLANAGAN '86

Rowel Friers

Rowel Friers is known mainly as a cartoonist and has worked for newspapers and magazines both in Ireland and abroad for more than forty years. In his satirical sketches he gently pokes fun at the conventions and pretensions of contemporary society. His line is swift and economical, its handling assured. Friers has also designed for stage and television productions and has produced numerous book illustrations.

His self-portrait, in indian ink and coloured pencil, is a mixture of academic drawing and caricature. Influenced by the masks of drama (Friers was a keen amateur actor), it presents the two sides of both his own and the Irish experience. On the left is a colourful, happy Friers. Here are the friendly faces and humorous characters from the pages of *Punch* and *Dublin Opinion*. The atmosphere is relaxed and carefree. One man talks to his dog, another plays with his cat. A group of men joke over a drink. All seems idyllic in the green fields with the country cottage in the distance. The right-hand side, illustrated in black and white, is dominated by 'madmen with their bombs and guns and politicians with their poison tongues': a view of contemporary Northern Ireland which has preoccupied Friers in recent years. The faces of individual politicians are identifiable. A masked soldier and the draped figure of Death, who holds a sickle, gape out eerily from the mass of heads. A bombed house is in flames. A man in a cap, his face half-covered, protects himself from the fumes. One soldier aims a rifle; another is armed with a hand-gun. With the exception of the surprise appearance of the Mexican dancing couple in the background – also featured in *Punch* and *Dublin Opinion* – the scene is pessimistic and bleak. Friers, understandably, looks solemn and disquieted.

Born in Belfast, 1920. Studied at Belfast College of Art. Member of the Royal Ulster Academy. Lives and works in Hollywood, Co Down.

Selected Exhibitions	1953 C.E.M.A. Gallery, Belfast
	1965 BBC, Belfast
	1972 Queen's University, Belfast
	1979 Grendor Gallery, Hollywood, Co Down
	1986 Davis Gallery, Dublin
	Exhibits regularly at the Royal Ulster Academy.
Collections	Arts Council of Northern Ireland, Belfast
	Derry City Council
	Royal Ulster Academy, Belfast – Diploma Collection
	Ulster Museum, Belfast
	University of Limerick
Selected Bibliography	John Hewitt, *Art in Ulster: 1*, Arts Council of Northern Ireland and Blackstaff Press, Belfast, 1977

Self-Portrait, 1984. Coloured pencil and ink on paper, 46 x 68.
Signed: 'Rowel Friers '84'.

Paul Funge

On leaving the National College of Art in Dublin in the mid-1960s, Paul Funge worked for some time in stage design. He had thought originally that he might be an actor. This did not happen, but 'the drama thing', as he calls it, as well as a strong sense of design, have always been essential to his work. His subject-matter is varied: strangely surreal figurative scenes (the titles of which suggest private jokes or fantasies), portraits and nudes. Common to all his painting is a preference for large areas of pure colour juxtaposed, a variety of paint surfaces, and an alternating between a detailed rendering and a more abstract, often stylised interpretation of form. All of these elements are integral to his self-portrait.

This self-portrait was painted in the mid-1970s, shortly after the artist had returned from a lengthy stay in Spain. He was, he says, very influenced at the time by the 'trappings and garb' of the Spaniards, hence the ruffled collar reminiscent of Velazquez. Here Funge divides his canvas into areas of relatively flat colour, thus achieving the spatial tensions particular to his portraits. These in turn are set off against the more detailed rendering of the face and the sparsely painted torso. The humorous exaggeration of his hair serves as an effective device to bring his figure forward, while at the same time introducing a novel and interesting shape into the composition. Although not as completely painted as many of his images, Funge's self-portrait possesses a distinctive immediacy and whimsical quality.

Born in Dublin, 1944. Studied at the National College of Art, Dublin. Lives and works in Dublin.

Selected Exhibitions

1968 *Perspective*, Project Arts Centre, Dublin
1974 University of California, Santa Barbara
1975 Künsthistorisch Instituut, Universitait van Amsterdam
1980 Project Arts Centre, Dublin
1984 Lincoln Gallery, Dublin

Selected Bibliography

Michael Kane, *Perspective*, catalogue introduction, Project Arts Centre, Dublin, 1968
Henry Sharpe, 'Paul Funge', in *Making Sense: Ten Painters 1963-1983*, exhibition catalogue, Project Arts Centre, Dublin, 1983
John Meany, 'Paul Funge', exhibition review, *Circa*, no.15, March/April 1984

Self-Portrait, 1977. Acrylic on paper, 72 x 54.
Signed: 'P. Funge 77'.

Martin Gale

In his painting, Martin Gale wishes to be 'one step removed from the subject'. To attain this goal he refers to photographs and paints in a realistic style which relies for its effect on smooth, invisible brushwork. He started out in the early 1970s painting close-up images of vegetables and plants. Soon his vision spread to the landscape of west Wicklow where he then lived. Unlike the wild landscapes of his contemporaries, Tim Goulding and Trevor Geoghegan (also in this Collection), Gale's narrative paintings are inhabited by people – mainly his family and friends. These figures, involved in their own worlds, often turn away from the viewer.

Gale's self-portrait is characteristic of his work in that it is a landscape with a figure rather than a figure in a landscape. Its main significance for Gale is the location. The scene is a place near his home in County Kildare which he knows and likes well. It has just rained. The sun has come out and the air is fresh. Forms are clearly defined, outlined for the most part in black. At first glance, it is the fallen tree which attracts the eye – not the figure of the artist who leans against it. Gale frequently uses such a compositional device to lead the eye into his paintings. He places himself in profile to one side of the image averting his gaze and barely indicating his features. The result is a particularly self-effacing portrait.

Born in Worcester, England, 1949. Studied at the National College of Art, Dublin. Member of Aosdána. Lives and works in Co Kildare.

Selected Exhibitions	1972 Joint exhibition with John Devlin, Davis Gallery, Dublin
	1974 Neptune Gallery, Dublin
	1981 Taylor Galleries, Dublin
	1981-2 *Family and Friends: An Artist's Response to the Figure in the Landscape*, Arts Counci touring exhibition
	1987 Taylor Galleries, Dublin
Collections	Arts Council/An Chomhairle Ealaíon, Dublin
	Guinness Peat Aviation, Shannon
	Hugh Lane Municipal Gallery of Modern Art, Dublin
	Office of Public Works, Dublin
	Waterford Municipal Art Collection, Garter Lane Arts Centre
Selected Bibliography	Bruce Arnold 'Martin Gale – an Appreciation', catalogue essay, and Patrick T. Murphy, catalogue introduction, *Family and Friends: An Artist's Response*, Arts Council/An Chomhairle Ealaíon, Dublin, 1981
	Aidan Dunne and Neil Monahan, 'Martin Gale: The Country, Family and Friends' in *Contemporary Irish Art*, ed. Roderic Knowles, Wolfhound Press, Dublin, 1982
	Frances Ruane, *The Allied Irish Bank Collection: Twentieth Century Irish Art*, Douglas Hyde Gallery, Dublin, 1986
	Ciaran Carty, 'Gale whips up the detail', *Sunday Tribune*, February 15, 1987

Self-Portrait,1983. Oil on canvas, 61 x 61.
Signed: 'Martin Gale'.

R. Brigid Ganly

Brigid Ganly was born into an active and successful artistic environment. Her father, Dermod O'Brien, became President of the Royal Hibernian Academy the year after her birth. She herself exhibited her first work and was elected an associate of the Academy at the age of nineteen. Having studied under Seán Keating and Patrick Tuohy at the Metropolitan School of Art in Dublin, she continued the tradition of portraiture and figure painting, experimenting with technique and media. Travel has been a major influence on her work. Shortly after leaving art school, she went to Italy to study the techniques of early Renaissance fresco and egg tempera painting. She subsequently used both of these techniques in her large religious murals and panel paintings. Frequent trips to Greece have been the source of many of her bright, diffusely lit landscapes in gouache and oils.

The self-portrait shows the artist at an early stage in her career. It was painted in Florence, where she rented a studio for some months in 1934, and was exhibited the following year at the annual exhibition of the Royal Hibernian Academy. This was a highly concentrated period of painting when Ganly was gaining confidence in the academic tradition. She depicts herself in the act of painting, pausing briefly to consider her subject. The tops of the brushes in her right hand are strangely cut off from view. Her light palette complements her gentle brushwork. Even at this early stage in her career, Ganly shows herself to be a skilled and sensitive portrait painter.

Born in Dublin, 1909. Studied at the Metropolitan School of Art, Dublin. Honorary Member of the Royal Hibernian Academy. Lives and works in Dublin.

Selected Exhibitions	1935 Dublin Painters Gallery
	1946 Joint exhibition with Kitty Wilmer O'Brien, Leinster Gallery, Dublin
	1965 Dawson Gallery, Dublin
	1980 Lincoln Gallery, Dublin
	1987 *Retrospective Exhibition*, Gorry Gallery, Dublin
Collections	Hugh Lane Municipal Gallery of Modern Art, Dublin
	Waterford Municipal Art Collection, Garter Lane Arts Centre
Selected Bibliography	Thomas Ryan, catalogue introduction, Gorry Gallery, Dublin, 1987

Self-Portrait, 1935. Oil on canvas, 56 x 46.
Signed: monogram initials, 'BOB 35'.

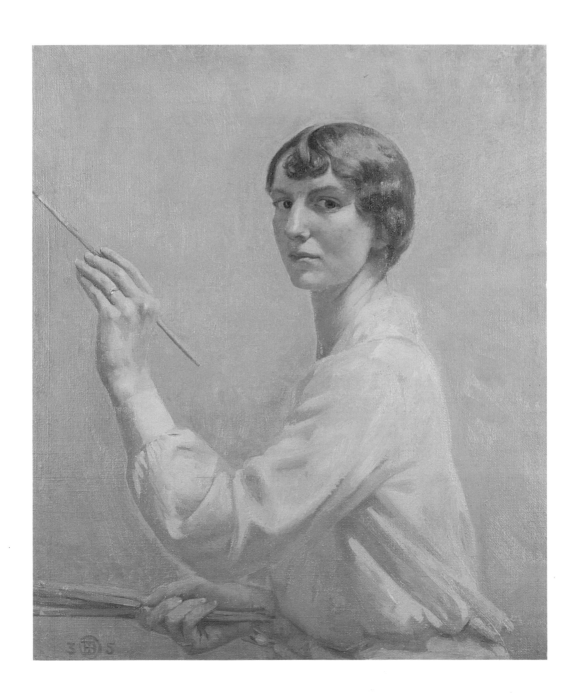

Norman Garstin

Norman Garstin was one of the group of artists known as the Irish Impressionists who, in the late nineteenth century went to paint in France. Having studied engineering in Cork and worked in the diamond mines in southern Africa, he decided to take up painting in his early thirties. He went first to the Academy of Art in Antwerp, to study with Charles Verlat, and then to Paris, where he worked under Carolus-Duran. In Paris he saw and greatly admired the paintings of Edouard Manet, whose direct tonal contrasts of dark and light clearly influenced Garstin's own work, particularly his Breton paintings. Like most of his contemporaries in France, Garstin was largely concerned with the effects of light on his subject-matter. He painted outdoor scenes – village life and landscapes – in contrasting dappled light, and small interiors where the browns and greys are relieved by light falling on a piece of fabric or glass. He travelled to Italy and Morocco before settling in Newlyn in Cornwall in the late 1880s.

His self-portrait, executed in chalk and body colour on cardboard, is small and intimate. The inscription, 'Yours sincerely', suggests that it may have been a gift to a friend. The pipe enhances this element of privacy. One can observe here Garstin's interest in contrasting areas of light and shade and his preference for building up form using colour rather than line. The body colour (watercolour mixed with white pigment), painted on tinted paper, highlights certain parts of the face so that it looks like a photographic negative. Using minimal means, Garstin attains a simple and assured image.

Born in Limerick, 1847. Studied at the Academy of Art, Antwerp and in the studio of Carolus-Duran in Paris. Died in Newlyn, Cornwall, 1926.

Selected Exhibitions	1904 *Guildhall Exhibition of Irish Art*, London 1978 *Two Impressionists- Father and Daughter: Norman and Alethea Garstin*, Penwith Galleries, St Ives; National Gallery, Dublin; Fine Arts Society, London 1979 *Artists of the Newlyn School (1880-1900)*, Newlyn, Penzance and Bristol 1984-5 *The Irish Impressionists; Irish Artists in France and Belgium, 1850-1914*, National Gallery of Ireland, Dublin and the Ulster Museum, Belfast
Collections	Hugh Lane Municipal Gallery of Modern Art, Dublin National Gallery of Ireland, Dublin Tate Gallery, London Victoria and Albert Museum, London Ulster Museum, Belfast
Selected Bibliography	Norman Garstin, 'The Art Critic and the Critical Artist', *The Studio*, August, 1893 *In Borderlands*, exhibition catalogue, Fine Art Society Galleries, 1904 Patrick Heron (introduction) and Michael Canney (biography), *Norman Garstin, 1847-1926, and Alethea Garstin, 1894-1978; Two Impressionists – Father and Daughter,* exhibition catalogue, Penwith Galleries, St Ives, 1978 Caroline Fox and Francis Greenacre, *Artists of the Newlyn School, (1880-1900),* exhibition catalogue, Newlyn, Penzance, Bristol Julian Campbell, *The Irish Impressionists: Irish Artists in France and Belgium. 1850-1914*, National Gallery of Ireland and the Ulster Museum, Belfast, 1984

Self-Portrait. Chalk and body colour on cardboard, 13 x 10.
Inscribed: 'Yours sincerely Norman Garstin'. Purchased from Gorry Gallery, Dublin, 1982.

Trevor Geoghegan

Unlike his neighbour Martin Gale, Trevor Geoghegan paints a Wicklow landscape in which there is no trace of human life. His wind-swept mountains and misty boglands seem too wild for human habitation. He paints in an essentially realistic style, contrasting individual textures and shapes. His dark, stormy skies are fiercely emotive. A more gentle mood prevails when dappled sunlight falls on a lone rock or rain-soaked tree, fragmenting their forms in the style of Monet. Fleeting weather conditions are captured and fixed onto the canvas.

In his self-portrait Geoghegan has located himself in the landscape of his paintings. He stands, off-centre and in profile, attentive to the view in front of him. The tree, which spreads across the canvas, separates him visually from the landscape and brings his figure forward. Colour harmonies unify the various elements. The familiar purples and greys predominate. Geoghegan delights in textural differences. He contrasts his face with the lichen on the tree, which in turn is set off against the bleached rough bog grass. The winter light which pervades the scene contrasts with the artificially bright light of the studio-painted self-portrait.

Born in London, 1946. Studied at Worthing College of Art, Sussex and Chelsea School of Art, London. Lives and works in Co Wicklow.

Selected Exhibitions	1972 Emmet Gallery, Dublin
	1979 Lincoln Gallery, Dublin
	1982 Wexford Arts Centre
	1984 Kenny Gallery, Galway
	1989 *East to West*, Solomon Gallery, Dublin
Collections	Algemene Bank Nederland (Ireland) Ltd, Dublin
	Arts Council/An Chomhairle Ealaíon, Dublin
	Office of Public Works, Dublin
	Guinness Peat Aviation, Shannon
	Irish Management Institute, Dublin
Selected Bibliography	Ciaran Carty, 'Trevor Geoghegan: Grass and Light' in *Contemporary Irish Art*, ed. Roderic Knowles, Wolfhound Press, Dublin, 1982
	Frances Ruane, catalogue introduction, Solomon Gallery, Dublin, 1983
	Frances Ruane, *The Allied Irish Bank Collection: Twentieth Century Irish Art*, Douglas Hyde Gallery, Dublin, 1986

Self-Portrait, 1988. Oil on canvas, 76 x 76.
Signed: 'T. Geoghegan'.
One of two portraits by the artist in the Collection.

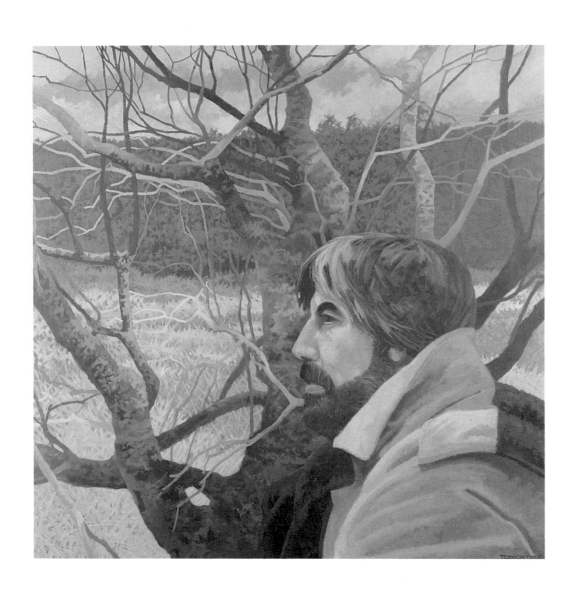

Arthur Gibney

In 1955 Arthur Gibney visited Italy with the help of a travelling scholarship from the Royal Institute of the Architects of Ireland. While there, he studied the integration of painting and sculpture in Renaissance and Baroque architecture. Since then, Italy, and in particular Venice, has been the source of inspiration for many of his paintings. His sunlit water-colours of Venetian churches and squares successfully combine a loose wash technique with a tighter, more formal approach. He likes to integrate the disciplines of drawing and painting, something which architectural studies readily allow. Part-time painting complements a full-time architectural practice: in both, Gibney remains preoccupied with the city and its development.

His self-portrait is based on recollection. Painted in 1986, it shows the young architect at his drawing board. He is distanced from the viewer by his concentration on the work in hand. There is a dreamy quality about the pose and paintwork. Here Gibney displays a characteristic ease and confidence in his handling of the medium. He uses a fine pencil to outline the basic forms, as in architectural detailing. Colours are subdued and subtly blended, the mauve of his jacket being a particular favourite.

Born in Dublin, 1931. Studied painting at the National College of Art and Design and architecture at the College of Technology, Bolton Street, Dublin. Member of the Royal Hibernian Academy. Lives and works in Dublin.

Selected Exhibitions Exhibits at the Royal Hibernian Academy.

Collections Electricity Supply Board, Dublin
 Jury's Hotel, Dublin
 Trinity College, Dublin

Self-Portrait,1986. Watercolour and pencil on paper, 35 x 34.
Signed: 'Arthur Gibney RHA '86'.

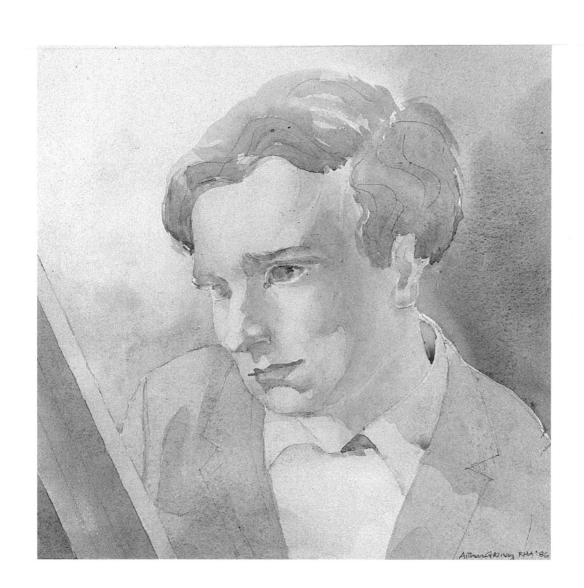

Rowan Gillespie

Rowan Gillespie spent the first ten years of his life in Cyprus. He began to cast bronze at the age of sixteen and it is the myths of ancient Greece which have inspired much of his work since. His classical figures are personal symbols. A kneeling Atlas struggles to hold up the world. Palamas climbs his ladder, knowing he will never reach his destination. Icarus is suspended in flight. The bodies are often flattened and attenuated, the surfaces roughly worked. Gillespie, like Rodin, has what he calls his 'family of people', each of whom expresses a range of emotions by a simple gesture or pose. He continues to work in bronze, experimenting with new techniques and perfecting those already learned. He casts his own work, which makes the experimental process much easier, particularly in the finishing stages.

Gillespie's self-portrait may be seen in the context of his recent work where a theme is taken and represented by a variety of different elements within one complex composition. Here it is the autobiographical theme, not surprisingly, which embraces many of the other themes expressed in his work over the years. Within the elongated tracery of bronze which constitutes his figure, he alludes to specific events and more general aspects of his life. Here he has incorporated many familiar motifs: the crouched and chained figures, the egg, fragments of trees and the small rounded bird. Also visible are a modelling tool, a ladder, a cross and chairs – again elements which have appeared in various of his narrative sculptures. It seems as if the artist feels the need for a certain distance: his head is separated from all this activity by a ruffled collar.

Born in Dublin, 1953. Studied at York School of Art, Kingston College of Art, London and Statens Künst Skole, Oslo. Lives and works in Dublin.

Selected Exhibitions
- 1974 Moss Künst Foreningen, Norway
- 1977 Lad Lane Gallery, Dublin
- 1979 Alwin Gallery, London
- 1987 Solomon Gallery, Dublin
- 1988 Draycott Gallery, London

Collections
Aer Lingus, Dublin
Allied Irish Investment Bank, Dublin
Bank of Ireland, Dublin
Dun Laoghaire Corporation, Dublin
Royal Dublin Society, Dublin

Self-Portrait, 1989. Bronze, 116 x 15.
Signed: 'Rowan Gillespie 1989'.

Michael Ginnet

Michael Ginnet's aim when painting is to communicate his feelings for his subject-matter 'as simply and directly as possible'. The planning and the structure of his paintings are vital in this regard. Drawings and written notes provide an important source of information, more so since his recent physical disability has greatly restricted his mobility. Landscapes are now fewer in number and he has begun to concentrate more on figure compositions and still lifes. He builds up his forms using small patches of colour, thereby creating a constant sense of movement.

Ginnet is a successful portrait painter and finds the recording of his own features to be a 'far less frustrating' task than recording those of someone else. His desire to be objective, however, is challenged particularly by the self-study. Here he paints what he sees: the green flesh tones, accentuated by the reflected light from his glasses and shirt, as well as the resulting complementary pinks. He breaks up the surface of the painting with individual brushstrokes, each of which describes a different tone.

Born in London, 1920. Studied at Margate and Brighton School of Art. Associate of the Royal Ulster Academy. Lives and works between Kinsale, Co Cork and Drumbeg, Co Antrim.

Selected Exhibitions 1944 *RAF War Artists*, National Portrait Gallery, London
 1975 Queen's University, Belfast
 1977 Octagon Gallery, Belfast
 Exhibits regularly at the Royal Ulster Academy.

Self-Portrait,1985. Oil on canvas, 41 x 31.
Signed: 'Michael Ginnet 85'.
One of two portraits by the artist in the Collection; other drawing part of original Kneafsey Collection.

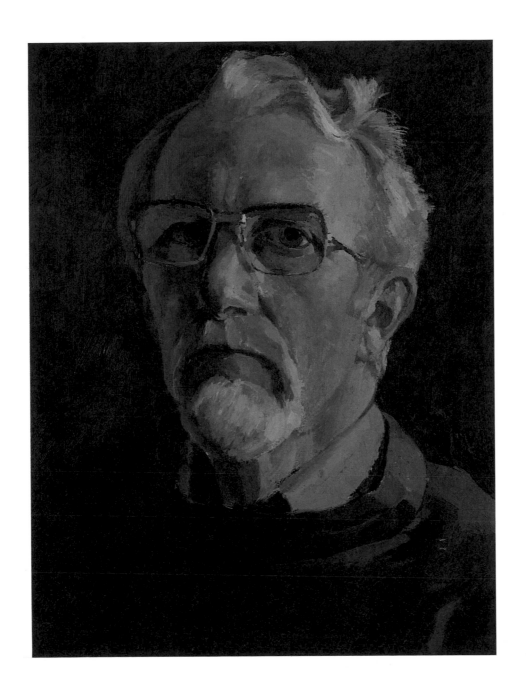

Tim Goulding

With his painting, Tim Goulding wishes 'to try and share the beauty of creation, to celebrate life'. Having received little formal art training, he taught himself to paint by experimenting with various media and styles. In the early 1970s, his work was stylistically close to pop art in its brightly coloured patterning of natural forms. By the mid-1970s, he had begun to focus almost exclusively on the landscape, which has continued to be his main source of inspiration. The first of the *plein air* paintings were detailed depictions of the Beara peninsula where he lives. Fields, houses and telegraph poles are all precisely rendered with fine, sometimes stippled, brushwork. In latter years, he has found a more personally expressive landscape through a more fluid use of both oils and acrylics. His *Cave* paintings (1987) continue to transcend the physical subject-matter so that it takes on a spiritual dimension. The light which emanates from these still, dark spaces is symbolic as well as actual.

Goulding has never worked from the figure; his self-portrait challenged him to do so for the first time. He presents a close-up view of himself, slightly cut off at the left-hand side of the painting. This cropping makes it seem as if the artist has entered our physical space. The self-consciousness of many self-portraits is replaced here by an attentive intimacy. Apparently at ease in his surroundings, Goulding looks openly and smiles gently towards the viewer. The landscape behind, painted in the tightly rendered style characteristic of his work from the late 1970s, is the view from his window in Allihies in West Cork. The Bull Rock can be seen on the horizon.

Born in Dublin, 1945. Studied textile design at Konstfackokolan, Stockholm. As a painter, mainly self-taught. Member of Aosdána. Lives and works in west Cork.

Selected Exhibitions 1969 David Hendriks Gallery, Dublin
1972 Cork Arts Society Gallery, Cork
1975 Octagon Gallery, Belfast
1977 Chastenet European Art Centre, London
1987 *Exploring the Cave*, David Hendriks Gallery, Dublin

Collections Arts Council/An Chomhairle Ealaíon, Dublin
Arts Council of Northern Ireland, Belfast
Hugh Lane Municipal Gallery of Modern Art, Dublin
Limerick City Gallery of Art
Trinity College, Dublin

Selected Bibliography Christopher Fitzsimon, 'Tim Goulding' in *The Irish Imagination 1959-1971*, published in association with *Rosc '71*, Municipal Gallery of Modern Art, Dublin, 1971
Ruth Silbick, 'Breakthrough into the Great Outdoors', *Irish Times*, January 27, 1982
Tim Goulding, 'In Wonder and Celebration' in *Contemporary Irish Art*, ed. Roderic Knowles, Wolfhound Press, Dublin, 1982

Self-Portrait, 1982. Acrylic on canvas, 45 x 35.
Signed: 'T.A.G. '82'.

Yann Renard Goulet

Yann Renard Goulet moved from Brittany to Ireland in 1947 and since this time, the subject-matter of his sculpture has been mostly Irish. His monumental bronze sculptures commemorate the lives of famed athletes and hurlers and members of the Irish Republican Army now dead. Goulet studied at the Ecole des Beaux-Arts in Paris under Despiau, Rodin's assistant. Here he learned to use bronze in a fluid and expressive manner. For Goulet, the expression is often one of violence or suffering, for which he finds inspiration in his own political activism. Bodies are lean and elongated, quite gracefully so in the case of his smaller religious reliefs and free-standing figures.

Although he can model a lifelike image with apparent ease, Goulet is not primarily concerned with literal representation: 'What you have to show are not the warts and the wrinkles. They will not indicate how you are and how you could be remembered.' In his self-portrait, he has focused on 'the strong head of the deep-sea fisherman that I was and the soldier that I became'. The upward tilt of the head and the thoughtful, outward-looking gaze suggest the idealism expressed in his work. In the tradition of Rodin he has modelled the head roughly, adopting his preferred method of cutting back the original plaster with a knife. The expressive potential of bronze allows him a freedom which he feels unable to attain in stone where 'one has to be too much of a slave'.

Born in Brittany, France, 1917. Studied at the Ecole Nationale Supérieure des Beaux-Arts, Paris. Member of the Royal Hibernian Academy. Member of Aosdána. Lives and works in Bray, Co Wicklow.

Selected Exhibitions	Exhibits regularly at the Royal Hibernian Academy
Commissions	Crossmaglen Memorial, County Armagh
	Charles Stewart Parnell Bust, House of Commons, London
	Custom House Memorial, Dublin
	John Field Memorial, National Concert Hall, Dublin
	Kerry Memorial, Tralee, Co Kerry

Self-Portrait. Bronze, height 31.
Signed: 'Y. Goulet RHA'.

Carol Graham

In 1976 Carol Graham began to use photography as a direct aid to painting. At the same time the striped skirt became the dominant image in her work. Already painting in a realistic style, her photographs helped her to define the composition of a work and to clarify the source and distribution of light. Some images are shown in close-up; others are cut off, viewed from above. The implication is 'that there is always more than meets the eye'. The use of photography also enabled the artist to achieve a much more convincing likeness in her portraits. She paints slowly. Initially she builds up her canvas with several layers of finely hatched acrylics and on top of this, she uses oils for the precise details of the image.

Graham's self-portrait, drawn in coloured pencil, provided her with an opportunity to show the relationship between herself and the *Striped Skirt* series, for which she was always the model, although her face was never shown: `The model becomes whoever the viewer wishes her to be.' Here she sits, comfortably and barefoot, resting her head in her hand, as if day-dreaming. The soft tones and bright summer light enhance the relaxed atmosphere. Graham applies the colour theory of the Impressionists, allowing the colours to mix optically. She surrounds herself with an aura of darker colours – suggesting a cushioned chair – which helps to define her figure. Graham wishes 'to challenge and seduce the viewer' with her images. Here she confronts common preconceptions of a finished piece by leaving a large area of the paper uncovered. In depicting her own image, she enjoyed both the technical problems of portraying a physical likeness and the particular freedom in choosing the pose, location and dress of the sitter.

Born in Belfast, 1951. Studied at the Art and Design Centre, Belfast. Member of the Royal Ulster Academy. Lives and works in Belfast.

Selected Exhibitions	1976 *Women of Ulster*, Arts Council Gallery, Belfast
	1981 Arts Council of Northern Ireland Gallery, Belfast
	1982 Joint exhibition with Basil Blackshaw, Arts Council of Northern Ireland Gallery, Belfast
	1982 Tom Caldwell Gallery, Dublin
Collections	Arts Council of Northern Ireland, Belfast
	Belfast City Hall
	Ulster Museum, Belfast
	Downpatrick Museum, Co Down
Selected Bibliography	Mike Catto, *Art in Ulster: 2*, Arts Council of Northern Ireland and Blackstaff Press, Belfast, 1977
	Brian Kennedy, 'Carol Graham's Photo-Realism', *Circa*, no. 5, July/August, 1982

Self-Portrait, 1987. Coloured pencil on paper, 45 x 43.
Signed: 'Carol Graham 2 87'.

CarolGraham 2 87

Patrick Graham

Patrick Graham received a conventional academic training at the National College of Art in Dublin in the early 1960s. During this time he became interested in the German Expressionists who, in 'their generosity to their own humanity: their own vulnerability', suddenly subverted his own understanding of art. With difficulty, he gradually ceased to rely on what he calls 'clever draughtsmanship' and surrendered to a more personally expressive way of painting and drawing. Through his highly charged figurative images he exposes the conflicts which he encounters in his own life and that of Irish society at large. Religious, political and sexual themes are explored in dark, densely painted canvases, many of which adopt the traditional religious format of diptych or triptych.

His self-portrait, painted on paper, is characteristic of his work in its division into separate sections. He surrounds his figure with rectangular blocks of colour. The outer frame of gold and red, relieved by a delicate triangular motif, suggests the preciousness of an icon. The main image is more forceful. Here a duality is expressed: 'a fragile physicality and a more durable faith in memory'. His face, partially over-painted in white, emerges tentatively from a dark background. Red ink drips, blood-like, from his forehead. It rests congealed over his deep-set eyes and sunken cheeks. Graham often uses text to support and extend the feeling of a painting. Mullingar, his birthplace, spelt out in thin white letters, is fixed in his memory. It was here as a schoolboy that he was first encouraged to paint. Graham's body, depicted in child-like fashion, bears his name and the date of the painting. It hovers above a strip of emerald green – an Irish reference, perhaps. As is often the case with Graham, a single painting embraces many elements.

Born in Mullingar, Co Westmeath, 1943. Studied at the National College of Art, Dublin. Member of Aosdána. Lives and works in Dublin.

Selected Exhibitions	1974 *Notes from Mental Hospitals and other Love Stories*, Emmet Gallery, Dublin
	1982 Lincoln Gallery, Dublin
	1983 *Making Sense: Ten Painters 1963-1983*, Project Arts Centre, Dublin
	1987 Jack Rutberg Fine Art Gallery, Los Angeles
	1988 Fischer Fine Art Gallery, London
Collections	Arts Council/An Chomhairle Ealaíon, Dublin
	Contemporary Irish Arts Society, Dublin
	Hugh Lane Municipal Gallery of Modern Art, Dublin
	National Concert Hall, Dublin
Selected Bibliography	Aidan Dunne, *Aspects of Ireland*, Department of Foreign Affairs, Dublin, 1983
	Henry Sharpe, 'Patrick Graham' in *Making Sense: Ten Irish Painters 1963-1983*, Project Arts Centre, 1983
	Aidan Dunne, *Brian Maguire/Patrick Graham*, catalogue essay, Octagon Gallery, Belfast, 1984
	Julian Campbell, catalogue introduction, Triskel Arts Centre, Cork, 1985
	John Hutchinson, 'Interview with Patrick Graham', *Irish Arts Review*, vol. 4, no. 4

Self-Portrait, 1988. Mixed media on paper, 87 x 57.
Inscribed and signed: 'for Robin Graham 1988'.

Peter Grant

Peter Grant studied sculpture at the National College of Art in Dublin, under Frederich Herkner (also represented in this Collection) and Oliver Sheppard. In 1939, while still a student, he designed a colossal warrior figure as the Irish entry to the New York World Fair, and which he executed in collaboration with Herkner. He continued to sculpt in the monumental tradition, working in wood, stone and bronze. In his sacred works, he has sought to reveal a timeless, universal quality, while his secular commissions focus more on the heroic ideal, as can be seen in his portraits of James Connolly and Henry Grattan.

His self-portrait, in bronze relief, is rendered in far greater detail than the larger works which rely upon simple lines and reduced form for strength of image. The eyes and nose are particularly carefully modelled. Grant places much emphasis on what he calls 'a strong sense of rhythmic design'. In the religious works, he sees it as having a profound spiritual effect, 'reconciling unity with diversity, contrast with harmony, and in this regard, is said to be analogous to the one and the many of the mystics'. In the secular sculpture, its role is more apparent; the textured pattern, worked over the surface of the self-portrait and the gently undulating background vitalize and unify the piece.

Born in Pomeroy, Co Tyrone, 1915. Studied at the National Colege of Art, Dublin. Lives and works in Dublin.

Exhibitions	1948 Pan-Celtic Arts Festival, Lorient, Brittany
	1950 Holy Year Exposition, Rome
	1963 Liturgical Arts Festival, Riverside, California
	Exhibits regularly at the Royal Hibernian Academy.
Commissions	Cardinal D'Alton, Fransiscan Convent, Dundalk
	Edmund Rice Memorial, Callan, Co Kilkenny
	James Connolly, Belfast
	Joseph Plunkett, National Gallery of Ireland, Dublin
	Major John MacBride, Westport
Selected Bibliography	James White 'The Art of the Sculptor', *Standard*, November 22, 1946
	Peter Grant, 'The New Religous Art in Ireland', *Hibernia*, March 1962

Self-Portrait 1987. Bronze relief, 38 x 32.
Signed: '87 Peter Grant'.

Ann Griffin Bernstorff

Since she was a student, Ann Griffin Bernstorff wished to use her academic training to paint in a way that differed from anything she had already learned. She now has developed a naive style which allows her to create images that are 'slightly dislocated from reality'. Her figures have the fixed stares and china-doll complexions of a Bronzino painting. In her large group portraits, families in party dress are arranged formally in front of their country houses, accompanied by farm animals as pets. Animals have always featured in Griffin's work. A woolly sheep or a laying hen deserves a full-length portrait; the feeling conveyed is one of care and respect.

Her self-portrait, like many of her paintings, is *a pastorale*. By incorporating a painting within a painting, the artist can present two different images of herself. In the inner canvas she appears as mother. The lamb-in-arms and the two sheep symbolise her children. Her husband, depicted as a shepherd herding more sheep, may be seen in the distance. Proportion is typically distorted; the house appears doll-size in relation to the figures. The larger seated self-portrait is that of the artist who remains outside the painting she has created. At her feet are the two sheep – the children – of the inner painting. She displays her paintbrushes and palette, inscribed with her name and address and the names of her children and sheep. The exaggerated hairstyle of both this and the inner image reveal Griffin's preference for stylised, simplified forms, inspired by the work of the early Italian Primitives and the Primitive portrait painters of North America.

Born in Limerick, 1938. Studied at the National College of Art, Dublin, the Yves Brayer Atelier and the Ecole des Beaux-Arts, Paris. Lives and works in New Ross, Co Wexford.

Selected Exhibitions 1964 Molesworth Gallery, Dublin
 1979 Wexford Arts Centre
 1984 Gordon Gallery, Derry
 1988 *Portal to Portals*, group exhibition, Portal Gallery, London

Self-portrait, 1987. Oil on canvas, 60 x 75.
Signed: 'Ann Griffin Bernstorff 1987'.

Patrick Hall

Painting for Patrick Hall begins at an intuitive, emotiona level: intellect and consciousness are brought to bear at a later stage. The element of the unknown or the unexpected is necessarily part of this way of working. His series of male nudes in interiors, which date to the early 1980s, are sensual and sexually explicit. Their bright colours and simplified arabesques recall Matisse's nude studies. *The Flaying of Marsyas* (1985) sequence considers the challenge between the individual and authority. Marsyas, a satyr of Greek myth, challenged Apollo to a musical competition. Apollo won and had Marsyas tied to a tree and flayed alive: the artist, often working outside or on the edge of the society, may not always be heard. In his own art, Hall wishes for a sort of silence 'that in some unknowable way feeds energy and passion while being the denial of them'.

For Hall 'art is making order out of chaos'. In his self-portrait he depicts himself in a swirling sea of pinks with a single streak of orange running through it. The browns and pinks, reminiscent of his large canvases painted in the early 1980s, are applied in broad, expressionistic brushstrokes. They are hot and animated. Here we can see clearly how he works his paint on the canvas. Strong, directional brushstrokes describe the forms of his head and lend a vibrant dynamic quality to the background. The hair is thickly impastoed; less so the face, which is striped with brown and white. Here, as in all of his work, Hall is interested more in encounter than expression.

Born near Roscrea, Co Tipperary, 1935. Began to study painting with Patrick Pye. Continued to study at the Chelsea School of Art and the Central School of Art, London. Member of Aosdána. Lives and works in Dublin.

Selected Exhibitions	1980 Lincoln Gallery, Dublin
	1983 *Making Sense: Ten Painters 1963-1983*, Project Arts Centre, Dublin
	1985 *Flaying of Marsyas*, Temple Bar Gallery, Dublin
	1987 *'Heart' and other recent paintings*, Pentonville Gallery, London
	1989 *The Eye of the Needle*, Temple Bar Gallery, Dublin
Collections	Arts Council/An Chomhairle Ealaíon, Dublin
	Hugh Lane Municipal Gallery of Modern Art, Dublin
Selected Bibliography	Henry J. Sharpe, 'Patrick Hall' in *Making Sense: Ten Painters 1963-1983*, Project Arts Centre, Dublin, 1983
	Ciaran Carty, 'As Soon as You Stop Running You're Dead', *Sunday Independent*, February 13, 1983
	Michael O'Brien, 'A Talk with the Painter Patrick Hall', *The Beau*, no. 3, Dublin, 1983/1984
	Patrick Quilligan, 'Painting from Myth', *Irish Times*, April 2, 1985
	Aidan Dunne, 'Life Lines: The Paintings of Patrick Hall' in *Patrick Hall: 'Heart' and other recent paintings*, catalogue essay, Pentonville Gallery, London, 1987

Self-Portrait, 1982. Oil on canvas, 55 x 45.
Unsigned.

Charles Harper

Although not a portrait painter, Charles Harper has, since the early 1970s, chosen the human head as the central motif for his paintings. Working mainly in watercolour, he constructs a grid system which contains and confines the rhythmical series of bandaged heads and twisted bodies. Recent variations on this theme have been freer in their interpretation. Overlapping heads, often in brightly coloured jester head-dress, now occupy a gridless space of animated acrylic paint.

Harper is increasingly concerned with the potential ambiguity of the visual image. Hiis self-portrait is a complex piece which the artist, in his attempt to be as articulate as possible, realises may mean different things to different people. With it he presents various aspects of his life. To construct the main self-image he made a drawing from a photocopy of a photograph of himself. To the left is a fragment of the original photograph. Harper juxtaposes what he calls a 'Hollywood image' of a kissing couple and part of a map of Limerick, where he lives, due to a certain cold and contrived quality which he finds in both. On his head, another map fragment forms the base of a hat, the upper section of which consists of a torn magazine photograph, coloured in a pretty pink and featuring a collection of sharp edges. Here he points to the contradictory nature of many of the images 'fed' to us by the media: *how* something is represented often has little to do with *what* is being represented. The hat which contains such potentially violent objects is not a protective one; instead it provides a symbolic means of mental destruction – hence the printed words below, 'Black outs'. The grids and painted squares are familiar, as is the strongly autobiographical element of the painting which is his first formal self-portrait.

Born in Valencia, Co Kerry, 1943. Studied at the Limerick School of Art; Fisherkdesen Film Studio, Bonn, West Germany and the National College of Art, Dublin. Member of Aosdána. Lives and works in Limerick.

Selected Exhibitions	1966 Molesworth Gallery, Dublin
	1976 Tom Caldwell Galleries, Dublin and Belfast
	1980 *Retrospective Exhibition*, Butler Gallery, Kilkenny
	1986 Grafton Gallery, Dublin
	1987 Triskel Arts Centre, Cork
Collections	Arts Council/An Chomhairle Ealaíon, Dublin
	Arts Council of Northern Ireland, Belfast
	Crawford Municipal Art Gallery, Cork
	Limerick City Gallery of Art
	University of Limerick
Selected Bibliography	Harriet Cooke, interview with the artist, *Irish Times*, December 21, 1982
	Paul O'Reilly, catalogue essay, *Retrospective Exhibition*, Butler Gallery, Kilkenny, 1980
	Linda Kavanagh, interview with the artist, *Art about Ireland*, vol. 2, no. 1, 1980
	Paul O'Reilly, 'Charles Harper: Head, Body and Grid' in *Contemporary Irish Art*, ed. Roderic Knowles, Wolfhound Press, Dublin, 1982
	John Hutchinson, 'Through the Grid', *Irish Times*, February 18, 1983

Self-Portrait, 1982. Mixed media on paper, 56 x 76.
Signed: 'Charles Harper 1982'.

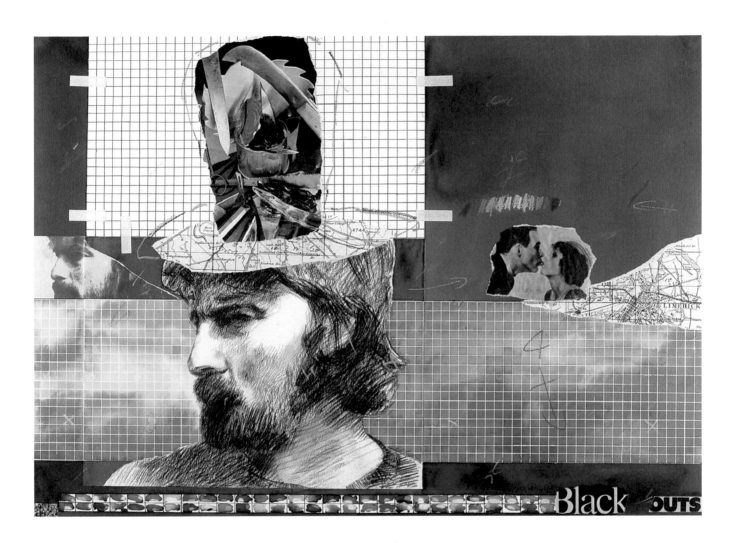

Black OUTS

Ernest Hayes

As a student under Seán Keating in the early 1930s, Ernest Hayes was given a solid grounding in portrait and figure painting. In subsequent years he lived in Germany where he enjoyed a successful career as a portraitist. He was a passionate traveller. Frequent trips to Italy and France revealed to him the importance of light in painting. He painted both the Irish and the Continental landscapes in an impressionistic style, adhering to the colour theories of Eugene Chevreul. With time his style and composition became freer. The Wicklow landscapes, painted during the last ten years of his life, are perhaps the freshest of all.

This self-portrait, painted when Hayes was a nineteen-year-old student, was exhibited in 1933 – the year it was painted – at the Royal Hibernian Academy. He presents himself in the traditional three-quarter view, creating a dramatic contrast between the brightly lit and obscured areas of his face. He paints in broad brushstrokes with characteristic strength and vitality. The predominantly dark palette, typical of his early work, lends a serious tone to the portrait.

Born in Dublin, 1914. Studied at the Metropolitan School of Art, Dublin. Member of the Royal Hibernian Academy. Died in Dublin, 1978.

Selected Exhibitions	1937 Victor Waddington Galleries, Dublin
	1981 European Fine Arts Gallery, Dublin
	Exhibited regularly at the Royal Hibernian Academy.
Collections	Hugh Lane Municipal Gallery of Modern Art, Dublin
	National Museum of Ireland, Dublin
	Tipperary (S.R.) County Museum, Clonmel
Selected Bibliography	Blaithín O Cíobháin, 'Gently, Ernest comes into his own', *Irish Press*, November 11, 1981
	Anne Crookshank, *Ernest Hayes: The Wild Garden*, catalogue introduction, privately published, 1984

Self-portrait, 1933. Oil on canvas, 56 x 50.
Signed: 'Ernest C. Hayes 1933'.
Purchased from Mrs Hildegard Hayes.

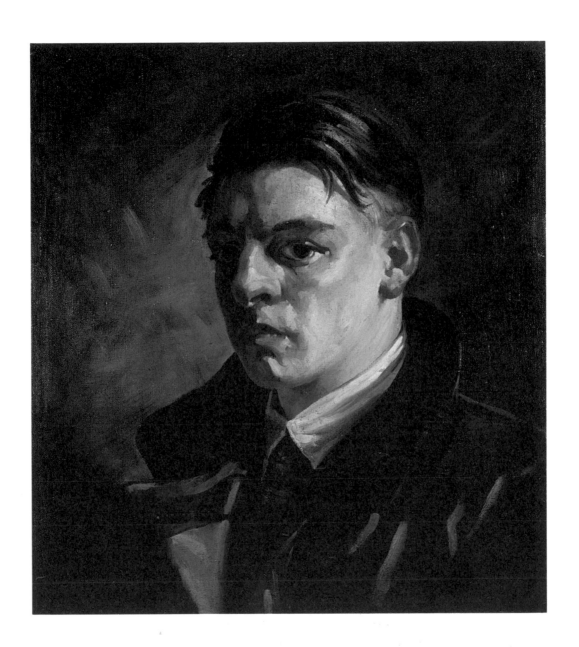

Henry Healy

Henry Healy did not paint portraits; in his paintings people are part of a landscape or city scene. He travelled and painted all over Europe, including Holland, Spain, Italy, France, Portugal and the islands of the Aegean. However, he seemed most at home in the west of Ireland where he spent much of his time in later life. There he ran popular summer courses in which he is known to have stressed the importance of 'scaffolding' in a painting. His own canvases contain strong vertical and horizontal elements; a building, a rooftop, a ship's mast, a horizon or shoreline – often defined in black – impose structure upon a mass of energetic and highly expressive brushwork.

Healy's self-portrait is painted with a typically vibrant palette. Vermilion and French ultramarine, both used to striking effect in the portrait, were particular favourites with Healy. His tonal values are rich and varied. Paint is visibly and liberally applied in quick, short daubs of a brush or a palette knife. Healy adopted the *alla prima* method, painting directly onto the canvas and, more often than not, completing the picture in one sitting. The result is that layers of oil paint, usually left for a long period of time to dry, here blend together. This is particularly evident in parts of the face and jacket. The patches of blue and green and the roughly painted black and white background add to the liveliness of the portrait.

Born in Dublin, 1909. Studied at the National College of Art, Dublin and in Paris. Member of the Royal Hibernian Academy. Died in Dublin, 1982.

Selected Exhibitions 1970 Barrenhill Gallery, Baily, Co Dublin
1970 Exhibition of watercolours, Davis Gallery, Dublin
1973 Barrenhill Gallery, Baily, Co Dublin
1976 Oriel Gallery, Dublin
1982 Taylor Galleries, Dublin
Exhibited regularly at the Royal Hibernian Academy.

Collections Arts Council/An Chomhairle Ealaíon, Dublin
Bank of Ireland, Dublin
Office of Public Works, Dublin
St Patrick's Training College, Dublin
University College, Galway

Self-Portrait, 1979. Oil in board, 50 x 40.
Signed: 'Henry Healy'.

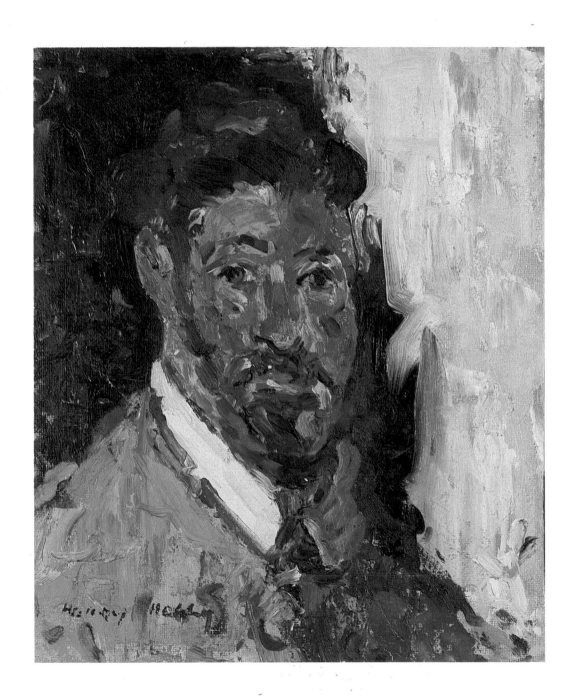

Patrick Hennessy

Patrick Hennessy is essentially a realistic painter, who often reveals a surrealistic outlook on life. His landscapes are expansive and airy; his interiors and architectural scenes often eerie in their gloomy darkness. The elements of a still life, possess an "other-worldly" atmosphere. A satin ribbon lies on a life-drawing; fragments of classical statues are linked together by a single line of crimson paint; two butterflies and a photograph rest on a heavily grained table. In these, and in other more obviously *trompe-l'oeil* paintings, Hennessy displays a remarkable ability to exploit the illusive quality of paint.

This self-portrait was painted when the artist was twenty-five. He has dedicated it to a friend called Frieda on the occasion of her birthday. He paints in watercolour, fluidly and sensitively. The clear light which highlights his face is the same as that which picks out the varied surfaces and textures of his still lifes. The eyes and mouth in particular are palpably real. He paints himself against a pale blue wash which is reflected in parts of the face. He looks hesitantly and slightly startled at his own image. This is a more open self-portrait than many others which Hennessy has painted, where he tends to conceal or disguise his image. These include paintings where he appears reflected in the shiny surface of a Christmas bauble, in a photograph from an exhibition catalogue or, as in *Portrait Figures* in the National Gallery of Ireland, where, wearing dark glasses, he is shown standing in profile in front of one of his own paintings.

Born in Cork, 1915. Studied at Dundee College of Art, in Paris and in Rome. Member of the Royal Hibernian Academy. Died in London, 1980.

Selected Exhibitions	1956 Thomas Agnew & Sons, London
	1957 David Hendriks Gallery, Dublin
	1981 Cork Arts Society Gallery, Cork
	1984 David Hendriks Gallery, Dublin
	1986 Joint exhibition with Henry Robertson Craig, Christie's, London
	Exhibited regularly at the Royal Hibernian Academy.
Collections	Crawford Municipal Art Gallery, Cork
	Hugh Lane Municipal Gallery of Modern Art, Dublin
	Limerick City Gallery of Art
	National Gallery of Ireland, Dublin
	Waterford Municipal Art Collection, Garter Lane Arts Centre
Selected Bibliography	Sheila Pim, *Paintings 1941-1951: A Retrospective Exhibition* by Patrick Hennessy, RHA, catalogue introduction, Dublin Painters Gallery
	Dorothy Walker, 'Patrick Hennessy' in *The Irish Imagination 1959-1971*, published in association with *Rosc '71*, Municipal Gallery of Modern Art, Dublin, 1971
	Hilary Pyle, 'Patrick Hennessy' in *Irish Art 1900-1950*, published in association with Rosc Teoranta, Crawford Municipal Art Gallery, Cork, 1975
	Sean McCrum, 'Photograph Painter', exhibition review, *Sunday Tribune*, March 18, 1984
	Gerald Davis, '*Exiles*: Patrick Hennessy' in *Critics Choice*, Hugh Lane Municipal Gallery of Modern Art, Dublin 1988

Self-Portrait, 1940. Watercolour on paper, 30 x 20.
Unsigned but inscribed: 'To Frieda on her birthday. To me fair friend you can never be old. August 1940.'
Privately purchased, 1985.

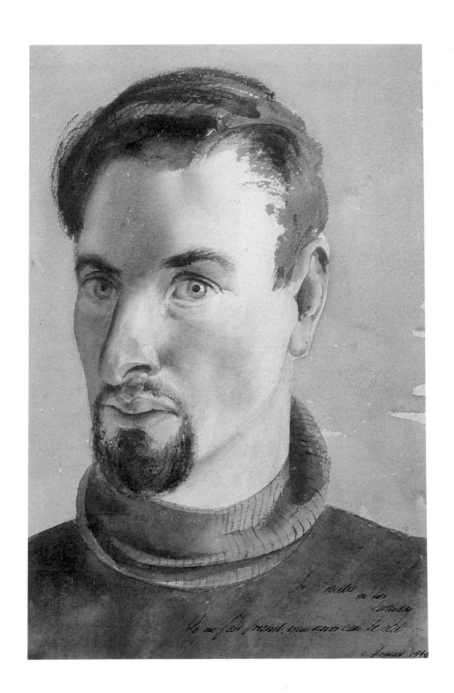

To Nellie on his
Birthday
To me fair friend, you never can be old

August 1940

Frederick Herkner

Frederich Herkner came from Austria to Dublin in 1938, having been appointed Professor of Sculpture at the National College of Art. The following year, he was commissioned to make the eighteen-foot-high statue of *Mother Eire* for the Irish Pavilion at the New York World Fair. He continued to work in this monumental tradition both in Ireland and abroad for the rest of his life. After the outbreak of the Second World War, he returned to Germany where he continued teaching. A year later, he was drafted and sent to the Russian front. After the war he worked on the restoration of war-damaged monuments in Vienna. On his return to Ireland in 1947 he resumed teaching at the National College of Art. He received many commissions for portrait busts and full-figure sculptures in bronze, stone, wood and terracotta. In these he simplified his forms, creating easily understood and dramatic images.

Herkner's self-portrait in charcoal and pastel possesses the same direct quality as his sculpture. With a vigorous use of clearly defined hatched lines and a minimum of colour, he portrays himself as the focused and energetic personality that his colleagues and students remember him to be. As is often the case with sculptors' drawings, the image is relatively flat, lacking the volume which he so successfully achieved in his plastic work. His eyes look up, perhaps at a life mirror which is used to gain an aerial view of a piece of sculpture. It has frequently been observed that artists' physical features manifest themselves in their portraits of others. In Herkner's case, many of his subjects share his strong jawbone and high forehead.

Born in Brüx, Austria, 1902. Studied at the School of Art in Teplitz-Schönau and the Academy of Fine Arts, Vienna. Member of the Royal Hibernian Academy. Died in 1986.

| Selected Exhibitions | 1953 *Contemporary Irish Art*, National Library of Wales, Aberystwyth
Exhibited regularly at the Royal Hibernian Academy. |
|---|---|
| Collections and Commissions | Sean McDermott Memorial, Curragh Camp, Kildare
National Museum, Prague
Statue of Our Lady, Ballintubber, Co Mayo
Uffizi Gallery, Florence – Self-Portrait Collection |

Self-Portrait, 1981. Charcoal and pastel on paper, 39 x 30.
Signed: 'Herkner'.
Original Kneafsey Collection.

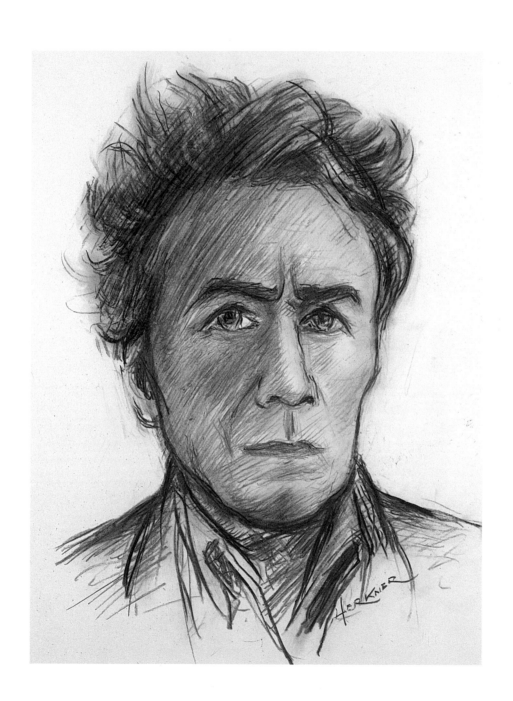

Patrick Hickey

Having trained initially as an architect, Patrick Hickey made his first painting at the age of twenty-seven. Its subject matter – the Wicklow landscape – has inspired his work ever since. He moves happily between paint and print, exploiting the fluidity and textures of both. His delicately coloured etchings, in which animal and plant life playfully intertwine, are oriental in their spare asymmetry and fluent lines. The painted still lifes are serene; the landscapes often wild and wind-swept.

With his self-portrait Hickey wishes to convey 'the essential solitariness of a painter: God offers you a choice – truth or repose – you can't have both'. He depicts himself in the company of – but slightly apart from – two of his colleagues in the School of Architecture at University College Dublin, where he worked for many years. They look to one side; he, dressed differently, looks to the other. The crow which rests on a branch above Hickey's head is taken from an ink drawing by Rosetsu, a nineteenth-century Japanese artist whose work he admires. It symbolizes painting and drawing. The map on the other side represents buildings and sites. The solid forms of the artist and the crow contrast with the linear depiction of the two architects and the map. Thus he reveals, both visually and metaphorically, the split in his own experience between these two disciplines. Such alienation, which Hickey sees as 'the direct result of opting to paint', may simply be, he suggests, part of the general human condition.

Born in India, 1927. Studied architecture at University College Dublin and etching and lithography at the Scuola del Libro, Urbino. Member of Aosdána. Lives and works in Dublin.

Selected Exhibitions	1964 Dawson Gallery, Dublin
	1970 Dawson Gallery, Dublin
	1974 Prudhoe Gallery, London
	1981 Taylor Galleries, Dublin
	1989 Taylor Galleries, Dublin
Collections	Allied Irish Bank, Dublin
	Arts Council/An Chomhairle Ealaíon, Dublin
	Crawford Municipal Art Gallery, Cork
	Hugh Lane Municipal Gallery of Modern Art, Dublin
	Limerick City Gallery of Art
Bibliography	Tony Hickey, 'Patrick Hickey' in *The Irish Imagination 1959-1971*, published in association with *Rosc '71*, Municipal Gallery of Modern Art, Dublin, 1971
	Cyril Barrett S.J., 'Patrick Hickey' in *Irish Art 1943-1973*, in association with Rosc Teoranta, Crawford Municipal Art Gallery, Cork, 1980
	Marianne Hartigan, 'Interview with Patrick Hickey', *Irish Arts Review*, vol. 3, no.1
	Frances Ruane, *The Allied Irish Bank Collection: Twentieth Century Irish Art*, Douglas Hyde Gallery, Dublin, 1986

3 Architects. Etching 5/20, 30 x 45.
Signed: Patrick Hickey.

3 Architect Patrick Procktor 5/70

David Hone

David Hone is best known as a portrait painter. As a student in the early 1940s under Seán Keating and Maurice MacGonigal, he gained considerable experience in drawing the figure, both from the antique and the live model. Portraiture was highly regarded and greatly encouraged at the time. Hone, like many of his contemporaries, has continued this tradition, painting both large commissions and smaller private work. His other subject-matter includes landscapes and still lifes, in which he tends to sacrifice detail for an overall atmosphere or feeling.

His portraits, like his landscapes, are concerned more with mood and character than with a photographic likeness. He attains this quality by a loose handling of paint as well as a keen sensitivity to facial expressions. The self-portrait in this collection was one of a series of small studies completed in the early 1960s. He depicts himself close-up, with a serious, scrutinising look and carefully sets up a successful colour harmony between his own figure and the background. The painting exhibits a characteristic lightness of palette and brushwork, evident also in his portrait of 'The Pope' O'Mahony in the National Gallery of Ireland.

Born in Dublin, 1928. Studied at the National College of Art, Dublin. Past President of the Royal Hibernian Academy (1977-82). Lives and works in Dublin.

Selected Exhibitions	1955 Dublin Painters Gallery
	1975 Irish Art 1900-1950, in association with Rosc Teoranta,
	Crawford Municipal Art Gallery, Cork
	Exhibits regularly at the Royal Hibernian Academy.
Collections	Crawford Municipal Art Gallery, Cork
	National Gallery of Ireland, Dublin
Selected Bibliography	Hilary Pyle, 'David Hone' in *Irish Art 1900-1950*, published in association with
	Rosc Teoranta, Crawford Municipal Art Gallery, Cork, 1975

Self-Portrait, 1965. Oil on board, 25 x 19.
Signed: 'D. Hone '65'.
Original Kneafsey Collection.

Francis Xavier Hourigan

Frank Hourigan is both a painter and a sculptor. He sculpts in bronze relief, usually to commission. Most of his public work is in Mayo, where he taught art for over thirty years. It includes a 1798 memorial column and a bronze plaque commemorating Archbishop John McHale. His paintings are less academic in style. Focusing on landscape, seascape and still life, he tends to simplify shapes and shadows. Reflections are particularly central to the still lifes in which he juxtaposes a variety of surfaces which catch and mirror the light.

In contrast to the licence he takes when painting his landscapes, Hourigan wished to be 'strictly honest' when painting his self-portrait. Such objectivity, he felt, 'helped me to see myself as others do'. He looks innocently at his own image. Here he has painted – thinly in parts – on the rough side of the board, which gives additional texture to the painting. Typically, his colours are muted and tonal variations are subtle. The grey tones, which dominate, unify the composition. The overall mood is gentle and unassuming.

Born in Cork, 1914. Studied at the Crawford School of Art, Cork and the National College of Art, Dublin. Lives and works in Cork.

Selected Exhibitions	Exhibits at the Royal Hibernian Academy and the Cork Arts Society annual exhibitions.
Commissions	Archbishop John McHale Memorial, Crossmolina, Co Mayo
	Michael Cusack Memorial, Corran, Co Clare
	1798 Memorial, Castlebar, Co Mayo
	Stations of the Cross, St Patrick's Well Park, Ballina, Co Mayo

Self-Portrait, 1987. Oil on board, 45 x 4.
Signed: 'Hourigan'.

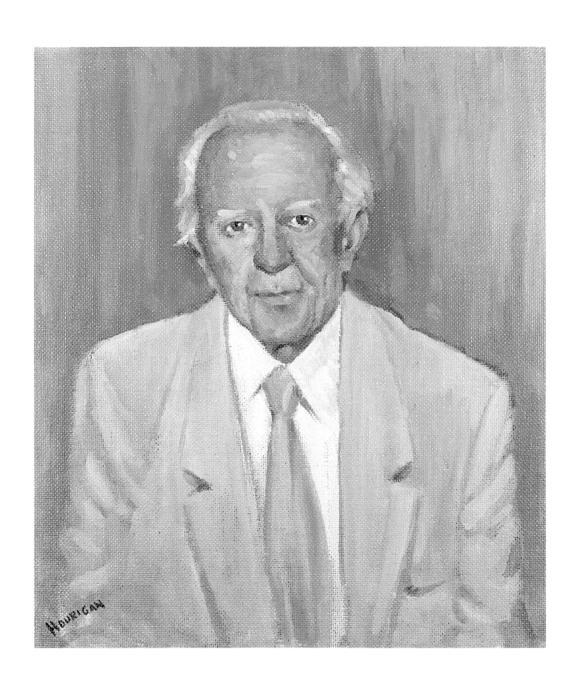

Marshall C. Hutson

Marshall Hutson came to Ireland in 1930 to lecture in sculpture and craft at the Crawford School of Art in Cork. Here he taught, among other subjects, engraving, wood carving, metalwork and lace. Although best known as a sculptor, diversity in materials and form has been a hallmark of his work which includes murals, religious statues and monumental public sculpture. He enjoys the various qualities of each medium and the challenge of experimenting with different techniques. He has painted realistic landscapes and figure studies in oils, watercolour and egg tempera, and sculpted in wood, bronze and stone. Sometimes he adopts a more abstract approach, emphasising the decorative element of the forms. Regardless of the medium being used, there is always with Hutson 'an insatiable desire to keep on exploring'.

Hutson painted his first oil on canvas at the age of nine. It is appropriate, then, that he should paint rather than sculpt his self-portrait. The painting, made when the artist was forty years of age, came about more because of his availability as a reliable model than because of a particular desire to record his own features. Hutson was teaching anatomy at the time and was interested in 'the accurate rendering of form and character and various ways of lighting the figure'. He has painted on the reverse side of a piece of hardboard, exploiting its rough texture. He uses bright highlights to model the face which stares solemnly outward. By painting dark over light and by introducing a rich sienna background, he brings a warmth to the portrait.

Born in Nottingham, England, 1903. Studied at Nottingham College of Art. Member of the Royal Hibernian Academy. Lives and works in Cork.

Selected Exhibitions Exhibits regularly at the Royal Hibernian Academy.

Collections and City Hall, Cork
Commissions Cork Public Library
 Crawford Municipal Art Gallery, Cork
 Society of Friends, Dublin
 University College Cork

Self-Portrait, 1943. Oil on board, 36 x 24.
Unsigned.

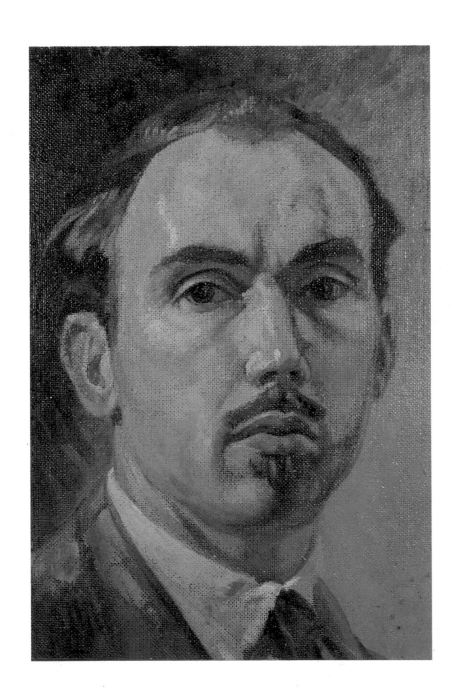

Dick Joynt

Dick Joynt's sculpture has often been compared to that of primitive cultures, specifically pre-Columbian and Polynesian. He is not consciously aware of such an influence, but acknowledges that themes and symbols are rediscovered and reinterpreted by each generation of artists. He draws much of his inspiration from rites and rituals which he has observed all over the world. He works mainly in stone, carving his figures in simplified curvilinear forms. The sun has been an important symbol for Joynt. A large sun-goddess, carved in sandstone, sits solidly on the ground. Sun-worshippers crouch, shapely female nudes recline with limbs outstretched and Mother Earth stands serene. His scale and carving methods vary. Sometimes the surface is smooth; at other times the chisel leaves a rough indented pattern on the stone's surface. Faces are flattened and features are reduced to a minimum of detail.

Joynt worked for ten years (1972-82) at the Dublin Art Foundry, where he gained a thorough understanding of bronze. He still likes the immediacy and the adaptability of clay. Although academic in style in comparison with the stone figures, this – his first self-portrait – is freer in its handling of material and interpretation of form than the other bronze portraits which he has made. One can observe in the portrait the result of the additive process of clay-modelling, which reproduces the various textures of the skin, hair and clothing. Here Joynt has managed to convey both a physical likeness and a sense of focused concentration.

Born in Dublin, 1938. Self-taught artist. Lives and works in Co Kildare.

Selected Exhibitions	1966 Dublin Painters Gallery
	1979 Lincoln Gallery, Dublin
	1983 Lincoln Gallery, Dublin
	1985 Kenny Gallery, Galway
	1988 *A Celebration*, David Hendriks Gallery, Dublin

Collections and Commissions: Algemene Bank Nederland, Dublin; Convent of Mercy Secondary School, Athy, Co Kildare; Dublin County Council; Wolfhound Press, Dublin

Selected Bibliography: Frances Ruane, *The Allied Irish Bank Collection: Twentieth Century Irish Art*, Douglas Hyde Gallery, Dublin, 1986
Kate Robinson, 'Joynt's vision of humanity', exhibition review, *Sunday Independent*, September 9, 1988

Self-Portrait, 1985. Bronze, height 42.
Signed: 'Dick Joynt '85'.

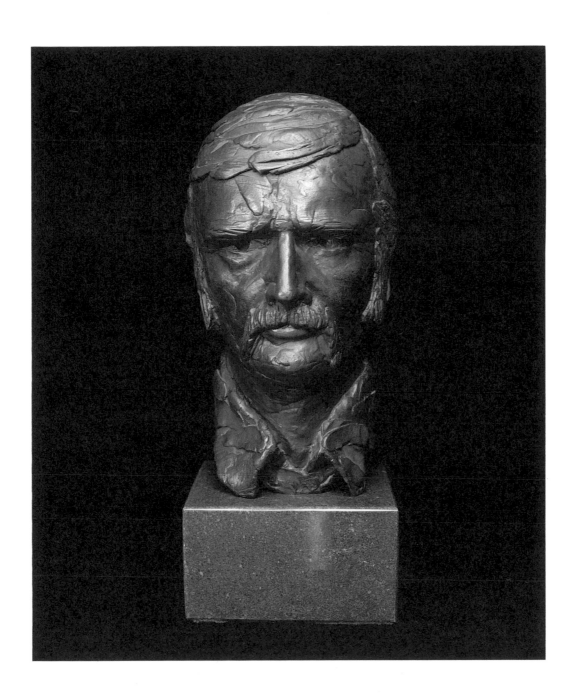

Michael Kane

Michael Kane began to paint in the early 1960s, drawing much of his inspiration from the art of the past. Sometimes he refers directly to individual paintings or artists. Cézanne and the Fauves have been significant influences on his use of colour. Traditional themes are often revitalised. In large triptychs he relates biblical tales in contemporary settings. Although he now paints in an increasingly expressionistic manner, Kane abandoned painting for wood-block printing in the early 1970s. His crude linear woodcuts have proved to be an appropriate medium for the many portraits – including his own – which he has made over the years. Never losing sight of the basic anatomical structure, he often exaggerates the features of a face; noses are pointed, chins recede, ears protrude. There is little that is pretty about these images. The multi-figure scenes are equally forbidding. Couples confront each other in bleak urban surroundings which also provide the backdrop for a modern-day *Judith and Holofernes*. The presence of art history is felt also in the woodcuts, where the mood and style is reminiscent of the graphic work of the German Expressionists.

Kane's self-portrait, woodblock printed on Japanese paper, has the larger-than-life quality of many of his crowded triptychs. His face, viewed from above, fills the sheet of paper. He leans forward, his head resting firmly in his hand, and confronts the viewer with his penetrating gaze. The lines and solid areas of the print are bold and assured. With them Kane concentrates on the essential elements. They model rather than delineate. There is here, as always with Kane, an intensity of form and feeling.

Born in Dublin, 1935. Studied at the National College of Art, Dublin. Member of Aosdána. Lives and works in Dublin.

Selected Exhibitions	1960 Ritchie Hendriks Gallery, Dublin
	1970 Project Arts Centre, Dublin
	1975 *The Inward City*, Emmet Gallery, Dublin
	1980 Lincoln Gallery, Dublin
	1989 *Michael Kane – A Retrospective Selection*, Graphic Studio Gallery, Dublin
Collections	Arts Council/An Chomhairle Ealaíon, Dublin
	Hugh Lane Municipal Gallery of Modern Art, Dublin
	Limerick City Gallery of Art
	Monaghan County Museum
	Trinity College, Dublin
Selected Bibliography	Eiléan Ní Chuilleanáin, catalogue introduction, Project Arts Centre, Dublin, 1970
	Anthony Cronin, catalogue introduction, Lincoln Gallery, Dublin, 1980
	Peter Fallon, catalogue introduction, Gallery Press Graphics, Lincoln Gallery, Dublin; Triskel Arts Centre, Cork; Gratten Gallery, Tralee, 1981
	Henry J. Sharpe 'Michael Kane' in *Making Sense: Ten Painters 1963-1983*, Project Arts Centre, Dublin, 1983
	Henry J. Sharpe, *Michael Kane, His Life and Art*, Bluett, Dublin, 1983

Self-Portrait IV 4/25. Woodblock print on Japanese paper, 91 x 61.
Signed: 'M. Kane 24.10.'81'

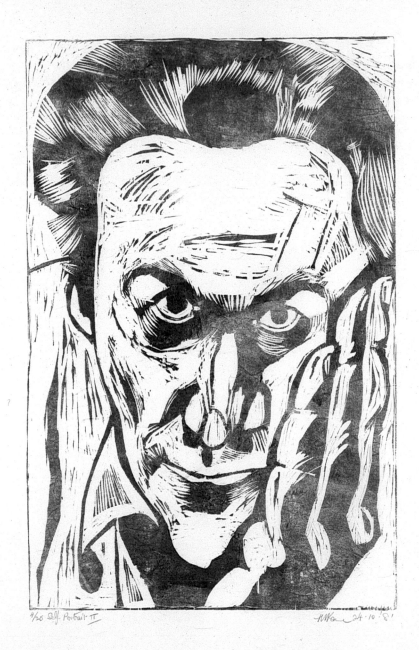

4/25 Self Portrait II N Keane 24·10·8'

Seán Keating

Seán Keating's best-known works document, in heroic fashion, a troubled history of rebellion and civil war. Armed nationalists are portrayed in a realist style as tough heroes, whose honourable duty it is to defend their country. His pastoral paintings depict the lives of the inhabitants of the Aran Islands, where the artist spent four years in his early twenties. He also painted numerous portraits and religious themes. Working until shortly before his death at the age of eighty-eight, Keating was one of the most prolific and significant Irish artists of the first part of this century.

Keating was perhaps better skilled as a draughtsman than as a painter. He gained a sound knowledge of drawing from William Orpen, studying with him in Dublin and working as his studio assistant in London for a year in 1915. As Professor of Painting at the Metropolitan School of Art (latterly the National College of Art), Keating continued to place great emphasis on drawing skills. He made numerous charcoal drawings throughout his career, many of which were preparatory sketches for figures in his paintings. His self-portrait displays his ability to model a face in minute detail. He builds up the surface with varying thicknesses of charcoal, and selectively smudges or rubs it away to give volume to the form. He sets himself off-centre. Calmly gazing with one eye, he studies the viewer intently with the other. Keating was seventy-four when he drew this self-portrait. It conveys the strong personality of a man who spoke out loudly against 'modern art', art critics and the poor patronage of the arts in Ireland.

Born in Limerick, 1889. Studied at the Limerick Technical School for Drawing and the Metropolitan School of Art, Dublin. President of the Royal Hibernian Academy (1948-62). Died in Dublin, 1977.

Selected Exhibitions
1930 Hackett Galleries, New York
1931 Victor Waddington Galleries, Dublin
1956 Ritchie Hendriks Gallery, Dublin
1963 *Retrospective Exhibition*, Municipal Gallery of Modern Art, Dublin
1986 *Exhibition of Works on Paper by Seán Keating*, Grafton Gallery, Dublin

Collections
Crawford Municipal Art Gallery, Cork
Hugh Lane Municipal Gallery of Modern Art, Dublin
Limerick City Gallery of Art
National Gallery of Ireland, Dublin
Ulster Museum, Belfast

Selected Bibliography
Sean Keating, 'Art Does Not Get a Chance in Ireland', *The Irish People*, February 29, 1936
James White, *Seán Keating: Painting - Drawings*, catalogue introduction, retrospective exhibition, Municipal Gallery of Modern Art, Dublin, 1963
Hilary Pyle, 'Seán Keating' in *Irish Art 1900-1950*, published in association with Rosc Teoranta, Crawford Municipal Art Gallery, Cork, 1975
Willie Healy, 'Keating - a portrait of the artist', *Irish Press*, December 22, 1977
Joan Fowler, 'Seán Keating: *The Men of the West*' in *Critics Choice*, Hugh Lane Municipal Gallery of Modern Art, Dublin, 1988

Self-Portrait, 1963. Pastel on paper, 51 x 43.
Signed: 'Keating'.
Original Kneafsey Collection.

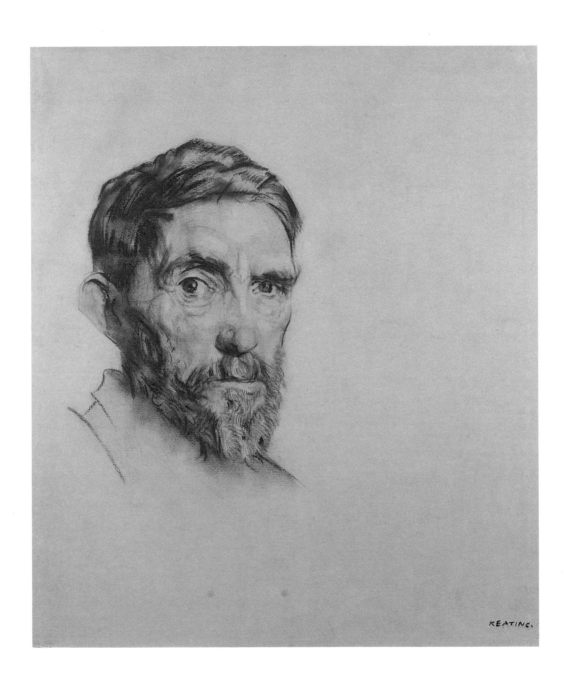

Oisin Kelly

Oisin Kelly believed that 'an artist's job is not to decide what role he is going to play but to accept the rôle that society asks him to play'. Thus he was happiest working to commission. He felt strongly that art should communicate with as many people as possible. For this reason he was particularly attracted to sacred sculpture, based on a universal rather than a personal language. The art of ancient and early Christian Ireland supported his view that sculptural form must be simple and direct. He worked mainly in bronze and wood, varying the scale and concentrating on Irish subjects. Dancers, footballers, politicians, mythological figures and wildlife are all carved and modelled with dignity and restraint.

Kelly's self-portrait may be seen as an apt expression of his belief that art must respond to a need. It originates with a series of linen tea towels which he designed for Kilkenny Design Workshops where he was an artist-in-residence. On each cloth was printed an old Irish proverb. The phrase *'Ní thagann ciall roimh aois'* – sense comes only with age – is an optimistic comment on growing old, while at the same time providing a witty and original representation of his moustache and beard. Although very different in mood and content, the portrait shares with his sculpture a simplicity of design and an essential reduction of form.

Born in Dublin, 1915. Studied at the National College of Art, Dublin and Chelsea School of Art, London. Member of the Royal Hibernian Academy. Died in Kilkenny, 1981.

Selected Exhibitions	1971 *The Irish Imagination 1959-1971*, in association with *Rosc '71*, Municipal Gallery of Modern Art, Dublin 1975-6 *Irish Art 1900-1950*, in association with Rosc Teoranta, Crawford Municipal Art Gallery, Cork 1978 *The Work of Oisín Kelly, Sculptor*, retrospective exhibition, Ulster Museum, Belfast; Douglas Hyde Gallery, Dublin; Crawford Municipal Art Gallery, Cork 1980 *Irish Art 1943-1973*, in association with Rosc Teoranta, Crawford Municipal Art Gallery, Cork
Collections and Commissions	*Chariot of Fire*, Irish Life Centre, Dublin *Children of Lír*, Garden of Remembrance, Dublin Crawford Municipal Art Gallery, Cork Hugh Lane Municipal Gallery of Modern Art, Dublin National Gallery of Ireland, Dublin
Selected Bibliography	Brian Fallon, 'Oisín Kelly' in *The Irish Imagination 1959-1971*, published in association with *Rosc '71*, Municipal Gallery of Modern Art, Dublin, 1971 Dorothy Walker, *The Work of Oisín Kelly, Sculptor*, catalogue essay, retrospective exhibition, the Arts Councils of Ireland, 1978 Una Lehane, 'The Sculptor Speaks', interview with the artist, *Irish Times*, May 5, 1978 Cyril Barrett S.J., 'Oisín Kelly' in *Irish Art 1943-1973*, published in association with Rosc Teoranta, Crawford Municipal Art Gallery, Cork, 1980 Frances Ruane, *The Allied Irish Bank Collection: Twentieth Century Irish Art*, Douglas Hyde Gallery, Dublin, 1986

Self-Portrait, 1980. Silk-screen print on linen, 76 x 52.
Signed: 'Oisín Kelly '80'.

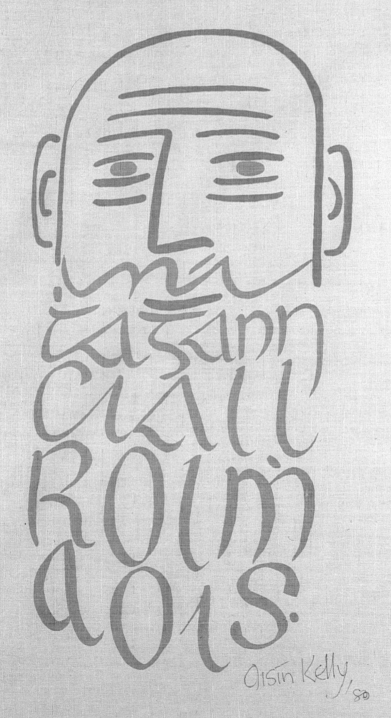

Oisín Kelly
/80

SENSE COMES ONLY WITH AGE. A **K** DESIGN·100% LINEN·MADE IN THE REPUBLIC OF IRELAND

Harry Kernoff

Harry Kernoff, although not a Dubliner by birth, was one of the city's most astute observers. In his paintings, drawings and woodcuts, which span almost fifty years from the mid-1920s until his death in 1974, he recorded various aspects of life in Dublin's city and suburbs. While still an apprentice in his father's furniture-making business, he began to attend night-classes at the Metropolitan School of Art. Here he was greatly encouraged by Seán Keating and Patrick Tuohy but although he admits to their influence, his style and subject-matter are his own. His detailed views of houses, shopfronts, alleys and street corners are broadly painted in oils and watercolour. The days are sunny, the shadows short and the colours clear. His views of Dublin's coast are expansive; his pub interiors, are more intimate. His woodcuts, for which he is best known, are executed in a characteristic linear style and display a striking simplification of form.

Kernoff was also a successful and popular portrait painter. He painted and drew many contemporary Irish writers – Joyce, Yeats and O'Casey among them – as well as a number of self-portraits of which this is one of the earliest. Contrary to what the garb might suggest, Kernoff did not serve in any of the defence forces. Like his self-portrait in a top hat, this is intended as a whimsical, humorous self-image, though his rather anxious look might suggest otherwise. Kernoff often worked in pastel, which he employs here more sparsely than usual, allowing the tinted paper to become a more integral part of the drawing. The window reflected in the helmet adds to the quirkiness of the image.

Born in London, 1900. Attended the Metropolitan School of Art, Dublin.
Member of the Royal Hibernian Academy. Died in Dublin, 1974.

Selected Exhibitions	1931 Ritchie Hendriks Gallery, Dublin 1974 Godolphin Gallery, Dublin 1975 *Irish Art 1900-1950*, in association with Rosc Teoranta, Crawford Municipal Art Gallery, Cork 1976-77 *The Harry Kernoff Memorial Exhibition*, Hugh Lane Municipal Gallery of Modern Art, Dublin
Collections	Crawford Municipal Art Gallery, Cork Hugh Lane Municipal Gallery of Modern Art, Dublin National Gallery of Ireland, Dublin Waterford Municipal Art Collection, Garter Lane Arts Centre Ulster Museum, Belfast
Selected Bibliography	John Ryan, *Harry Kernoff : a selection of Dublin paintings*, catalogue introduction, Godolphin Gallery, 1974 Hilary Pyle, 'Harry Kernoff' in *Irish Art 1900-1950*, published in association with Rosc Teoranta, Crawford Municipal Art Gallery, Cork, 1975 Ciaran MacGonigal, *The Harry Kernoff Memorial Exhibition*, catalogue introduction, Hugh Lane Municipal Gallery of Modern Art, Dublin, 1976 Frances Ruane, *The Allied Irish Bank Collection Twentieth Century Irish Art*, Douglas Hyde Gallery, Dublin, 1986

Self-Portrait 1940. Pencil, pastel and wash on paper, 41 x 33.
Signed: 'Kernoff 14-10-40'.
Original Kneafsey Collection.

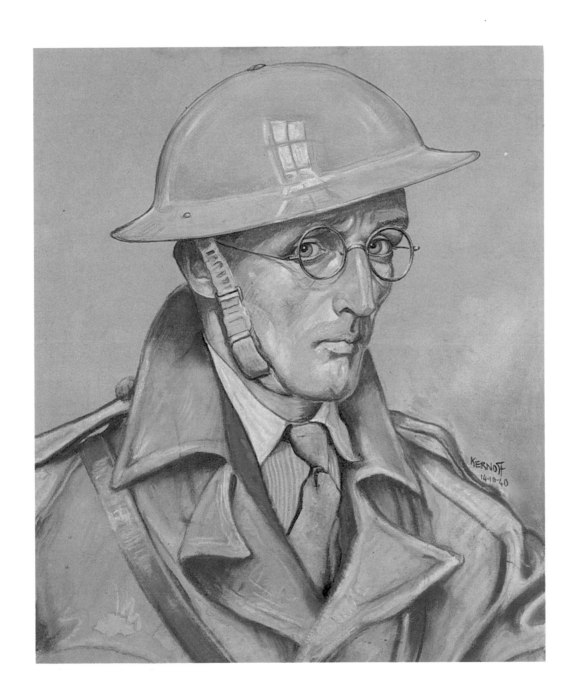

Cecil King

Cecil King had been collecting paintings for many years before he himself began to paint at the age of thirty-three. His earliest works are semi-figurative landscapes and cityscapes. By the mid-1960s he had developed the geometrical abstraction for which he is best known. Drawing his inspiration from very specific images – such as the circus, the city and the coast – King combines colour, line and angular form to create a series of purely abstract canvases, The paint is flat, yet the paintings recede. Subtle tensions and shifts of emphasis within a composition are brought about by the juxtaposition of contrasting colours and the intrusion of fine lines, often white, which have the effect of opening up an otherwise solid mass of colour.

In the light of his continued preference for abstraction, his self-portrait comes as quite a surprise. Yet, despite its realism, it has a basic abstract quality. The facial features are described in a minimum of detail by the broadly contrasting areas of light and shade. The effect is that obtained by a silk-screen print, a process which the artist used in the *Berlin Suite* and other series. To make the portrait, King cut out and painted over an image of himself taken from an exhibition poster. Unusually, he paints with visible brushstrokes on board. The way in which he introduces a trace of orange into the solid dark area of his tie, is reminiscent of the thin lines of bright paint, often orange or red, which break up his abstract canvases.

Born in Rathdrum, Co Wicklow, 1921. Self-taught artist. Died in Dublin, 1986.

Selected Exhibitions	1959 Ritchie Hendriks Gallery, Dublin
	1967 Richard Demarco Gallery, Edinburgh
	1975 *Ten Year Retrospective*, Butler Gallery, Kilkenny
	1980 David Hendriks Gallery, Dublin
	1981 *Retrospective Exhibition*, Hugh Lane Municipal Gallery of Modern Art, Dublin
Collections	Crawford Municipal Art Gallery, Cork
	Hugh Lane Municipal Gallery of Modern Art, Dublin
	Tate Gallery Print Collection, London
	Trinity College, Dublin
	Ulster Museum, Belfast
Selected Bibliography	James White, catalogue introduction, Ritchie Hendriks Gallery, Dublin, 1959
	Kenneth Jamison, catalogue introduction, Arts Council Gallery, Belfast and Richard Demarco Gallery, Edinburgh, 1967
	Ethna Waldron, *The Berlin Suite*, introduction to suite of six screen prints, Editions Alecto, London, 1970
	Hilary Pyle, 'Cecil King' in *The Irish Imagination* 1959-1971, published in association with *Rosc '71*, Municipal Gallery of Modern Art, Dublin, 1971
	Ethna Waldron, *Cecil King: Retrospective Exhibition*, catalogue introduction, Hugh Lane Municipal Gallery of Modern Art, Dublin, 1981

Self-Portrait, 1983. Oil on board, 26 x 21.
Signed: 'Cecil King'.

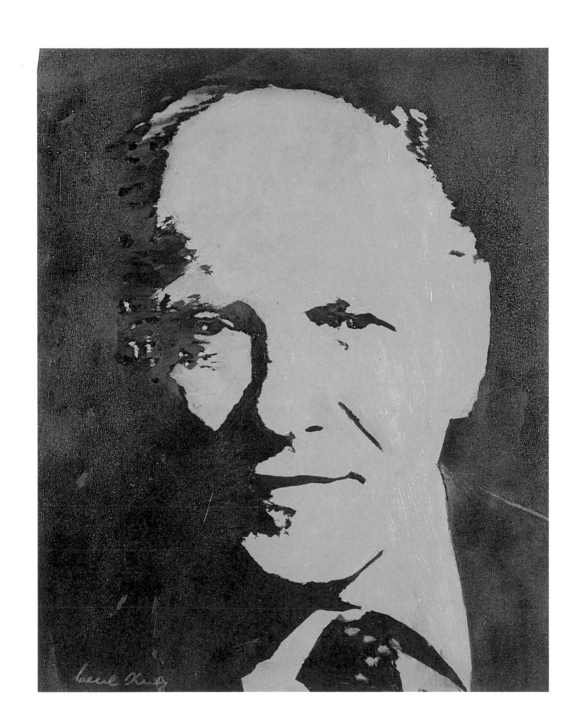

Richard Kingston

Richard Kingston grew up on a coastal farm in County Wicklow. This marshy, water-logged landscape finds its way again and again into his paintings. There is a remarkably expansive quality about these works. His horizons, gently hinted at, rarely limit the view. A particularly fluid use of his medium – mainly oil on board – and a lack of concern with visual detail allow him to convey the mood of a place; in the words of a Chinese poem to which he refers, 'something besides the form, something beyond the sound'. He paints in series and for the last three years has based his paintings almost exclusively on the Giants' Causeway in County Antrim. Adopting a systematic approach, he has made hundreds of drawings, colour studies and paintings of this one location. Like the Wicklow landscape, the Causeway, always changing, has been a particularly rich source of inspiration.

Although he paints mostly in oil, Kingston finds watercolour a more challenging medium. He likes the fact that it must be worked quickly if its translucent qualities are to be maintained, and in his self-portrait he skilfully meets these demands. Kingston draws with paint. Using a limited palette, he depicts certain features – most notably the eyes – in detail, and leaves other parts of the face barely painted. The stark white, unpainted background of many watercolour portraits is here replaced by a pale grey wash, which lends a subdued tone to the work.

Born near Newcastle, Co Wicklow. Self-taught artist. Member of the Royal Hibernian Academy. Lives and works in Dublin.

Selected Exhibitions	1958 Ritchie Hendriks Gallery, Dublin
	1962 Ritchie Hendriks Gallery, Dublin
	1963 Ritchie Hendriks Gallery, Dublin
	1980 Studio Gallery, Wellington Road, Dublin
	Exhibits regularly at the Royal Hibernian Academy.
Collection	Waterford Municipal Art Collection, Garter Lane Arts Centre
Selected Bibliography	Marian Burleigh, 'The Future and Richard Kingston', *Forgnán*, June-August, 1962
	'Profile – Richard Kingston', *Art about Ireland*, vol. 1, no. 5, 1979
	Frances Ruane, *The Allied Irish Bank Collection: Twentieth Century Irish Art*, Douglas Hyde Gallery, Dublin, 1986

Self-Portrait, 1982. Watercolour on paper, 42 x 29.
Signed: 'Richard Kingston 82'.

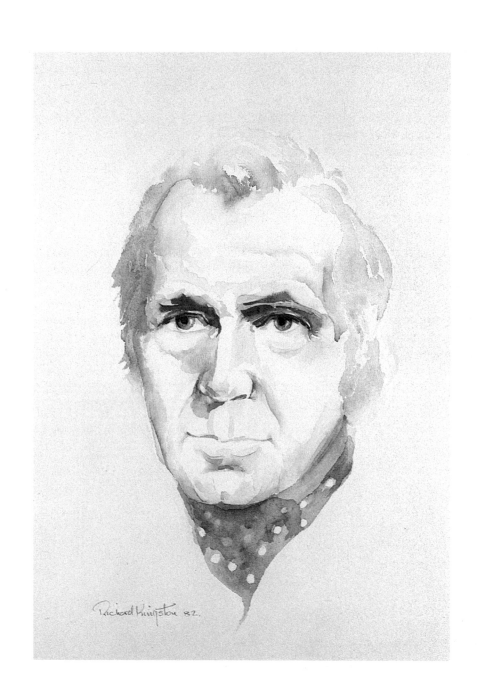

Richard Kingston '82.

Sonja Landweer

Sonja Landweer is best known in this country as a ceramist. She came to Ireland in 1965 as artist-in-residence to Kilkenny Design Workshops. While there, she developed an extensive range of glazes and industrial clay bodies both for the small workshop and for industrial production. Her own work, inspired by nature, is innovative in its interpretation of form and materials. Her simple yet generously rounded vessels stem from a small base. She fires each piece several times which gives a range of dense earth colours and textures. Sometimes she contrasts the textures of feathers and fibre with those of the dense clay. Since the early 1980s she has moved away from the potter's wheel and has worked in a variety of media. The small fluid forms which she sculpts in pale porcelain are those of animals and plants. Her wing-shaped linoprints are original in their layering of oil paints. Recently she has made `body sculpture' using stoneware, bone and slate, the shapes recalling those of Celtic torcs and bracelets.

Landweer's self-portrait is executed in gouache, charcoal and wax crayon. It is a forceful image which has an immediate impact. The crayon, thinly applied over the face, acts like a glaze, allowing the paper beneath to show through. A minimal and expressive use of charcoal lends a sculptural depth to the face. Her hair is roughly indicated by a few broad strokes of black gouache. She looks upwards, as if at a mirror. Although different from her abstract sculpture, Landweer's self-portrait is based on the same principles of what she calls 'space and counterspace'. In both disciplines she is concerned with modelling form in space; in the ceramics the space is actual, in the drawing it is suggested.

Born in Amsterdam, 1933. Studied at Amsterdam School of Industrial Design. Member of Aosdána. Lives and works in Kilkenny.

Selected Exhibitions	1958 Gallery Liernur, The Hague
	1972 Museum of Decorative Arts, Copenhagen
	1974 *New Ceramics*, Ulster Museum, Belfast; City Library, Art Gallery and Museum, Limerick; Crawford Municipal Art Gallery, Cork
	1978 *World Craft Council Exhibition: The Bowl*, Göteborg, Sweden
	1981 David Hendriks Gallery, Dublin
Collections	Centraal Museum, Utrecht
	Gemeente Museum, The Hague
	Museum Boymans van Beuningen, Rotterdam
	Stedelyk Museum, Amsterdam
	Ulster Museum, Belfast
Selected Bibliography	P. Rada, *Modern Ceramics: Pottery and Porcelain of the World*, Czechoslovakia, 1966
	Glenn Gnelson, *Ceramics: A Potter's Handbook*, U.S.A., 1966
	Michael Robinson, *New Ceramics*, catalogue introduction, Ulster Museum, Belfast, 1974
	Seamus Heaney, 'The Nerves in Leaf', *Ireland of the Welcomes*, March/April, 1982

Self-Portrait, 1986. Gouache, charcoal and wax crayon on paper, 25 x 21.

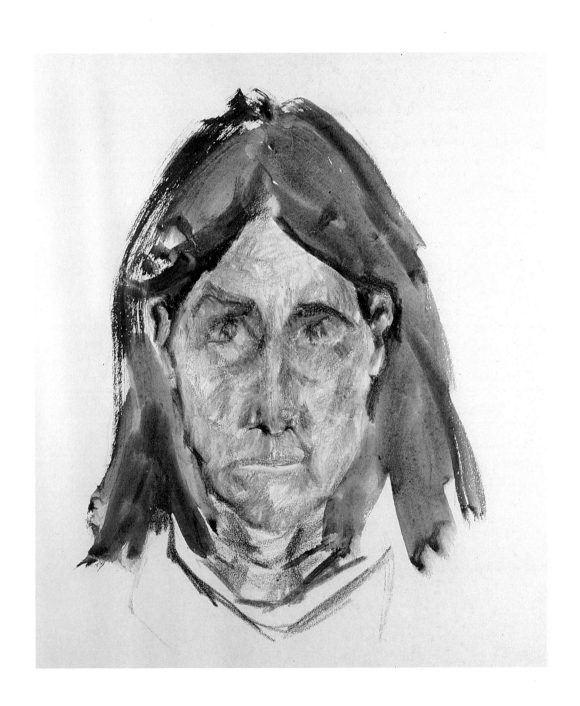

Louis le Brocquy

Few artists have pursued a theme with such single-mindedness as has Louis le Brocquy. For over twenty five years his paintings and drawings have featured human heads, or rather faces, as he employs the minimum of visual detail to convey the essence of a personality. His portraits of literary figures are perhaps the most familiar: Yeats, Joyce, Beckett, Lorca, and Strindberg among them. Le Brocquy, who works mostly from photographs, is concerned not so much with obtaining a physical likeness which he usually does – as with allowing the paint to reveal the presence which lies behind the external appearance. For him the paint and painting have an existence separate from the artist.

Like many artists, le Brocquy believes that a painter is continually making self-portraits, 'since what he tries objectively to draw up from the depths of his canvas lies really somewhere in his own head'. This formal self-portrait, like some of his portraits of Bacon and Beckett, is painted in bright watercolours, which provide a dramatic contrast to the white and grey impastoed heads of earlier years. The basic structure of the head, is barely depicted. Its presence, however, is strongly felt. The eyes look out from beneath a colourful array of short, overlapping daubs of paint. A faint blue indicates a protruding brow. As with his other portraits, le Brocquy hopes that this image, has 'a little of its own life: that it is outside me'. Such objectivity, he admits, is not easily attained. He finds and admires it in Rembrandt's self-portraits 'which are not strictly self-portraits at all, but rather portraits of a man he saw in his mirror'.

Born in Dublin, 1916. Self-taught artist. Honorary member of the Royal Hibernian Academy. Lives and works in the south of France.

Selected Exhibitions	1947 Gimpel Fils Gallery, London 1966 *Le Brocquy: A Retrospective Selection of Oil Paintings 1939-1966*, Municipal Gallery of Modern Art, Dublin and the Ulster Museum, Belfast 1976 *A la Recherche de W.B. Yeats*, Musée d'art Moderne de la Ville de Paris 1981 *Louis le Brocquy and the Irish Head Image*, New York State Museum, Albany 1987 *Images of W.B. Yeats, James Joyce, Federico Garcia Lorca, Picasso, Samuel Beckett, Francis Bacon, 1975-1987*, Arts Council touring exhibition
Collections	Arts Council/An Chomhairle Ealaíon, Dublin Butler Gallery, Kilkenny Centre National d'Art Georges Pompidou, Paris Hugh Lane Municipal Gallery of Modern Art, Dublin Ulster Museum, Belfast
Selected Bibliography/ Sources	Anne Crookshank, *Le Brocquy: A Retrospective Selection of Oil Paintings 1939-1966*, catalogue introduction, Municipal Gallery of Modern Art, Dublin, 1966 John Montague, 'Primal Scream: The Later le Brocquy', *The Arts in Ireland*, vol. II, no. 1, 1973 Dorothy Walker, *Louis le Brocquy*, Ward River Press, Dublin, 1981 Michael Garvey, *Louis le Brocquy: Another Way of Knowing*, documentary film, RTE, 1986

Self-Portrait, 1981. *Study of Self in Watercolour* (on reverse). Watercolour and crayon on paper, 61 x 46. Signed: 'Le B 82'.

Melanie le Brocquy

One of the most striking features of Melanie le Brocquy's bronze figures is their scale. Few pieces are more than twelve inches in height and many could be held comfortably in the palm of one's hand. This invests the work with a characteristic intimacy. Her subject-matter is centred around the family; an infant learns to walk, a young girl holds her mother's hand, father and son stand closely together. The relationship between the figures is one of respect and tenderness. They stand upright but are not stiff. Forms are reduced to a simple statement. An expression is conveyed by a tilt of the head or a curve of the body.

In her early work the initial models were made from plaster. She now uses clay at this stage of the sculpting process, which has resulted in a greater variety of textured surfaces. More importantly, it has allowed her to work more freely and quickly so that she can roughly model a number of ideas in a relatively short space of time. The self-portrait was made using this method. She recognises affinities between her own image and some of Giacometti's female heads where the surface, especially around the area of the neck, is treated in a similarly crude and textured fashion. Typically, she simplifies the facial features and emphasizes the expressive qualities of her material. Here she uses a 'Marini finish' whereby plaster is mixed with rough clay, taken from the original mould, and painted back on to the cast bronze.

Born in Dublin, 1919. Studied at the National College of Art, Dublin, the Royal Hibernian Academy Schools and the Ecole des Beaux-Arts, Geneva. Member of Aosdána. Lives and works in Dublin.

Selected Exhibitions	1962 *III Biennale Christlicher Künst der Gegenwart*, Salzburg
	1973 Joint exhibition with William Scott, Dawson Gallery, Dublin
	1976 Joint exhibition with Patrick Heron, Dawson Gallery, Dublin
	1986 *Looking in Two Directions*, retrospective exhibition, Taylor Galleries, Dublin
	1986 *Irish Renascence*, Pyms Gallery, London
Collections	Allied Irish Bank, Dublin
	Arts Council/ An Chomhairle Ealaíon, Dublin
	Crawford Municipal Art Gallery, Cork
	Dublin Corporation
	Hugh Lane Municipal Gallery of Modern Art, Dublin
Selected Bibliography	*Irish Renascence*, Pyms Gallery, London, 1986
	Brian Fallon, `Irish women artists in the nineteen-fifties', in *Irish Women Artists from the Eighteenth Century to the Present*, the National Gallery of Ireland and the Douglas Hyde Gallery, Dublin, 1987

Self-Portrait,1985. Bronze, height 30.
Signed: 'M le B'.

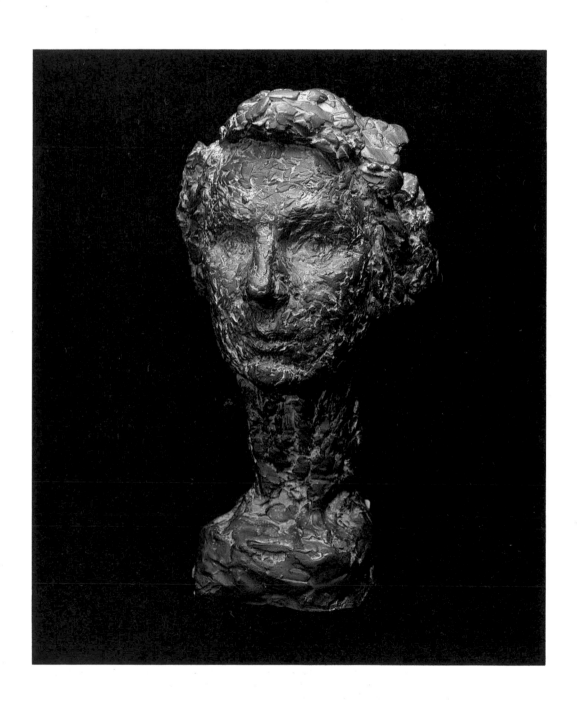

William John Leech

As a student of Walter Osborne's in the Metropolitan School of Art in Dublin, William John Leech learned much about painting with light. He further developed this knowledge and skill when he went to study in Paris and then to work in Brittany. In his paintings from this time, sunlight is diffuse and dappled in the corner of a garden, reflected in concentrated patches in a dark interior or shimmering on a lake or river. Leech returned to Ireland for brief periods in the early years of the twentieth century and in 1910 he went to live in London. His subject-matter remained mostly French and his style impressionistic, with an increasing emphasis on the decorative potential of abstract areas of colour.

Leech was probably in his early seventies when this portrait was painted. Stylistically it is consistent with his later work, in which he was more concerned with the arrangement of shapes in space than the depiction of precise visual detail. The broad and assured handling of paint is that of his mature period. This full-length study is a more private portrait than many of his others. Here Leech admits the viewer into his bedroom-cum-studio. He is in the middle of painting and looks up briefly to check his reflection in the mirror. He paints the scene from above, resulting in the cropped diagonal composition which he greatly favoured. He stands, knees bent, in a relaxed attitude. His right foot steps out of the painting into the viewer's space. The effect is immediate and intimate.

Born in Dublin, 1881. Studied at the Metropolitan School of Art and the Royal Hibernian Academy Schools, Dublin and the Académie Julian, Paris. Member of the Royal Hibernian Academy. Died in Surrey, 1968.

Selected Exhibitions	1911 William Wildman Gallery, London
	1912 Goupil Gallery, London
	1944 Dawson Gallery, Dublin
	1975 *Irish Art 1900-1950*, in association with Rosc Teoranta, Crawford Municipal Art Gallery, Cork
	1981 *The Irish Impressionists: Irish Artists in France and Belgium, 1850-1914*, National Gallery of Ireland, Dublin and the Ulster Museum, Belfast. Exhibited regularly at Royal Hibernian Academy.
Collections	Crawford Municipal Art Gallery, Cork
	Hugh Lane Municipal Gallery of Modern Art, Dublin
	Limerick City Gallery of Art
	National Gallery of Ireland, Dublin
	Ulster Museum, Belfast
Selected Bibliography	Alan Denson, *An Irish Artist W.J. Leech, R.H.A., 1881-1968*, vol. 1 (an introductory guide to his artistic career), Kendal, 1968
	Alan Denson, *An Irish Artist W.J. Leech, RHA, 1881-1968*, vol.2, *His Life Work – A Catalogue*, part 1, Kendal 1969
	Hilary Pyle, 'W.J. Leech' in *Irish Art 1900-1950*, published in association with Rosc Teoranta, Crawford Municipal Art Gallery, Cork, 1975
	Pat Murphy, 'W.J. Leech 1881-1968', *Irish Times*, August 5, 1977
	Julian Campbell, *The Irish Impressionists: Irish Artists in France and Belgium, 1850-1914*, National Gallery of Ireland, Dublin, 1984

Self-Portrait. Watercolour on paper, 52 x 37.
Signed: 'Leech'.
Purchased Tulfarris Art Gallery, Blessington, 1982. One of two portraits by the artist in the collection.

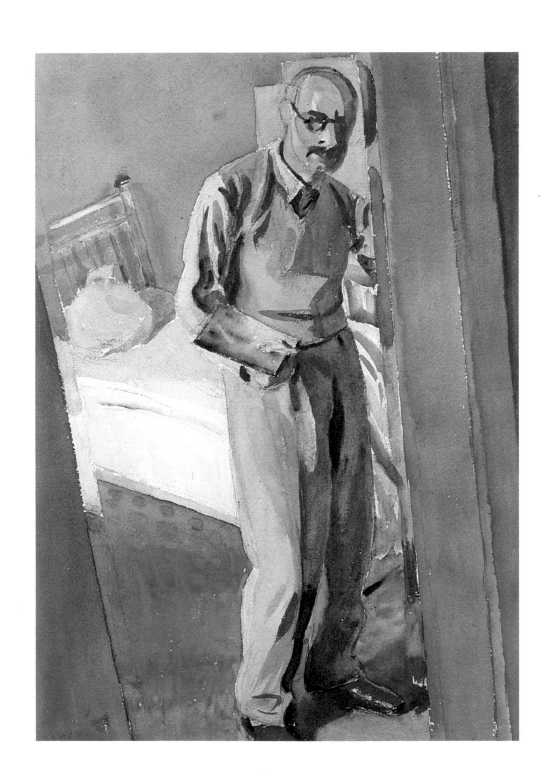

James Le Jeune

James Le Jeune trained as an architect and practised as such in London for seventeen years. After serving in the army during the Second World War, he decided to give up architecture for his first love, painting. In 1948 he moved to Ireland, where he established a successful career as a portrait painter. His sensitivity to the range of human emotions – and his ability to convey these in a natural and sincere way – is rare in the context of contemporary Irish portraiture. His commissioned portraits are as unaffected as the studies which he made of his friends and family. He also painted atmospheric landscapes, cityscapes and figure studies in oil and watercolour. Many of these were executed in Spain and America, where he worked for a number of years.

This self-portrait is one of two which Le Jeune painted in his early fifties. He has approached it with innate candour and depth. He looks openly and earnestly at the viewer. The features of the face are sensitively rendered; the eyes and mouth are particularly expressive. The area of white paint behind the neck and shoulders is an original device which offsets his darkly-clothed figure from an even darker background. An equally effective structural element – which imaginatively could be read as an easel – is provided by the horizontal and vertical lines to the left of the composition. The scumbled paintwork of both of these features, the short, wide brushstrokes of his hair and face, and the tiny daubs of bright red paint scattered throughout are all characteristic features of Le Jeune's sensitive and animated handling of paint.

Born in Canada, 1910. Studied architecture at the Central London Polytechnic. Attended art classes at Heatherly College, London and the National College of Art, Dublin. Member of the Royal Hibernian Academy. Died in Dublin, 1984.

Selected Exhibitions 1983 *A Century of Irish Painting*, University College Galway
1984 Arts Club, Dublin
Exhibited regularly at the Royal Hibernian Academy.

Collections Crawford Municipal Art Gallery, Cork
National Gallery of Ireland, Dublin

Self-Portrait. Oil on canvas, 60 x 50.
Signed: 'Le Jeune'.

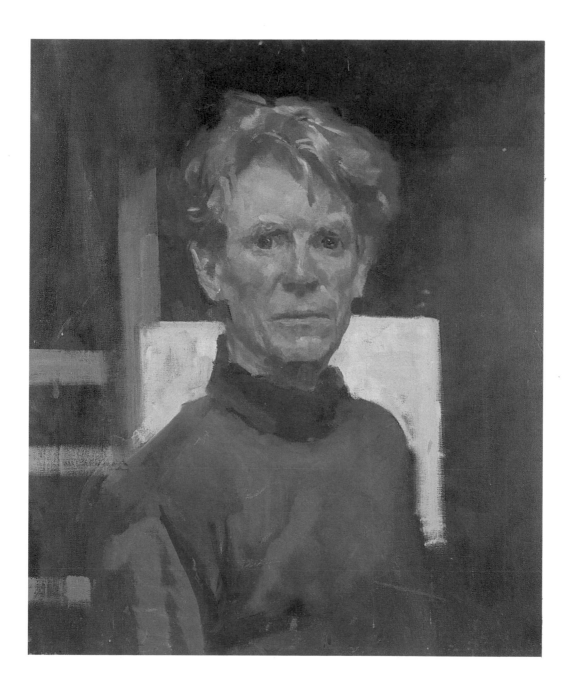

David Lilburn

David Lilburn uses a wide variety of print media in a very personal way. Sometimes he combines different techniques, painting over a monoprint or silk-screen. His line is dynamic and his use of colour selective and expressive. He works in series, which vary greatly in their sources of inspiration. Recent themes have included the circus, which is 'always enchanting: all the acts are full of heroism'; *Stepping Stones*, a response to John Liddy's poem; buildings of Amsterdam; and a redrawing of images and artefacts from Minoan culture. Most of these are monoprints, executed in a fluid, painterly manner.

Lilburn has printed and drawn many self-portraits, some humorous, some less so. This self-portrait, a dry-point, reveals his typically energetic use of line. Scratching the relatively soft surface of the copper plate, with a hard needle, he produces a line that is dense and slightly blurred – almost like that of a charcoal drawing. Typically, Lilburn has experimented with surface textures; here he uses sandpaper, a small wheel and bits of hard steel to make the various markings on the face. His whole head fills the page, and, in spite of his sideways look, he immediately confronts the viewer. His large forehead and small chin seem slightly out of proportion: Lilburn worked on the print on a horizontal surface. To recapture the artist's perspective, the viewer must look at it from ground level at an angle of about 45°.

Born in Limerick, 1950. Studied at Limerick School of Art and Design and Scuola di Belle Arti, Urbino. Lives and works in Limerick.

Selected Exhibitions
1983 Joint exhibition with Joe Wilson, Belltable Arts Centre, Limerick, Grapevine Arts Centre, Dublin and Peacock Gallery, Craigavon
1984 Joint exhibition with Michael Byrne, Limerick City Art Gallery
1985 Three-man exhibition with Dietrich Blodau and Jim Sheehy, Merriman School, Lisdoonvarna

Collections
Limerick Contemporary Art
Mary Immaculate College of Education, Limerick
Thomond College, Limerick
University of Limerick

Self-Portrait, 1989. Dry-point, 63 x 43.
Signed: 'A/P David Lilburn'.

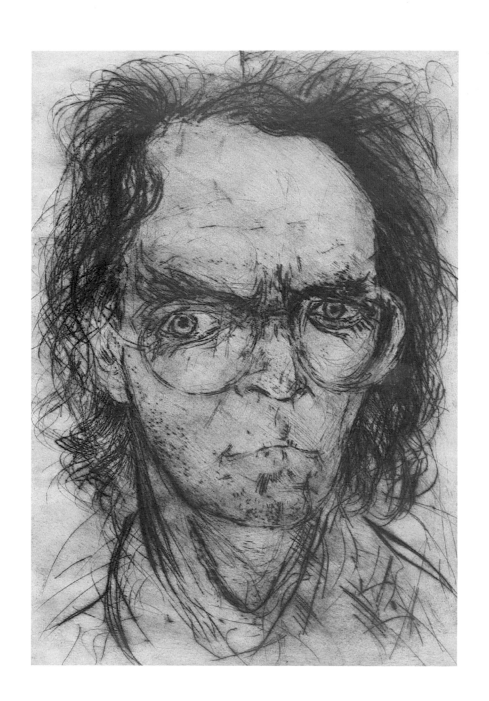

Gladys Moore Maccabe

Gladys Moore Maccabe's involvement in the visual arts has been long-standing and varied. She has lectured and written about art, she founded the Ulster Society of Women Artists, and has been painting professionally for more than fifty years. Using a variety of media – oil, watercolour, acrylic and pastel – she works swiftly and fluidly. The race-meeting is a recurrent theme, as it incorporates her two favourite subjects: people and horses. In her small, colourful canvases, horses pace up and down impatiently before the race while the racegoers cast a keen eye on the day's form. A market-day scene bustles with activity, as the crowds of shoppers eagerly surround the stalls. A summary use of black outlines the figures and an impressionistic juxtaposition of complementary colours highlights a detail. Such features add to the vitality and spontaneity of her painting.

Maccabe has painted several self-portraits throughout her career. Here she depicts herself, in formal dress, actually painting and not, as in other works, pausing to survey the viewer. The pose is elegant, the profile striking. Characteristically, she contrasts dark with light; her pale skin and fair hair complement the more sombre tones of the rest of the painting. Also familiar is the way in which she introduces tiny patches of bright pigment – here provided by the paint on the paintbrushes – into a solid area of dark colour, in this case, her black dress. For Maccabe, the problem of objectivity remains. She points out: 'While I do not see myself exactly like this, I feel it is a fair likeness. To see ourselves as others see us – that is something quite different.'

Born in Randalstown, Co Antrim, 1918. Studied at Belfast College of Art. Member of the Royal Ulster Academy. Lives and works in Belfast.

Selected Exhibitions
1956 *Artists of Fame and Promise*, Leicester Galleries, London
1958 Joint exhibition with Max Maccabe, Belfast Museum and Art Gallery
1961 Joint exhibition with Max Maccabe, Ritchie Hendriks Gallery, Dublin
Exhibits regularly at the Royal Ulster Academy.

Collections
Arts Council/An Chomhairle Ealaíon, Dublin
Arts Council of Northern Ireland, Belfast
Imperial War Museum, London
Queen's University, Belfast
Ulster Museum, Belfast

Selected Bibliography
John Hewitt, *Art in Ulster: 1*, Arts Council of Northern Ireland and Blackstaff Press, Belfast, 1977

Self-Portrait, 1985. Acrylic on board, 76 x 63.5.
Signed: 'Gladys Maccabe'.

James McCreary

James McCreary likes to represent things 'out of context'. His compositions, as a result, often amuse. In brightly coloured lithographs, tropical fish, attached to a pole, swim around a garden; a vase of flowers casts the shadow of a full-bellied man; the patterns on an insect's wing are the features of a human face. Other images are more fantastical. Multi-coloured birds or insects create fluid rhythms in a speckled haze of colour. A strong sense of pattern and the suspended quality of the images suggest the influence of Japanese art, which McCreary has always admired.

His self-portrait, drawn in coloured pencil, has a quirky humour. It consists of two separate drawings, which the artist found to have an enhanced strength when placed alongside each other. The long, slender forms, which barely contain the features of his face, relate to a series of still lifes with vases and flowers on which he was working at the time. Apparently asleep on the left-hand side, the artist awakens on the right – a metaphor perhaps for the artistic process. He opens one eye as if to take a peep at the viewer. The viewer, in turn, may be left feeling slightly curious as to the nature of the person behind the closed and half-closed eyes. In its absence, the power of eye contact is reaffirmed. The portrait drawings are a characteristic example of McCreary's working method, revealing a concern for detail, a subtle blending of colour and a sparse, uncluttered treatment of subject-matter.

Born in Dublin, 1944. Studied at the National College of Art, Dublin. Lives and works in Dublin.

Selected Exhibitions	
	1973 Project Arts Centre, Dublin
	1976 *Graphic Studio Retrospective Exhibition*, Hugh Lane Municipal Gallery of Modern Art, Dublin
	1979 Bell Gallery, Belfast
	1983 Lincoln Gallery, Dublin
	1984 *British International Print Biennale*, Bradford

Collections	
	Arts Council/An Chomhairle Ealaíon, Dublin
	Bank of Ireland, Dublin
	Crawford Municipal Art Gallery, Cork
	Hugh Lane Municipal Gallery of Modern Art, Dublin
	Ulster Museum, Belfast

Self-Portrait, 1987. Coloured pencil on paper, 66 x 91.
Signed: 'James McCreary '87' (on reverse).

Patrick McElroy

Patrick McElroy's initial training as a welder with the Great Southern Railway provided him with invaluable experience in the handling of metals. He works with technical ease and skill in a wide range of media, including steel, bronze, copper, enamel and terracotta. In both his religious and secular work, he prefers to let the material dictate the form rather than forcing it to act uncharacteristically. His steel figures tend to be angular, the forms in bronze more fluid. The colourful altar furnishings, in *cloisonné* enamel, are reminiscent of Celtic decoration in their intertwining of animal and human forms.

Since the early 1980s McElroy has devoted more time to non-commissioned work. The figure of a bird, suggesting movement and freedom, has predominated: Icarus, with wings of solid steel, takes flight. The human form is reduced to a series of rhythmical curves in bronze, or stick-like figures in rods of steel. For McElroy what is implied is just as important as what can be seen. The decision to omit information is one which he has made in his self-portrait. He crudely abstracts the features of his face, which are represented by two large triangular eyes, a box-like nose, and a cleanly-cut strip of sheet bronze for a mouth. This mask image is explicitly primitive, its effect being accentuated by the green patina suggestive of an archaeological artefact. McElroy has always admired the heads of the Early Irish Bronze Age. He sees his portrait, which refers specifically to these heads, as a link between himself and the image makers of the past.

Born in Dublin, 1923. Studied at the National College of Art, Dublin. Lives and works in Dublin.

Selected Exhibitions	1975 Emmet Gallery, Dublin
	1980 *Irish Art 1943 -1973*, in association with Rosc Teoranta, Crawford Municipal Art Gallery, Cork
	1982 Taylor Galleries, Dublin.
	1987 *Sculpture in Context*, Fernhill, Dublin
	1987-8 *Meta-Furniture*, Sculpture Society Ireland touring exhibition
Commissions	Church of the Four Winds, Clifden, Co Galway
	Church of St Fionan, Falcarragh, Donegal
	Coras Iompar Eireann, Dublin
	Dunmarray Shopping Centre, Belfast
	St Vincent's Hospital, Dublin
Select Bibliography	Cyril Barrett S.J., 'Patrick McElroy' in *Irish Art 1943-1973*, published in association with Rosc Teoranta, Crawford Municipal Art Gallery, Cork, 1980
	James White, catalogue introduction, Taylor Galleries, Dublin, 1982

Self-Portrait, 1988. Hammered sheet bronze, 38 x 23.
Signed: 'P. McElroy 88' (on reverse).

Brett McEntagart

Brett McEntagart is primarily a *plein air* landscape painter in oils. He works in the tradition of the French Impressionists, analysing the tones and colours to render the exact play of light on his subject-matter. Paint is applied in small, flickering patches of bright colour and, even in the areas of darkest shadow, black is never used. He paints mainly in France where he stays during the summer months and enjoys the freedom provided by watercolour, which he uses when travelling. McEntagart has always been attracted by the way in which print forces him to extend an idea in a deliberate and disciplined way that is not naturally part of the painting process. In his etchings of old Dublin he often combines printing techniques to produce a variety of textures and tones.

His self-portrait, in its subject-matter, is a radical departure from his main work; in its method of execution, however, it is similar. Here, McEntagart paints what he sees rather than what he knows. The flesh tones include a pale violet, reflected by the cravat of the same colour. The uninterrupted off-white background is unusually bright. Typically, he uses short, multi-directional brushstrokes which appear to hover on the surface of the painting, creating a shimmering effect, particularly in the background. He places himself slightly off-centre and looks, somewhat expectantly, at the viewer.

Born in Dublin, 1939. Studied at Dartmouth College, New Hampshire and University of Colorado. Member of the Royal Hibernian Academy. Lives and works in Dublin.

Selected Exhibitions	
	1957 David Hendriks Gallery, Dublin
	1966 Molesworth Gallery, Dublin
	1970 Brown Thomas Gallery, Dublin
	1984 *Yugoslavian Print Biennale*, Ljubliana
	1986 Joint exhibition with James Nolan, James Gallery, Dalkey, Co Dublin
	Exhibits regularly at the Royal Hibernian Academy
Collections	Hugh Lane Municipal Gallery of Modern Art, Dublin

Self-Portrait. Oil on board, 46 x 36.
Signed : '.Brett.'

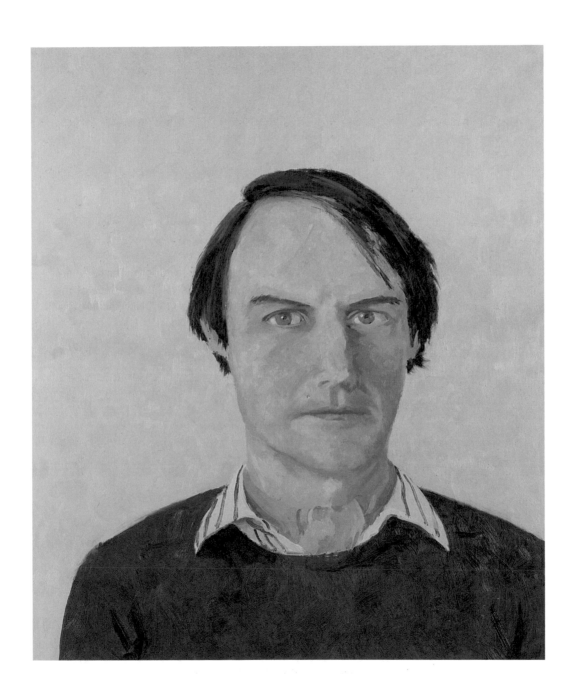

Janet McLoughlin-Minch

Having left the National College of Art in 1960, Janet McGloughlin-Minch spent many years breeding, showing and jumping championship horses and ponies. This interest carried through to her art when, in 1975, when she began to paint and draw professionally, specialising in animal portraiture. She still works in pastel, but since the early 1980s has devoted most of her time to making equestrian sculptures in bronze. Most of her pieces, like that included in her self-portrait, are less than a foot in height. Keeping to this domestic scale, she freezes a moment of intense movement, models it in wax, and casts it – sometimes quite roughly – in bronze.

McGloughlin-Minch has never made a bust in bronze. Although initially tempted to do so for her self-portrait, she chose the more familiar medium of pastel which she uses for most of her portraits, both animal and human. The choice of tinted paper is effective in rendering a more solid image than is usual. Varying the theme of artist-at-work, she depicts herself alongside one of her sculptures, *Power Struggle*, in which two horses rear up, one biting at the other's mane. There are no working tools in evidence. The work has been completed, leaving the artist free to communicate directly with the viewer.

Born in Dublin, 1938. Studied at the National College of Art, Dublin. Lives and works in Co Meath.

Selected Exhibitions	1986 Solomon Gallery, Dublin
	1986 Cashel Palace, Cahir
	1987 Tinchel Gallery, Dublin
	1987 *Celebration of the Bog*, Royal Hospital, Kilmainham, Dublin; Carroll Gallery, Longford; Butler Gallery, Kilkenny; Glebe Gallery, Churchill, Donegal; Limerick City Art Gallery
Commissions	McKee Barracks, Dublin

Self-Portrait, 1987. Pastel on paper, 65 x 45.
Signed: 'Janet McLoughlin-Minch A.N.C.A 1987'.

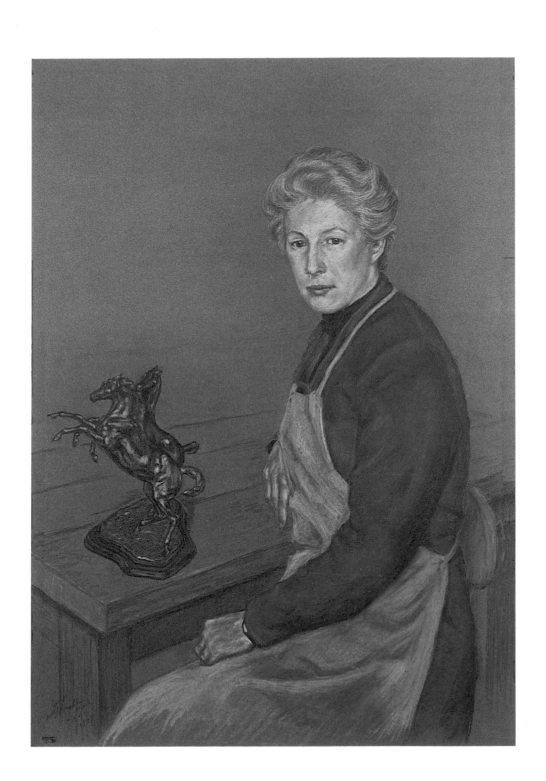

Theo McNab

Surface and Structure was the title of Theo McNab's most recent exhibition, which he shared with Charles Tyrrell in 1987. A partial view of one of his abstract canvases, included in his self-portrait, gives an insight into the extent to which these two elements are central to his painting. The initial inspiration for his grid paintings comes from life: landscapes and, more specifically, light-filled enclosed spaces. To construct these views, he applies the mathematical principles for mixing colours and fixing lines established by the medieval Italian mathematician, Leonardo Fibonacci, as well as the naturally occurring harmonic proportion of horizontal to vertical – known as the Golden Mean. Staining the canvas with multiple layers of thinned acrylic paint, McNab achieves a remarkable translucency and depth in his compositions.

The realism of his self-portrait is unexpected. The background painting, however, is more familiar. It relates to a series of paintings, made at the same time as the portrait, in which McNab was studying the effect of seasonal light changes. Even in this relatively dark painting, the light seems to emerge surprisingly from the centre of the canvas. An even brighter light shines on the artist's face, which is rendererd in precise detail using very fine brushwork. The formal contrast between his own figure and the painting behind is reconciled by the colour harmony, carefully established between the same two elements. The desire for order and precision inherent in his grid landscapes is evident also in the self-portrait.

Born in Dublin, 1940. Self-taught artist. Member of Aosdána. Lives and works in Dublin.

Selected Exhibitions	1973 David Hendriks Gallery, Dublin
	1976 Cork Arts Society Gallery
	1980 David Hendriks Gallery, Dublin
	1981 *Impact Art*, Municipal Gallery, Kyoto, Japan
	1987 *Surface and Structure*, joint exhibition with Charles Tyrell, Douglas Hyde Gallery, Dublin
Collections	Allied Irish Bank, Dublin
	Hugh Lane Municipal Gallery of Modern Art, Dublin
	Trinity College, Dublin
	University College Dublin
	University College Galway
Selected Bibliography	Cyril Barrett S.J., 'Theo McNab' in *Irish Art 1943-1973*, published in association with Rosc Teoranta, Crawford Municipal Art Gallery, Cork, 1980
	Roderic Knowles, ed., 'Theo McNab: Calculation and Sensibility' in *Contemporary Irish Art*, Wolfhound Press, Dublin, 1982
	Frances Ruane, *The Allied Irish Bank Collection: Twentieth Century Irish Art*, Douglas Hyde Gallery, Dublin, 1986
	Liam Kelly, *Surface and Structure*, catalogue essays, Douglas Hyde Gallery, Dublin, 1987
	Ciaran Carty, 'Visual Thinking', interview with the artist, *Sunday Tribune*, September 6, 1987

Self-Portrait. Acrylic on canvas, 38 x 25.5.
Signed: 'Theo McNab' (on reverse).

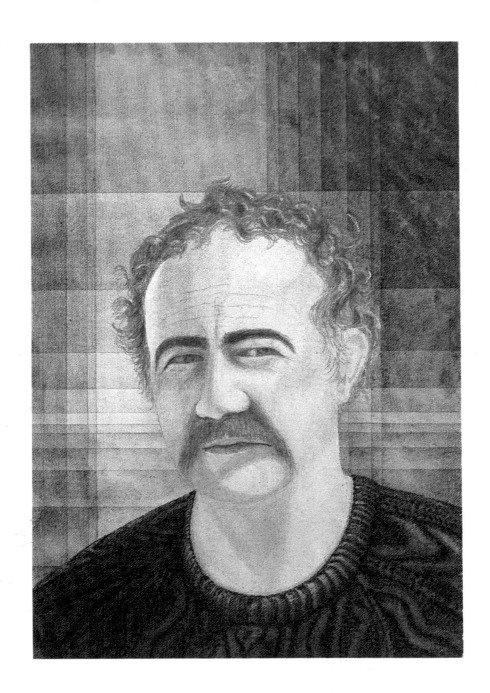

Donald McPherson

Donald McPherson spent much of his life travelling around the coasts of Donegal and Galway, recording his favourite locations in watercolour. In these views, vast expanses of damp sand stretch out to low horizons, broken perhaps by a group of rocks or a few figures walking or riding on horseback. He paints in varying lights throughout the year. Using pure transparent washes, he captures the bright sunlight reflected in water on a clear summer's day or the mood of a misty winter's morning on a riverbank. Sometimes he chooses to paint a more detailed view which might include a cluster of stone walls around a farmhouse in Connemara or a close-up study of some reeds by a lake. In these, where the medium is more opaque, his graphic skills are much in evidence.

McPherson's self-portrait, painted the year before he died, is a gentle, unassuming study which clearly reveals his proficient handling of the watercolour medium. His facial features are delicately rendered in detail. The background and torso are indicated by the more characteristic loosely applied wash. Typically, he limits his palette, and leaves a large area of the paper uncovered, which highlights the face and enhances the simplicity of the painting.

Born in Belfast, 1920. Studied at Belfast College of Art. Member of the Royal Ulster Academy. Died in Belfast, 1987.

Selected Exhibitions 1966 Group exhibition, Gordon Gallery, Derry
 1984 Group exhibition, Combridge Fine Arts, Dublin
 Exhibited at the Royal Ulster Academy

Self-Portrait, 1986. Watercolour on paper, 48 x 38.
Signed: 'Donald McPherson 1986'.

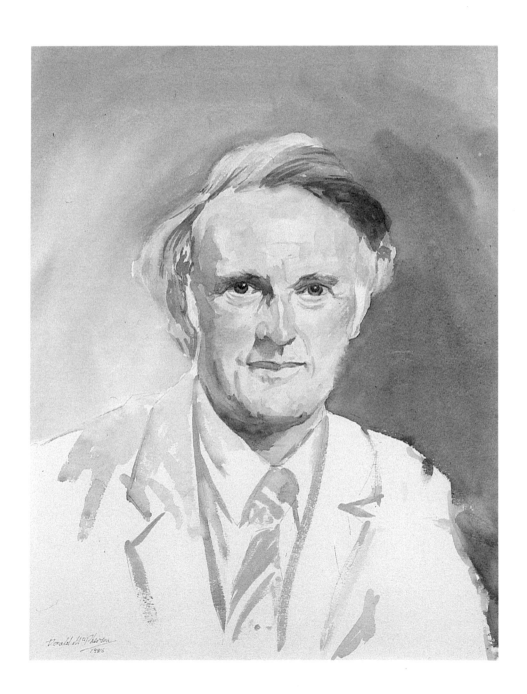

Donald McPherson
1986

F.E. McWilliam

F.E. McWilliam's sculpture does not fit easily into any category or school. He has worked in a variety of styles and media over the years, drawing his inspiration from the human figure. Having left Ireland at the age of eighteen, he studied at the Slade School of Fine Art in London. During the 1930s he was associated with the British Surrealists with whom he exhibited for the first time in 1938. By this stage he had visited and was greatly impressed by Brancusi. McWilliam's own work from this period, in wood and stone, shows the influence of the older sculptor. His semi-abstract figures have rounded, sometimes hollowed forms. The flattened figures of the 1950s are angular and roughly textured. The bronze *Legs* of the 1960s and the bomb-blasted *Women of Belfast* series from the early 1970s are more dynamic and powerfully expressive. Scale is of little importance for McWilliam, unless a specific site demands it, as in the case of his giant bronze *Princess Macha* in Derry.

McWilliam's work has become increasingly representational over the years. During this time he has made many portraits, some quite unconventional, such as the mosaic head of Picasso. In all, he achieves an impressive physical likeness as well as real insight into the sitter's personality. His self-portrait in this collection manifests both of these elements. Despite its lively, textured surface, the mood is calm and self-contained. This private aspect of sculpture is, for McWilliam, an essential counterpart to the more public element.

Born in Banbridge, Co Down, 1909. Studied at Belfast College of Art and the Slade School of Art, London. Honorary Member of the Royal Ulster Academy. Lives and works in London.

Selected Exhibitions	1939 London Gallery, London
	1958 West of England Academy, Bristol
	1977 Bell Gallery, Belfast
	1981 *Retrospective Exhibition*, Ulster Museum, Belfast; Douglas Hyde Gallery, Dublin; Orchard Gallery, Derry
	1989 *Retrospective Exhibition*, Tate Gallery, London
Collections	Art Institute of Chicago
	Arts Council of Northern Ireland, Belfast
	Museum of Modern Art, New York
	National Portrait Gallery, London
	Ulster Museum, Belfast
Selected Bibliography	Roland Penrose, *McWilliam Sculptor*, Alec Tiranti Ltd., London, 1964
	Harriet Cooke, interview with the artist, *Irish Times*, October 31, 1973
	John Hewitt, *Art in Ulster: 1*, Arts Council of Northern Ireland and Blackstaff Press, 1977
	Mike Catto, *Art in Ulster: 2*, Arts Council of Northern Ireland and Blackstaff Press, 1977
	Brian Fallon, 'F.E. McWilliam: First among Irish Sculptors', *Irish Times*, February 14, 1987

Self-portrait,1986. Bronze, height 35.5.
Signed: 'McW 1/'.
One of two portraits by the artist in the Collection.

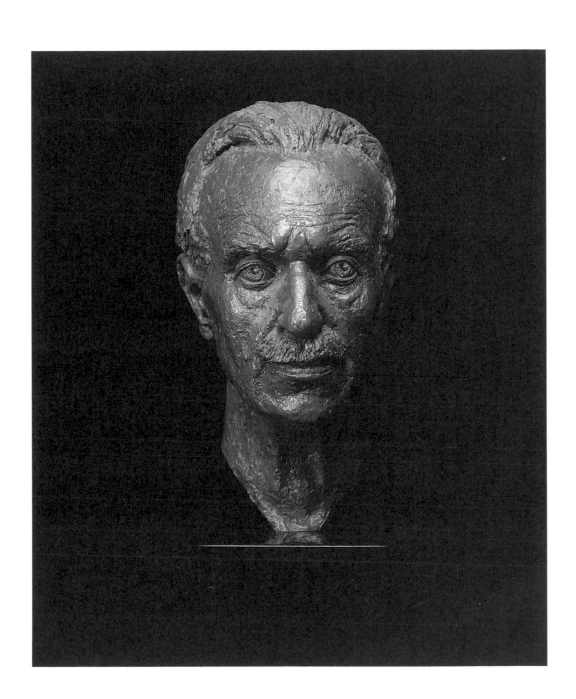

Anne Madden

At the age of fourteen, Anne Madden moved from England to the Burren in County Clare. The large megalithic stone monuments particular to this region have since provided a rich source of inspiration. In the early 1970s, her work took the form of a series of large, dark canvases, vertically segmented by thin, bright lines. With these paintings she confronts her personal preoccupation with the universal theme of death. The early 1980s revealed a greater optimism. The brightly coloured rectangles from this period represent the open spaces of windows and doors and reflect the central issue of her work – namely, the reconciliation of opposites: the inner and the outer world, light and dark, male and female, day and night, life and death.

In the context of such pure abstraction, Madden's self-portrait seems anomalous. It is drawn on a page from a sketch book, using graphite and oil paint – the same materials used for the "opening" series. This small portrait shares with her large abstract canvases a subtle tonal gradation, which gives a *sfumato*, or slightly hazy, effect. Typically, tone is favoured over line. At first it appears as if the artist has surrounded herself with a drape or shawl. On closer inspection, she seems to emerge from a dark space, breaking through a lighter coloured surface, the jagged edges of which may be seen around her neck. As with the "opening" series, the notion of artistic vision is implied: the passage from dark to light, from interior to exterior. This portrait would seem to be a more profound self-study than the lifelike image might suggest.

Born in London, 1932. Studied at Chelsea School of Art, London. Member of Aosdána. Lives and works in the south of France.

Selected Exhibitions	1956 *Artists of Fame and Promise*, Leicester Galleries, London
	1960 Dawson Gallery, Dublin
	1979 Taylor Galleries Dublin
	1984 *Rosc '84*, Guinness Hop Store, Dublin
	1986 Armstong Gallery, New York
Collections	Arts Council/An Chomhairle Ealaíon, Dublin
	Centre National d'Art Contemporain Georges Pompidou, Paris
	Hugh Lane Municipal Gallery of Modern Art, Dublin
	Trinity College, Dublin
	Ulster Museum, Belfast
Selected Bibliography	James Johnson Sweeney, catalogue introduction, Dawson Gallery, 1968
	James White, 'Anne Madden' in *The Irish Imagination 1959-1971*, published in association with *Rosc '71*, Municipal Gallery of Modern Art, Dublin, 1971
	Ronald Alley, *The Paintings of Anne Madden*, catalogue introduction, Dawson Gallery, 1977
	Richard Kearney, 'Interview with Anne Madden', *Crane Bag*, vol. 4, no. 1, Dublin, 1980
	Marcelin Pleynet, *Anne Madden: Peintures et papiers récents* catalogue essay, Fondation Maeght, 1983

Self-Portrait, 1986. Graphite and oil paint on paper, 23 x 19.
Signed: 'Anne Madden Nov. 1986'.

Brian Maguire

Brian Maguire's paintings are a passionate response to his experience of contemporary Irish society. In his large, vibrant canvases he comments on the country's political and social injustices. Death and violence prevail: a gunman stands expectantly; murdered bodies are strewn across a blood-splattered landscape; lifeless figures float down a river. Amidst such anger the artist does not lose sight of the tenderness of human relationships. Lovers face each other with uncertainty, couples and children stand closely together. All this is expressed through an intensely emotional use of paint. Dark paintings are relieved by a glimmer of bright pigment. His painting is always animated but rarely optimistic.

Maguire has made a series of self-portraits, most of which date from the early 1980s. These, like all of his other portraits, are subjective studies which clearly attempt to reveal what lies beneath the physical surface. The portrait in this collection, painted in 1986, is no different in this respect. He studies himself intently; his gaze is searching, his painting direct. Colours merge in the face. A dry red and black contrast with a fluid grey. Where black paint is used in the larger works, here conté roughly outlines the forms. The "unfinished" quality of the portrait enhances its immediacy.

Born in Bray, Co Wicklow, 1951. Studied at Dun Laoghaire Vocational School and the National College of Art and Design, Dublin. Member of Aosdána. Lives and works in Dublin.

Selected Exhibitions	1981 Lincoln Gallery, Dublin
	1982 Triskel Arts Centre, Cork
	1984 David Hendriks Gallery, Dublin
	1986 *Four Irish Expressionists*, Boston College, North-Eastern University, Boston
	1988 *Brian Maguire, Paintings 1982-1987*, Orchard Gallery, Derry and Douglas Hyde Gallery, Dublin
Collections	Allied Irish Investment Bank, Dublin
	Arts Council/An Chomhairle Ealaíon, Dublin
	Butler Gallery, Kilkenny
	Contemporary Irish Art Society, Dublin
	University of Limerick
Selected Bibliography	John Hutchinson, 'Young Artists: Brian Maguire', *Irish Times*, August 18, 1982
	Henry Sharpe, 'Brian Maguire' in *Making Sense: Ten Painters 1963-1983*, Project Arts Centre, Dublin, 1983
	Jim Lynch, *Brian Maguire/Patrick Graham*, catalogue essay, Octagon Gallery, Belfast, 1984
	Donald Kuspit, *Brian Maguire*, catalogue essay, Douglas Hyde Gallery, Dublin and Orchard Gallery, Derry, 1988
	Aidan Dunne, 'Maguire's violent, expressive minimum', *Sunday Tribune*, April 17, 1988

Self-Portrait, 1986. Acrylic and conté on paper, 68 x 53.
Signed: 'Oct 86 B Maguire'.

Cecil Maguire

Cecil Maguire is concerned in his paintings with recording a way of life that is rapidly disappearing in Ireland. In parts of the west of the country he observes and paints small communities of people whose lives are dependent upon the land and sea. Fishermen are depicted mending their nets, young children stack turf or a group of people congregate after Sunday Mass. In recent years he has become preoccupied with the play of light at a particular time of day on different landscapes. The coasts of Normandy, Portugal and New England have all featured in these paintings, which find the artist delighting in 'the way in which the ordinary can become the extraordinary, even for a fleeting moment'.

Maguire, likes, in his own words, 'to look out rather than in'. Following the invitation to make a self-portrait for this collection, he became 'dangerously obsessive, if not narcissistic'. He completed six portraits in all, finally selecting this almost half-figure view. The way in which his figure recedes into the painting suggests that he worked from a mirror placed at an angle away from his body. His gaze is upward and outward. The earphones around his neck – a very contemporary reference – hint at the artist's work practice. The broad and sparsely applied brushwork and the simple background reveal Maguire's preference for a slightly abstracted naturalism.

Born in Lurgan, Co Armagh, 1930. Self-taught artist. Member of the Royal Ulster Academy. Lives and works in Belfast.

Selected Exhibitions
1976 Playhouse Gallery, Leeds
1980 Bell Gallery, Belfast
1981 Kenny Art Gallery, Galway
1984 Peel Gallery, Montreal
1986 Oriel Gallery, Dublin
Exhibits regularly at the Royal Ulster Academy.

Collections
Aer Rianta, Dublin
Queen's University, Belfast
Ulster Museum, Belfast
United Nations Headquarters, New York

Self-Portrait, 1985. Oil on board, 61 x 45. 5.
Signed: 'Maguire 85'.

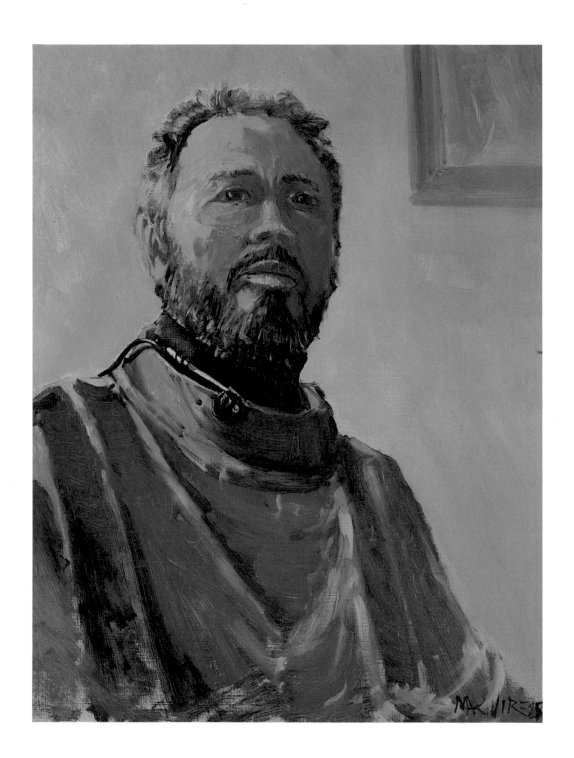

Tim Mara

As a student, Tim Mara wanted to make films. Constrained by lack of facilities and finance, he began to explore his interest in the narrative quality of images through the medium of screen print. He set up photographs like a stage set, so that the resulting print looked like a still from a film. As a series of screen prints, each image related to the rest but could also be viewed on its own. He draws his subject-matter from a wide variety of things seen – faces, pieces of fabric, domestic devices and still-life objects. Bright colours, simple shapes and a strong sense of pattern predominate. It is the actual process of printing, which dictates the final image, that Mara finds most rewarding.

Mara is interested in the many ways in which self-portraiture may be approached. He does not feel comfortable with the traditional self-portrait, but often uses his own image as a means of trying out an idea. In *Self portrait with a Contour Guage* he is concerned with the idea of technical precision. By using such a device he can obtain an exact profile of his face. There are seven profiles in all, including the two shadows cast and the less obvious imprint of the etching plate to the right of the gauge. The image is almost surreal, a term which has been used on other occasions to describe Mara's work. Here he combines the processes of screen printing and etching, revealing his assured handling of the medium.

Born in Dublin, 1948. Studied at Epsom and Elwell School of Art, Wolverhampton Polytechnic and the Royal College of Art, London. Lives and works in London.

Selected Exhibitions	1974 *New British Printmakers*, Brooklyn Museum, New York
	1976 Institute of Contemporary Arts, London
	1981 David Hendriks Gallery, Dublin
	1982 *Innovations in Contemporary Printmaking*, Ashmolean Museum, Oxford
	1988 Angela Flowers Gallery, London
Collections	Brooklyn Museum, New York
	National Gallery, New Zealand
	Tate Gallery, London
	Ulster Museum, Belfast
	Victoria and Albert Museum, London
Selected Bibliography	Guy Burn, 'Tim Mara, Angela Flowers', exhibition review, *Arts Review*, February 12, 1978
	Ciaran Carty, 'The Man who Became his Wife', *Sunday Independent*, June 14, 1981
	Francia Turner, 'Contemporary Print-making: Old Means and New. The Work of Kelpra, Mara, Herndorff', *Oxford Art Journal*, vol. 6, no. 1, 1983

Self Portrait with a Contour Gauge. Screen print and etching, 5/25, 56 x 75.
Signed : 'Tim Mara 1981'.
Presented by the Contemporary Irish Art Society.

Self, Portrait with a Critics Gaze, Tom Marioni 1986

George Morrison

George Morrison is well used to painting and drawing his own image. He frequently refers to it as an exercise in portrait-painting which, along with landscape painting, comprises most of his artistic output. Some heads, like this self-portrait, are realistically rendered in charcoal and conté crayon; others are interpreted in a freer manner using oils and watercolours. In all, there is a sculptural modelling of form. Here, Morrison makes effective use of a tinted paper and white highlight to give volume to the head. His shirt collar, roughly indicated in white, is the only element which might distract from the detailed features of his face. Working mainly from photographs, Morrison strives for 'a good head' which he hopes will also be a 'reasonable likeness'.

His landscapes, painted mainly in watercolour, are more abstract than the portraits. In these he is more interested in the arrangement of shapes and colours. Sky and water are worked wet-on-wet, giving an expansive feel to a boggy landscape, lit by a thin northern light. Detail of foliage and stonework is accurate, but never overworked. The handling of paint is always fresh and spontaneous. He builds up the oils by juxtaposing large patches of colour where the tones are either strongly contrasting or very subtly gradated. Whether working in a representational or abstract idiom, Morrison is primarily concerned with strength and immediacy of image. 'Timidity', he claims, 'must be relegated to a low place in a hierarchy of what I aim for.'

Born in Downpatrick, Co Down, 1915. Self-taught artist. Member of the Royal Ulster Academy. Lives and works in Belfast.

Selected Exhibitions Exhibits regularly at the Royal Ulster Academy.

Self-Portrait, 1985. Charcoal and conté on paper, 49 x 35. 5.
Signed: 'George Morrison'.

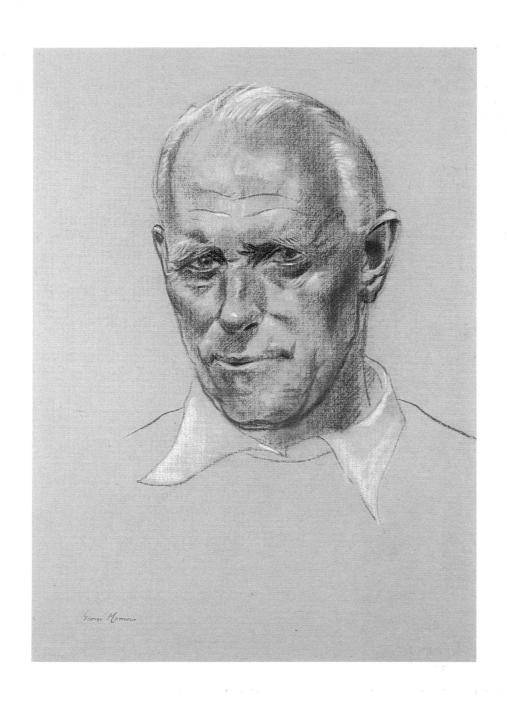

George Memmin

Charles Merrill Mount

Charles Merrill Mount is generally better known as an art historian than as an artist. He came to Dublin from London in the early 1960s, following in the footsteps of Gilbert Stuart, an American portrait painter, whose biography he was writing at the time. Stuart, who had also been based in London, lived in Dublin between 1787 and 1793. Mount spent about ten years in Dublin before returning to his native America. For Merrill Mount, the practical and critical disciplines of art are closely allied. His own painting indicates the influence of another American, John Singer Sargent, whose biography he completed in 1955. Like Sargent, Merrill Mount was a society portrait painter in America and London. Both painters continued the bravura tradition of Sir Thomas Lawrence and were greatly influenced by Manet's direct contrasts of light and shade as well as the sombre tones of Velazquez.

His self-portrait, executed when he was thirty-two, has much in common with a sketchy oil in an oval format painted by Sargent at the age of thirty. Merrill Mount's is a similarly hatched charcoal drawing in a circular format. The diameter of Merrill Mount's drawing is exactly the same as the width of the oval in Sargent's portrait. Sargent's is a three-quarter view; Merrill Mount has taken the technically less demanding option of the profile. Both artists make use of a bright light to highlight the face. The similarities show Merrill Mount to be a skilled copyist.

Born in New York, 1928. Studied at the Art Students League, New York. Lives in the United States.

Self-portrait, 1960. Charcoal on paper, diameter 30.
Signed: 'Charles Merrill Mount, Paris 1960' (obscured by mount).
Original Kneafsey Collection.

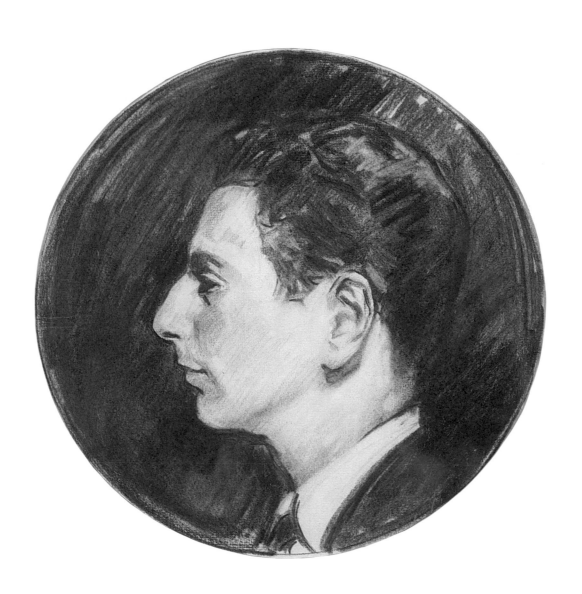

Michael Mulcahy

Michael Mulcahy studied sculpture in the early 1970s at the National College of Art in Dublin. In the late 1970s he practised performance art in the streets of Dublin and Düsseldorf. Between these periods, he lived and worked in northwest Africa. A more recent trip to Mali and time spent in Australia and Papua New Guinea have been the main inspiration for his painting since the early 1980s. In each place, he has become acquainted with the tribal lifestyles so dependent for survival on ancient traditions of myth and symbolism. In his paintings he brings together, in diagrammatic form, elements of his own experience and the rituals of tribal life. There are dark night-paintings, sometimes relieved by a glimmer of gold, and more recently, huge bright orange and yellow canvases suggesting the intense heat of the desert. Animal and plant life and more abstract linear markings fill these dynamic landscapes.

It would seem that Mulcahy has been indirectly painting his own image for many years. Lone male figures are depicted in profile against a Sahara landscape. A pair of floating heads, roughly delineated in black, confront one another in a large open space. This portrait may be seen as part of a recent series of mixed media drawings on paper. Mulcahy draws in much the same way as he paints, revealing his energetic and direct approach to his materials. He draws an angular head, repeatedly scoring the lines to give it strength and substance. The linear markings which float around the head are similar to those which animate the larger canvases.

Born in Cork, 1952. Studied at the Crawford School of Art, Cork and the National College of Art, Dublin. Member of Aosdána. Lives and works in Dublin.

Selected Exhibitions	1981 Gorey Arts Centre, Wexford
	1982 Lincoln Gallery, Dublin
	1983 Triskel Arts Centre, Cork
	1985 Taylor Galleries, Dublin
	1989 Douglas Hyde Gallery, Dublin
Collections	Arts Council/An Chomhairle Ealaíon, Dublin
	Butler Gallery, Kilkenny
	Hugh Lane Municipal Gallery of Modern Art, Dublin
	Trinity College, Dublin
	Ulster Museum, Belfast
Selected Bibliography	Henry Sharpe, 'Michael Mulcahy' in *Making Sense: Ten Painters 1963-1983*, Project Arts Centre, Dublin, 1983
	Dorothy Walker, *The Navigator*, catalogue introduction, Project Arts Centre, Dublin, 1983
	Noel Sheridan, *Fifth Biennale of Sydney – Private Symbol: Social Metaphor*, catalogue introduction, Art Gallery of New South Wales, 1984
	Dorothy Walker, 'From Alice Springs to Kanganaman', *Irish Arts Review*, vol. 2, no. 4, Winter, 1985
	Aidan Dunne, 'The Limits of Desire', catalogue essay, Douglas Hyde Gallery, Dublin , 1989

Self-Portrait, 1987. Mixed media on paper, 77 x 56.
Signed: 'Mick Mulcahy 87'.

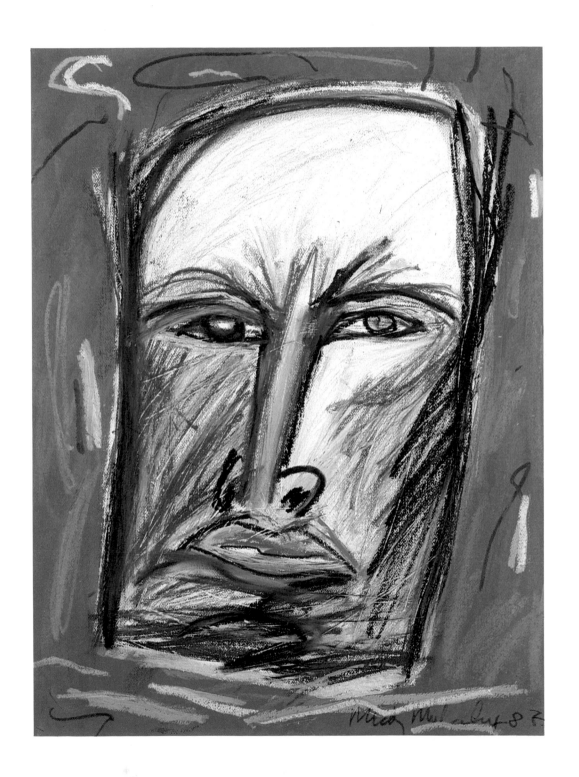

Brian Mulvany

Brian Mulvany studied fine art at the National College of Art in Dublin in the early 1960s and subsequently trained as a graphic designer. In the early years of his career he executed a number of portraits, including those of the signatories of the Proclamation of 1916 which hang in the foyer of the Abbey theatre in Dublin. He is particularly attracted to and influenced by the tradition of portraiture as exemplified by Seán Keating. Currently he works full-time as a graphic designer, specialising in commercial design and illustration.

His self-portrait, drawn in pencil, shows the artist at the age of twenty-five, soon after he began to design professionally. The lines used are simple and clear, the shading minimal. He depicts himself in the traditional three-quarter profile, looking away from the viewer.

Born in Dublin, 1943. Studied at the National College of Art and Design and the College of Commerce, Rathmines, Dublin. Lives and works in Dublin.

Collections Abbey Theatre, Dublin
 University of Limerick

Self-Portrait, 1968. Pencil on paper, 31 x 21.
Signed: 'Brian Mulvany 1968 (1)'.
Original Kneafsey Collection.

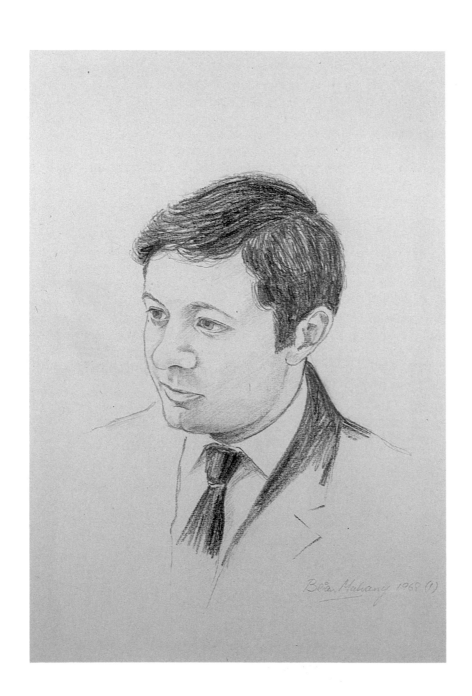

Béla Mahany 1968 (1)

Paul Nietsche

Paul Nietsche first came to Belfast in 1926 to visit Michael O'Brien, a lecturer at Queen's University. Both men had met some years before in Berlin. Between this time and 1934, when Nietsche settled in Belfast, he travelled throughout Europe, successfully exhibiting and selling his work. Back in Belfast, he built up a reputation as a skilful portrait painter. He worked slowly, taking up to fifteen or more sittings of one or two hours to complete each portrait. Landscapes, still lifes and flower studies comprise the rest of his subject-matter. His landscapes tend to be dark, his still lifes and flower paintings more colourful. His style is loose and his line assured. The emphasis on form, in the still lifes in particular, indicates the influence of Cézanne, whose work he saw and admired when living in Paris between 1912 and 1914.

Nietsche made many self-portraits throughout his life. This one is painted in gouache on board, a surface which he seemed to prefer to canvas. It is probably his last portrait, painted when he was sixty-two years old. Like the others, it has a direct, unassuming quality. Nietsche is more concerned to give an overall impression than a detailed view. The lively brushwork and use of black is typical of his painting style. As in his landscapes, colours are loosely mixed and predominantly earthy. The bluish-grey of the hair and the purple collar provide an arresting juxtaposition characteristic of Nietsche's late paintings.

Born in Kiev, USSR, 1885. Studied at the Imperial Art Academy, Odessa and the School of Fine Arts, Munich. Died in Belfast, 1950.

Selected Exhibitions	1934 Brook Street Art Galleries, London
	1939 John Magee's Gallery, Belfast
	1945 C.E.M.A. Gallery, Tyrone House, Belfast
	1952 Ulster Farmers' Union Hall, Belfast
	1984 *Paul Nietsche 1885-1950*, Arts Council of Northern Ireland Gallery, Belfast
Collections	Arts Council of Northern Ireland, Belfast
	Ulster Museum, Belfast
Selected Bibliography	Robin Bryans, *Ulster: A Journey Through the Six Counties*, Belfast, 1964
	John Hewitt, *Art in Ulster: 1*, Arts Council of Northern Ireland and Blackstaff Press, Belfast, 1977
	Brian Kennedy, *Paul Nietsche 1885-1950*, Arts Council of Northern Ireland Gallery, Belfast, 1984

Self-Portrait, 1947. Gouache on cardboard, 61 x 51.
Signed: 'Paul Nietsche 1947'.
Purchased from Hartley Fine Arts, London, 1983.

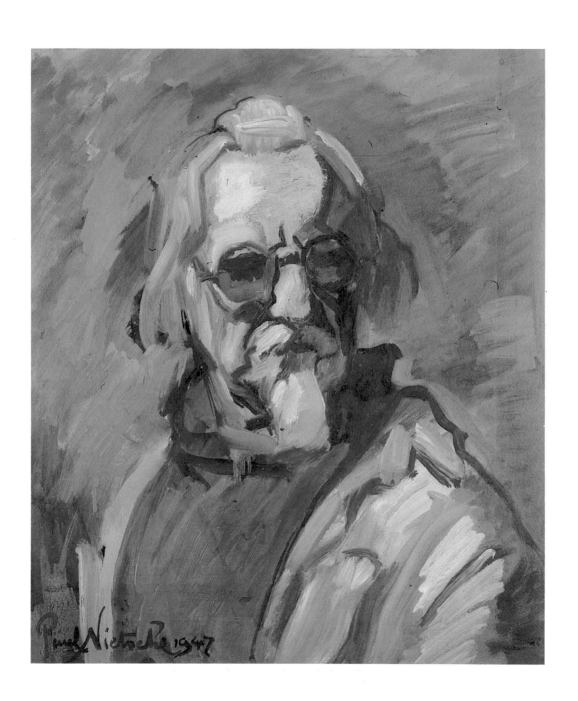

Tom Nisbet

Tom Nisbet is best known for his sunlit views of Dublin's streets and Grand Canal. His primary concern, both in his landscapes and townscapes, is to study and capture the way in which the light falls on the subject. Long shadows are cast by trees and buildings. His detailed compositions have a grainy quality, similar to the paintings of Russell Flint, whom Nisbet greatly admires. Nisbet heightens this effect in his landscapes in particular, where he exploits the rough texture of the paper.

A self-portrait was an unusual undertaking for Nisbet: 'In the normal course of events I would not dream of painting myself.' Here he paints in oil on board. He places himself, slightly off-centre, in front of two pictures, which are partially cut off from view. Behind his head and to the right hangs one of his own paintings, featuring a tall line of trees which casts shadows across the grass and path. To the left is a calendar, with a richly coloured illustration, which records the month and year in which the portrait was painted. Nisbet's roughly triangular form stabilises the composition. He faces straight out, fixing his gaze at a point above the viewer's line of vision.

Born in Belfast, 1909. Studied at the Metropolitan School of Art, Dublin. Member of the Royal Hibernian Academy. Lives and works in Dublin.

Selected Exhibitions Exhibited regularly at the Grafton Gallery, Dublin between 1944 and 1971 and continues to exhibit at the Royal Hibernian Academy.

Collections Butler Gallery, Kilkenny

Self-Portrait, 1981. Oil on board, 49 x 39.
Signed: 'Tom Nisbet'.

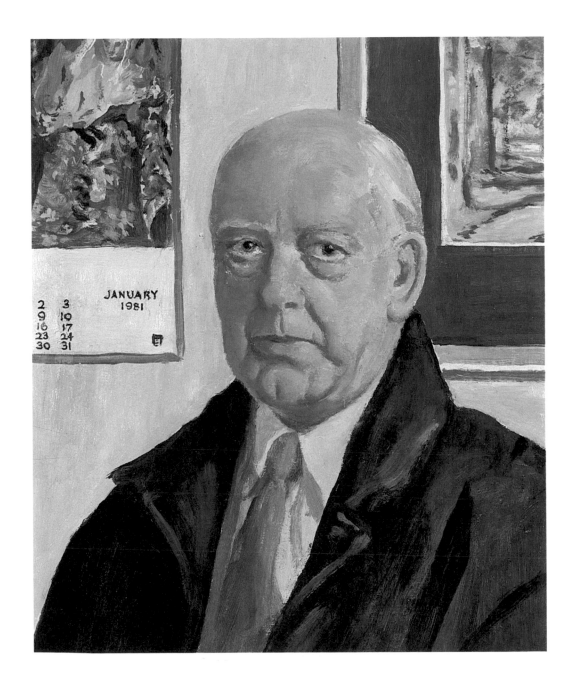

JANUARY
1981

2 3
9 10
16 17
23 24
30 31

James Nolan

James Nolan describes his chief concern in painting as the portrayal of 'idealised truth'.
For inspiration he looks to the art of classical Greece and to periods of antique revival. He
admires the respect which these epochs paid to what he calls 'the values' – a truthful and
harmonic relationship between the tones of a painting. Nolan also adheres to the classical
precepts of unity, proportion and the use of mythological themes. Landscape and
portraiture are his favoured subjects. He paints directly from nature; a dependence on
memory would, he feels belie any sense of truth. He regards portraiture as the most
challenging and the most difficult of genres.

Nolan is interested in the different ways in which a personality may be conveyed.
To explore this idea he has presented his own image in various character roles such as
artist, golfer and angler. With these self-portraits Nolan wishes to introduce himself to the
public 'by the skill of [his] hand rather than having recourse to a mechanical skill such as
photography'. Here he presents himself as artist-at-work. His paintbrush poised, he turns
and looks towards the viewer. In his right hand, he holds an outsize palette which, along
with the wide-brimmed hat, lends a flamboyant air to the painting. Nolan has adopted
what he considers to be the most difficult of artistic formulae: a dark figure, lit by a
northern light, placed against a light background. Although this is a relatively large work,
some day he would like to paint 'a really grand self-portrait' in the manner of Courbet's
Studio painting or Velazquez' *Las Meninas*.

Born in Dublin, 1938. Studied at the National College of Art, Dublin. Member of the Royal Hibernian
Academy. Lives and works in Dublin.

Selected Exhibitions 1980 *Irish Landscapes*, one-man exhibition, Robinson Gallery, Dublin
 1986 Joint exhibition with Brett McEntagart, James Gallery, Dalkey, Co Dublin
 Exhibits regularly at the Royal Hibernian Academy.

Collections Cincinnati Art Museum, Ohio
 Uffizi Gallery, Florence – Self-Portrait Collection

Self-Portrait, 1979. Oil on canvas, 91 x 81.
Signed: 'Nolan'.
One of two portraits by the artist in the Collection.

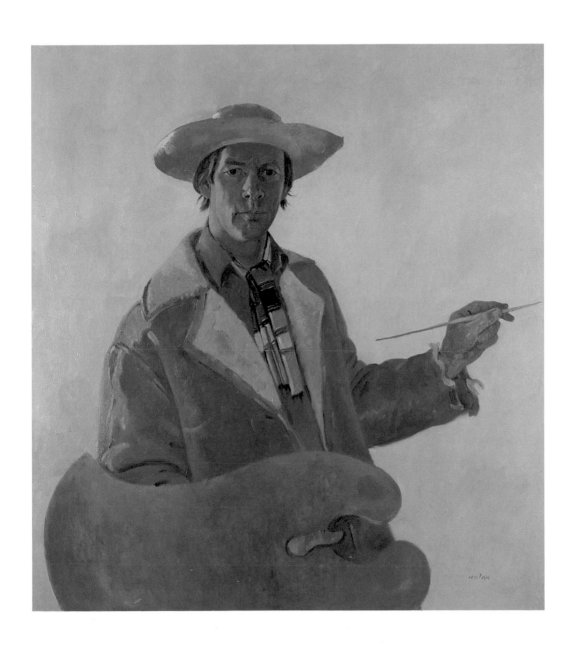

Eilís O'Connell

Eilís O'Connell is an abstract sculptor who makes large free-standing and smaller wall pieces in a wide range of materials. Inspiration for these sculptures comes from the art of prehistoric Ireland and from that of non-Western cultures. The columns of the late 1970s, in slate and stone, are like cubist totem poles; the curve and triangle have emerged subsequently. Colour and texture are vital to all of O'Connell's sculpture. She handpaints steel and, since the mid-1980s, has begun to incorporate fragments of feathers, slate and paper into bent steel compositions. This enables her to achieve her preferred combination of hard-edge steel and organic forms. She has further extended her use of materials in recent large curvilinear steel-framed structures covered with tautly stretched painted canvas.

O'Connell found it difficult to think about her self-portrait in an abstract way and so chose a very traditional mode of representation. Taking a mould of her own face, she has made a life-mask – as opposed to a death-mask – in bronze. The eyes are open, the eyelids scarcely modelled, the hollow eyeballs perfectly centred. It is unusual for O'Connell to work with such symmetry. The material is new for this artist but its surface handling seems familiar: the mottled patina is similar to the stippled painted surfaces of her steel sculpture.

Born in Derry, 1953. Studied at the Crawford School of Art, Cork and the Massachusetts College of Art, Boston. Lives and works in London.

Selected Exhibitions	1980 *Works on Paper*, group exhibition, Angela Flowers Gallery, London
	1981 David Hendriks Gallery, Dublin
	1984 *Rosc '84*, Guinness Hop Store, Dublin
	1985 *Four Artists from Ireland*, Arts Councils of Ireland touring exhibition and São Paolo Bienal, Brazil
	1986 *Steel Quarry*, Douglas Gallery, Dublin
Collections	Arts Council/An Chomhairle Ealaíon, Dublin
	Arts Council of Northern Ireland, Belfast
	Contemporary Irish Art Society, Dublin
	Derry City Council
	Institute of Chartered Accountants, Dublin
Selected Bibliography	Dorothy Walker, 'Portrait of the Artist as a Young Woman', *The Crane Bag*, vol. 4, no. 1, 1980
	Roderic Knowles, 'Eilís O'Connell: Steel, Marble, Slate', *Contemporary Irish Art*, Wolfhound Press, Dublin, 1982
	Rosemarie Mulcahy, 'Eilís O'Connell' in *Rosc '84*, Guinness Hop Store, Dublin
	Brian Ferran, 'Eilís O'Connell' in *Four Artists from Ireland*, the Arts Councils of Ireland, 1985
	Conor Joyce, *Steel Quarry: The Sculpture of Eilís O'Connell*, catalogue essay, Douglas Hyde Gallery, Dublin, 1986

Life-Mask, 1985-86. Bronze, height 20.
Unsigned.

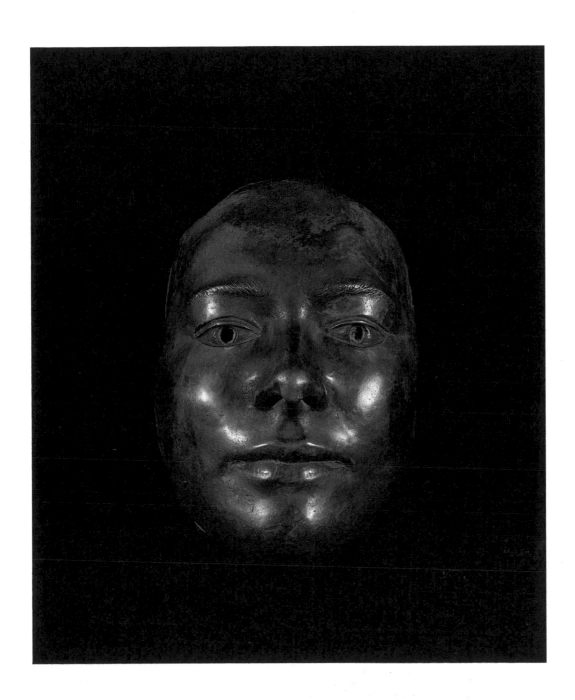

Catriona O'Connor

Watercolour is the medium with which Catriona O'Connor seems most at ease, working it in the fluid manner of her self-portrait. Her usual subject matter is landscape in which she wishes to 'reveal the latent colour', building up the semi-abstract forms with translucent layers of paint. She has worked in other media, including etching and batik. The emphasis is always on fluency of form and clarity of colour.

In her self-portrait, O'Connor appears to emerge out of one of her Burren landscapes. She is detached from the viewer, as she looks dreamily into the distance. The background colours, are applied in generous, fluid washes. A dark column of hatched lines to the right of the painting – suggesting the bark of a tree – seems very structured in comparison. It is a January day. A thin winter light highlights and models her face. A patch of blue sky hovers above her head. She depicts her features in detail, using fine, transparent washes. Below her face a single streak of bright pink against the blue, along with the golden yellow beside it, enlivens the colour scheme. The untouched white paper enhances the stark quality of the light. The sparsely painted area at the bottom of the portrait reveals the initial rough pencil sketch of her hands and torso.

Born in Killarney, 1945. Studied at the National College of Art, Dublin, the Accademia di Belli Arte, Florence and the Instituto Statale d'Arte, Urbino. Lives and works in Co Clare.

Selected Exhibitions	
	1967 *Colletiva Internazionale*, Palazzo Strozzi, Florence
	1967 Brown Thomas Gallery, Dublin
	1969 Galleria Casa Raffaello, Urbino
	1979 *Shinnors, O'Connor, Gemmell*, Cummins Gallery, Limerick
	1988 De Valera Library, Ennis Arts Festival, County Clare

Collections	
	Guinness Peat Aviation, Shannon
	University of Limerick

Self-Portrait, 1987. Watercolour, pencil and conté on paper, 51 x 40.
Signed: 'Catriona O'Connor'.

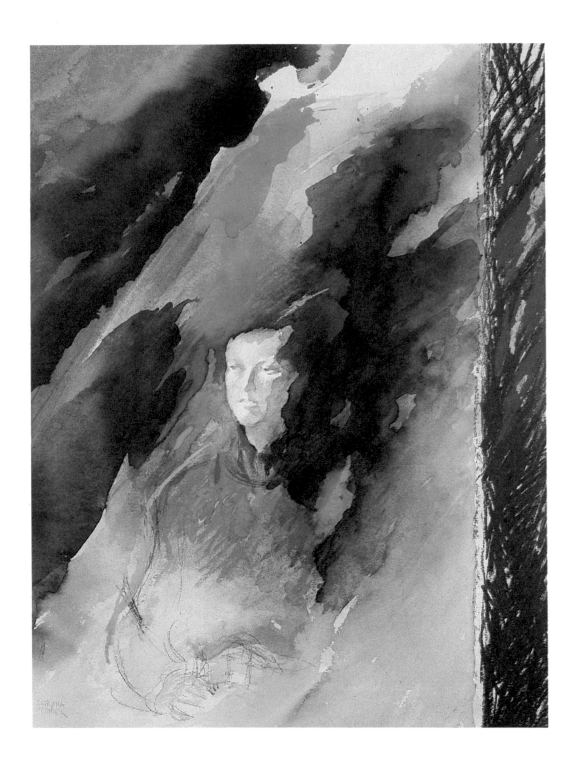

Jane O'Malley

Jane O'Malley paints mostly from her studio window in St Ives in Cornwall. The sea, which only sometimes appears in her work, acts as a backdrop to the simple abstracted shapes of the still lifes. A bowl of fruit or a vase of wild flowers take pride of place in a painting. She works mostly in oil on board, cutting into the hard surface with a knife. The lines, when painted over, become slightly raised, as in an intaglio print. Depth of form is achieved by the application of numerous thin glazes. She introduces a striking decorative element with the pattern of a tablecloth or a piece of pottery. Her paintwork is freer and her forms less defined in the brightly coloured acrylic canvases which she paints during the winter months spent in the Bahamas. In these she extends her subject-matter to the outdoor world of animals and plants.

O'Malley's self-portrait was painted near Callan in County Kilkenny, where she and her husband, Tony, spend their summers. Its date of completion can be seen on the vase. O'Malley, who is blonde and vibrant, has presented a rather gloomy image of herself, exaggerating the length of her nose and face. Her skin is grey, her expression sombre. She has surrounded herself with some flowers, a feather, some fish-hooks and flies – all objects which she associates with her life in Callan. The method of linear incision, the sensitive application of paint and a very definite strength of form can all be seen in this painting.

Born in Montreal, 1944. Self-taught artist. Lives and works between Cornwall, the Bahamas and Co Kilkenny.

Selected Exhibitions	1977 Newlyn Art Gallery, Newlyn
	1981 Taylor Galleries, Dublin
	1982 Salt House Gallery, St Ives
	1988 *Paintings and Drawings from the Bahamas, 1980-1987*, Penwith Gallery St Ives
	1989 Montpelier Studio, London
Collections	Allied Irish Investment Bank, Dublin
	Arts Council/An Chomhairle Ealaíon, Dublin
	Bank of Ireland, Dublin
	Municipal Gallery, Cuxhaven, Germany
Selected Bibliography	Patrick Hughes, preface to exhibition catalogue, Montpelier Studio, London, 1986
	Frances Ruane, *Allied Irish Bank Collection: Twentieth Century Irish Art*, Douglas Hyde Gallery, Dublin, 1986
	Aidan Dunne, 'Jane's plane in the frame', exhibition review, *Sunday Press*, April 19, 1987
	Bob Devereux, preface to exhibition catalogue, Salthouse Gallery, St Ives, 1988

Self-Portrait, 1988. Oil on board, 53 x 58.5.
Signed: 'Jane O'Malley 16.9.88'.

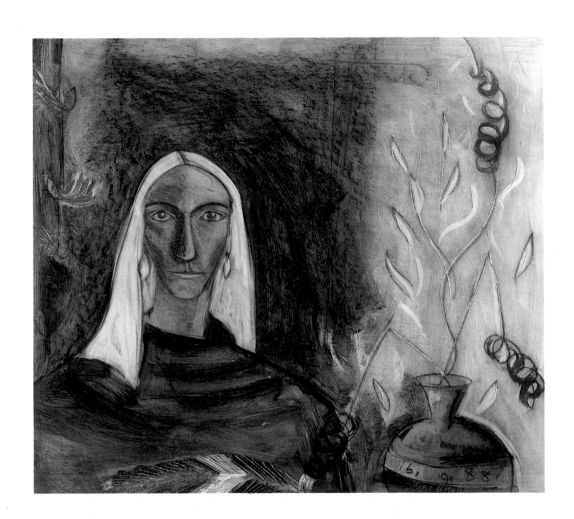

Tony O'Malley

Tony O'Malley completed his first oil painting at the age of thirty-two, while convalescing from an illness. Ten years later, he went on a painting holiday to St Ives in Cornwall where he settled in 1959. His early paintings are dark, brooding landscapes in which a lot of black is used. They feature the coasts of Cornwall and Clare Island, and the land and archaeological remains in and around his home town, Callan in Kilkenny. Natural forms are abstracted and flattened. Sometimes he divides his composition into roughly defined squares, like a window, which may contain the pattern of a field or a bird's wing. Since 1976 he has spent his winters in the Bahamas. The resulting canvases, brightly coloured and fluidly painted, are filled with fragments of the islands' exotic flora and fauna.

Self-portraiture has been, for O'Malley, an ongoing concern and point of reference. His portraits are, for the most part, small, dark and inward-looking. Here a lighter, more optimistic mood prevails largely due to the use of the warm, bright palette and the foliage patterns reminiscent of his Bahamian paintings. In fact the portrait was painted in his summer home near Callan. The colours which he uses to describe his figure are still relatively sombre, the lines characteristically simple. His eyes, darkened from view on many other occasions, are indicated here in a rich blue. O'Malley allows the roughly cut canvas to show through in parts, in much the same way as in other works he exposes the layers of underpainting by scraping back the surface with a fine point.

Born in Callan, Co Kilkenny, 1913. Self-taught artist. Honorary member of the Royal Hibernian Academy. Member of Aosdána. Lives and works between Cornwall, the Bahamas and Co Kilkenny.

Selected Exhibitions	1961 Sail Loft Gallery, St Ives 1984 *Painter in Exile*, retrospective exhibition jointly organised by the Arts Councils of Ireland, Ulster Museum, Belfast; Douglas Hyde Gallery, Dublin; Crawford Municipal Art Gallery, Cork 1986 Taylor Galleries, Dublin 1988 *Rosc '88*, Guinness Hop Store, Dublin 1989 *Island and Ocean*, Royal Hospital Kilmainham, Dublin, (first shown at Newlyn Art Gallery, Cornwall, 1986)
Collections	Arts Council/An Chomhairle Ealaíon, Dublin Butler Art Gallery, Kilkenny Guinness Peat Aviation, Shannon Irish Contemporary Art Society, Dublin Ulster Museum, Belfast
Selected Bibliography	Patrick Heron, catalogue introduction, Arts Council of Northern Ireland Gallery, Belfast, 1975 Brian Fallon, 'Tony O 'Malley', in *Six Artists from Ireland: An Aspect of Irish Painting*, Department of Foreign Affairs, Dublin, 1983 Brian Fallon, *Tony O'Malley: Painter in Exile*, Arts Council/An Chomhairle Ealaíon, Dublin, 1984 Brian Fallon, John Halkes, Patrick Heron, catalogue essays, *Island and Ocean: Recent paintings from the Bahamas*, Newlyn Orion, Cornwall, 1986 Muiris MacConghaile, *Places Apart*, documentary film, RTE, 1982

Self-Portrait, 1979. Oil on canvas, 28 x 30.5.
Signed: '8/79 O M'.

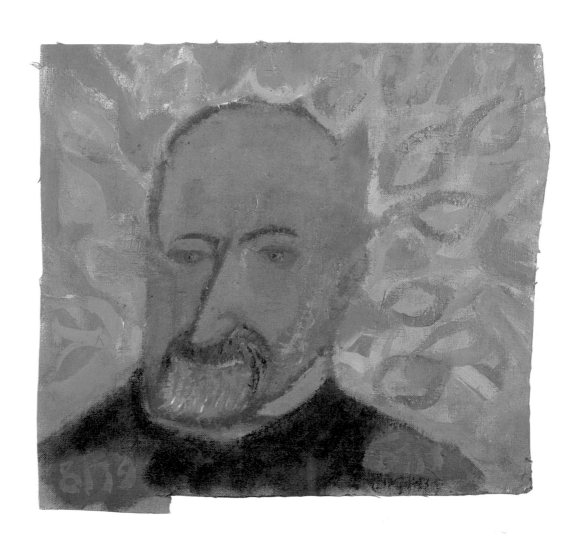

Domhnall O Murchadha

Domhnall O Murchadha has continued the tradition of monumental and bust sculpture which he studied in Cork under Marshall Hutson and Laurence Campbell. He works in a variety of materials including stone, wood, bronze, terracotta and resin. Most of his work consists of religious or civic commissions, for which he finds inspiration in the strong and simplified forms of the art of early Christian Ireland. The abstract formal values of sculpture are, for him, the most important and he firmly believes that these must not be sacrificed to excessive subjectivity.

O Murchadha believes that 'self-portraiture might not be a suitable subject for sculpture, or indeed for painting'. The problem, he feels, lies with the striving for the lifelike image, which so often results in the neglect of the overall design. In his own portrait, the artist has managed to portray a strong physical resemblance, while still giving priority to the design of the whole piece. His head emerges from the roughly hewn block, suggesting both the particular process of stone carving and the broader experience of personal discovery through art. The portrait was carved directly, without any preliminary models; hence the immediacy of the image. The marks of the chisel are clearly visible. A single indented line gives depth to the corner of the eye and of the mouth. With such simple means O Murchadha attains a consistent integrity of form and feeling.

Born in Cork, 1914. Studied at the Crawford School of Art, Cork. Associate of the Royal Hibernian Academy. Lives and works in Dublin.

Selected Exhibitions	Exhibits at the Royal Hibernian Academy
Collections and Commissions	Collège des Irlandais, Paris Crawford Municipal Art Gallery, Cork Independent House, Dublin National Gallery of Ireland, Dublin Our Lady of Knock, Co Mayo

Self-Portrait, 1985. Oolitic limestone, height 50.
Signed: 'd. o. murcada'.

Daniel O'Neill

Like many self-taught artists, Daniel O'Neill had a truly original approach to painting. There is a dreamlike – almost surreal – quality to many of his images which include landscapes, still lifes and figure studies in interiors. The colours are sombre and the surfaces heavily worked. Featured throughout his paintings are tall black-haired women who, with their Spanish looks and low-cut dresses, are like modern-day versions of Goya's *majas*, their expressions often darkened from view.

O'Neill frequently used his own image in his paintings. He appears as a lone figure in a vast infertile landscape or amongst a group of people, wearing the red waistcoat and full-sleeved shirt of this portrait. Here he presents himself in his studio, surrounded by various objects. The skull is an obvious reminder of the transience of existence. The torso may be one of his own works, or simply a cast to which he referred. On the easel is a painting of one of the familiar dark-haired women. In his hand he holds a palette and paintbrushes. His almond-shaped eyes – like those of the figures in the painting and sculpture – are crudely blacked out. All of the heads – including the skull – have similarly elongated shapes. The impastoed red is a favourite with O'Neill, as is the tenebrist interpretation of light, which here creates a mysterious atmosphere.

Born in Belfast, 1920. Attended classes at Belfast College of Art and worked for a short time in the studio of Sidney Smith in Belfast. Died in Belfast, 1974

Selected Exhibitions	1946 Victor Waddington Galleries, Dublin
	1952 *Retrospective Loan Exhibition*, Belfast Museum and Art Gallery
	1954 Joint exhibition with Colin Middleton, Tooth Galleries, London
	1963 Dawson Gallery, Dublin
	1970 McClelland Galleries, Belfast
Collections	Arts Council/An Chomhairle Ealaíon, Dublin
	Arts Council of Northern Ireland, Belfast
	Crawford Municipal Art Gallery, Cork
	Hugh Lane Municipal Gallery of Modern Art, Dublin
	Ulster Museum, Belfast
Selected Bibliography	Kenneth Jamison, 'Painting and Sculpture' in *Causeway: The Arts in Ulster*, ed. Michael Longley, Arts Council of Northern Ireland and Gill and Macmillan, 1971
	Hilary Pyle, 'Daniel O'Neill' in *Irish Art 1900-1950*, published in association with Rosc Teoranta, Crawford Municipal Art Gallery, Cork, 1975
	John Hewitt, *Art in Ulster: 1*, Arts Council of Northern Ireland and Blackstaff Press, 1977
	Frances Ruane, *The Allied Irish Bank Collection: Twentieth Century Irish Art*, Douglas Hyde Gallery, Dublin, 1986

Self-Portrait. Oil on canvas, 61 x 51.
Signed: 'Dan O'Neill'.
Purchased from Tulfarris Art Gallery, Blessington, 1982.

Paul O'Reilly

Paul O'Reilly's primary artistic concern is with colour. He explores its various properties using charcoal, conté and paint. Due to his slow working method and the night-time conditions under which he usually paints, his subjects tend to be still life objects: pieces of food or fruit, domestic implements and vessels. A bright, artificial light intensifies the colours which in the paintings are described by broad, individual patches and in the drawings by short, hatched lines. His basic approach to painting and drawing may be understood by studying his self-portrait.

By making a double self-portrait, O'Reilly offers a comparison between the two ways in which he employs colour. In the conté drawing he limits its use to tonal contrasts. Here colour plays a secondary role to line which dictates the forms and textures of the image. Local colour tends to be generalized, as is any mood or emotion which may be evoked by its use. In the smaller oil study, he studies 'the complexities of how colour behaves'. This involves paying attention to its hue, tone, intensity and temperature. Using colour in this way, he can respond to his subject-matter in a more direct and emotional manner. Looking at the two portraits, the viewer can perceive a greater intensity of feeling in the painting than in the drawing. O'Reilly's insertion of the painting into the heart area of the larger figure seems an appropriate way to indicate his preferred use of colour.

Born in New York, 1934. Studied at Syracuse University, New York, the Arts Students League, New York and the University of the Americas, Mexico. Lives and works in Co Tipperary.

Selected Exhibitions 1987 All + Ten Sorts, Mid-West Arts touring exhibition
1989 *Forty Foot of Art*, All + Ten Sorts touring exhibition, Triskel Arts Centre, Cork and Temple Bar Gallery, Dublin

Collections Limerick Contemporary Art

Self-Portrait, 1988. Conté on paper and oil on paper, 69 x 50.
Signed with monogram, '88.

Dennis H. Osborne

Over the years Dennis Osborne has experimented with various painting styles, but always with an emphasis on reality. In this, he has looked to and learned from the work of other twentieth-century artists, including his teachers Victor Pasmore and William Coldstream. He paints landscapes and portraits in oils and watercolours. The salient feature of his work is his use of colour as a means of constructing form.

Osborne's self-portrait clearly reveals his debt to Cézanne, whose use of colour he finds particularly appropriate when painting the flesh. By juxtaposing individual patches of colour, including the complementary greens and reds, he models the form and explores the underlying structure of the face. The background hue is reiterated throughout, thereby harmonizing the colour scheme of the whole painting. According to Osborne, 'self-portraits have always been with me as a stimulus, or acting as purgative when I am not at peace with my work'. He is conscious of 'a mystical illusion that exists when looking at a mirror image' and wishes to convey this in the portrait. He focuses his attention on his own image, thus intensifying the relationship between painter and subject.

Born in Portsmouth, 1919. Studied at Camberwell School of Art and Crafts, London. Associate of the Royal Ulster Academy. Lives and works in Co Down.

Selected Exhibitions	1959 *Ontario Society of Watercolours*, annual exhibition, Toronto Gallery
	1959 *Twentieth Biennial International Watercolour Exhibition*, Brooklyn Museum, New York
	1962 *Open Painting Exhibition*, Ulster Museum, Belfast
	1962 C.E.M.A. Gallery, Belfast
	1988 Ards Art Centre, Newtownards, Co Down.

Collections	Art Gallery of Hamilton, Canada
	Arts Council of Northern Ireland, Belfast
	Department of the Environment for Northern Ireland
	Lisburn Museum, County Antrim
	National Trust, Northern Ireland

Self-Portrait, 1970. Oil on board, 45 x 34.
Signed: 'D. H. Osborne 70'.
Original Kneafsey Collection.

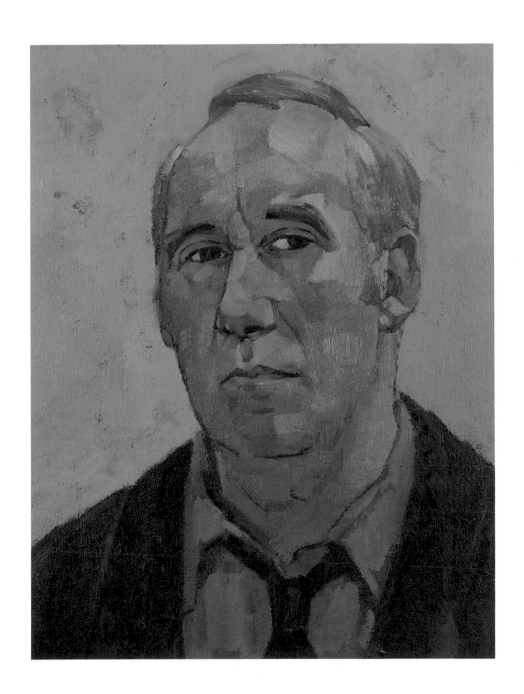

Patrick O'Sullivan

Patrick O'Sullivan trained initially as a modeller in the classical tradition. On leaving art school, he developed these skills, carrying out portrait commissions in London. Since his move to Ireland in 1970, he has been working in marble, both on large-scale public commissions and smaller domestic pieces. He carves organic – sometimes interlocking – irregular forms with curvilinear silhouettes. The influence of Brancusi is evident in his use of hollow shapes and that of classical Greece in the fragments of fluted columns and volutes which he incorporates into his abstract compositions. The marble used is mainly Carrara or Connemara, the latter being particularly attractive for its naturally occurring mottled pattern. Sometimes he combines wood and stone in the same piece.

O'Sullivan has drawn upon his initial training in making his self-portrait. The head is roughly modelled in bronze and darkly patinated. The additive process of modelling lends a vitality – an almost nervous energy – to the piece. His brow is furrowed and his eyes alert and focused. The texture of the beard enhances the physical likeness. This portrait provides a complete contrast to the smooth, white forms of the marble pieces. With it, O'Sullivan reminds the viewer of his ability to work with equal success in modelling as he has shown in carving.

Born in London, 1940. Studied at Carlisle College of Art and the Royal Academy School, London. Member of Aosdána.

Selected Exhibitions	1964 County Gallery, Lewes, Sussex, England
	1978 Oliver Dowling Gallery, Dublin
	1979 Triskel Arts Centre, Cork
	1980 Octagon Gallery, Belfast
	1984 Taylor Galleries, Dublin
Collections and Commissions	Arts Council/An Chomhairle Ealaíon, Dublin
	Crawford Municipal Art Gallery, Cork
	Fitzgerald Sculpture Park, Cork
	Guinness Peat Aviation, Stamford, Connecticut, USA
	University College, Dublin
Selected Bibliography	Desmond MacAvock, 'Sculptor in the Classical Tradition', *Irish Times*, September 26, 1984
	Frances Ruane, *The Allied Irish Bank Collection: Twentieth Century Irish Art*, Douglas Hyde Gallery, Dublin, 1986.

Self-Portrait, 1985. Bronze, height 28.5.
Unsigned.

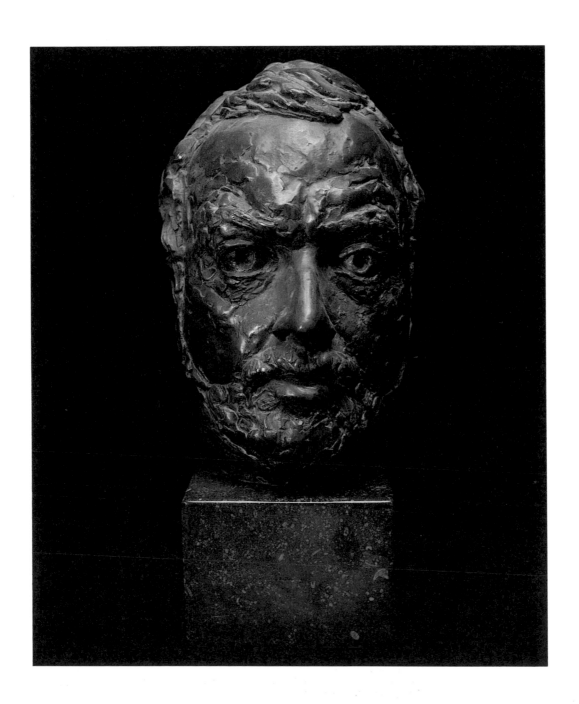

Jack Pakenham

Jack Pakenham's painting has always been concerned with human suffering and alienation. Since 1975, he has responded specifically to the violence in Northern Ireland. His bleak images of contemporary Belfast contain metaphors and symbols which he hopes 'will first of all surprise the eye, then work directly on the nervous system and eventually ignite a cerebral response through association of experience'.

In his self-portrait he places himself in the graffitied surroundings which provide the backdrop to most of his paintings. The empty streets swirl in a nightmarish fashion. The houses seem derelict. The ventriloquist's doll, partially cut off from view and perched on a box labelled 'FRAGILE', is one of Pakenham's most evocative and potent images. For the artist it symbolises many things: the victim of war, 'the ultimate manipulated little man whose words are only what someone else gives him ... the innocent who faces his torturers, grinning in the vain hope that all is some kind of game'; the masked terrorist whom the artist has never seen, 'the face of the girl who planted the bomb in the Abercorn Restaurant ... the face of the boy who shot a policeman helping children across the road'. Staring directly out from the painting, Pakenham wishes to express the hopelessness of his role as social conscience in an environment 'where hypocritical and bigoted forces prevail'.

Born in Dublin, 1938. Self-taught artist. Member of the Royal Ulster Academy. Lives and works in Belfast.

Selected Exhibitions	1968 Bell Gallery, Belfast
	1872 Tom Caldwell Gallery, Belfast
	1984 *Encounters*, Octagon Gallery, Belfast
	1984 *Italian Journey Images*, Fenderesky Gallery, Belfast
	1987 David Hendriks Gallery, Dublin
Collections	Arts Council/An Chomhairle Ealaíon, Dublin
	Arts Council of Northern Ireland, Belfast
	Newtownabbey Borough Council
Selected Bibliography	Mike Catto, *Art in Ulster: 2*, Arts Council of Northern Ireland and Blackstaff Press, Belfast, 1977
	Jack Pakenham, 'The Doll as Victim and Terrorist' in *Contemporary Irish Art*, ed. Roderic Knowles, Wolfhound Press, Dublin, 1982

Self-Portrait, 1987. Acrylic on board, 60.5 x 60.5.
Signed: 'Pakenham'.

Eric Patton

Eric Patton alternates between his loosely painted landscapes, in which pattern predominates, and a more precise, academic style which he adopts in his architectural compositions. In paintings which date from the 1950s and 1960s, forms are abstracted and bright colours predominate. Heightened colour continues to be a vital element in the more realistic landscapes of recent years, inspired by his travels in the United States, Spain, Iceland, Scotland, England and Ireland. His commissioned work consists largely of topographical views. These include a folio of prints of Georgian Dublin and a series of paintings and drawings of the city of Jeddah in Saudi Arabia.

Patton has made a few self-portraits over the years but does not consider them to be an important part of his artistic output. He saw in this project an opportunity to make a precise drawing in pen and ink, a medium which he has used successfully in his architectural studies. Here one can observe the range of effects which he achieves through a skilful and varied use of line. His face is brightly lit from one side. The shadow is indicated by a dense cross-hatching. The tinted paper and highlights of white wash give further depth to the head. Here his preference for simplified shapes and shadows is revealed. The artist looks sideways, as if at a mirror, which distances him slightly from the viewer.

Born in Dundalk, 1925. Self-taught artist. Member of the Royal Hibernian Academy. Lives and works in Dublin.

Selected Exhibitions
1948 Grafton Gallery, Dublin
1961 Ritchie Hendriks Gallery, Dublin
1965 Bell Gallery, Belfast
1972 Tom Caldwell Gallery, Belfast
1981 Gallery 22, Dublin
Exhibits regularly at the Royal Hibernian Academy.

Collections
Waterford Municipal Art Collection, Garter Lane Arts Centre

Self-Portrait, 1983. Ink, wash and conté on paper, 32 x 24.
Signed: 'Eric Patton 1983'.

Self portrait. Eric Patton, 1983

Raymond Piper

Raymond Piper began his artistic career making drawings of old Irish buildings and archaeological sites. Many of these were used to illustrate Richard Hayward's books, *Ulster and the City of Belfast* and *Munster and the City of Cork*. During the past two decades he has been studying and making precise botanical illustrations – in pencil and watercolour – of orchids throughout the British Isles. He has re-examined existing theories of their origins and survival and discovered new species. However, Piper regards portraiture as his 'main art form', which allows him, financially, to pursue his other interests. Amongst his commissions are portraits of various Lord Mayors of Belfast, which hang in the City Hall. He believes that 'portraits are best painted in an impressionistic manner with bold strokes, unless Holbein could be followed!'

Piper would have preferred to paint his self-portrait, but time did not allow. Nevertheless, it is appropriate, in the light of his long-established reputation as a draughtsman, that he should represent himself in a conté drawing. Here he makes effective use of a simple hatched technique, describing in monochrome the areas of light and shade. Piper comments on this portrait: 'I am not attempting to express anything in particular artistically here – just a reproduction of my features as those of an ageing man.' Like many others in this collection, Piper was surprised by what he discovered in making a self-portrait: 'It was simply an observation of a face I know well, but had never realised what it really contained until I had drawn it.'

Born in London, 1923. Self-taught artist. Member of the Royal Ulster Academy. Lives and works in Belfast.

Selected Exhibitions	1953 C.E.M.A. Gallery, Belfast
	1962 Queen's University, Belfast
	1969 Kenny Gallery, Galway
	1975 Ulster Museum, Belfast
	1989 Arts Council of Northern Ireland Gallery, Belfast
	Exhibits regularly at the Royal Ulster Academy.
Collections	Armagh County Museum, Armagh
	City Hall, Belfast
	Ulster Museum, Belfast
Selected Bibliography	John Hewitt, *Art in Ulster: 1*, Arts Council of Northern Ireland and Blackstaff Press, Belfast, 1977

Self-Portrait, 1987. Conté on paper, 50 x 32.
Signed: 'Raymond Piper 1987'.

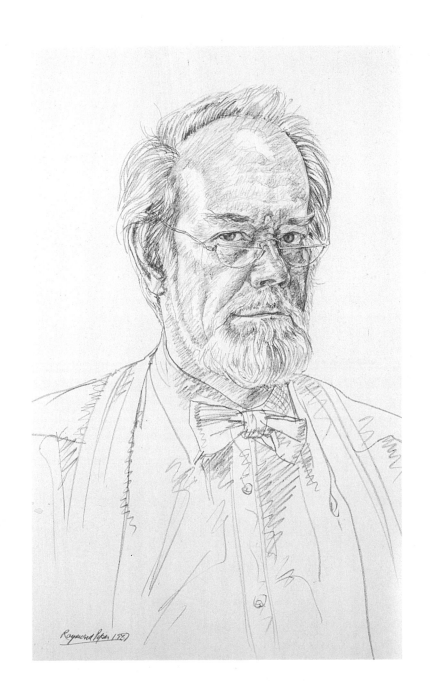

Raymond Piper 1987

Mary Farl Powers

In the early 1980s Mary Farl Powers moved away from her etchings of abstract, rounded forms to use paper in a new and innovative way. She began to tear, fold, overlap and paint upon embossed sheets of paper, creating relief forms and free-standing sculptural pieces. Her self-portrait, her only portrait to date, is based upon this new way of working. In its representation it is a significant departure from her normally abstract work, while reflecting many of its concerns.

One of Farl Powers' main themes is the interplay of order and chaos from which all life and art emerges. In both her etchings and her works in cast paper she explores these elements by using a strict symmetry on the one hand and a loose calligraphic marking on the other. In her self-portrait she wished to emphasize the facial symmetry by portraying her face from the front, adding a second mouth to strengthen this effect: 'The main head is upside-down because it looks better that way.' The symmetrical wings of torn paper are those of a moth. This insect, which has been a central image in her work, is a personal symbol of both fear and fascination. The dog, which she has placed below this, represents for the artist 'comfort, reassurance and ordinariness'. Typically, she has left large areas of the paper uncovered so that the independent forms float on the picture's surface and yet seem comfortably stable. The underlying principles of order and (seeming) disorder prevail. Here she contrasts the detailed delineation of her facial features with the roughly torn outlines of the principal forms. She allows the colours to bleed beyond their defined areas, resulting in what she describes as 'an unexpectedly garish look'. As is often the case, a new and exciting element emerges almost accidentally.

Born in Minnesota, USA, 1948. Studied at Dun Laoghaire School of Art, Minnesota State University and the National College of Art, Dublin. Member of Aosdána. Lives and works in Dublin.

Selected Exhibitions
1972 Peacock Theatre Gallery, Dublin
1977 Godolphin Gallery, Dublin.
1981 Tom Caldwell Gallery, Belfast
1984 Taylor Galleries, Dublin
1987 Fenderesky Gallery, Belfast

Collections
Arts Council/An Chomhairle Ealaíon, Dublin
Contemporary Irish Art Society, Dublin
Hugh Lane Municipal Gallery of Modern Art, Dublin
Ulster Museum, Belfast
University College, Dublin

Selected Bibliography
Dorothy Walker, 'Irish Women Artists, 1960-1975' in *Irish Women Artists from the Eighteenth Century to the Present Day*, the National Gallery of Ireland and the Douglas Hyde Gallery, 1987

Self-Portrait, 1985. Watercolour on paper, 54.5 x 51.
Signed: 'Mary Farl Powers' (on reverse).

Patrick Pye

Patrick Pye readily acknowledges his admiration for artists from different ages and disciplines. As a schoolboy, he liked the poetry of T.S. Eliot for its honesty in dealing with contemporary concerns, particularly those of a spiritual nature. Pye has sought the spiritual quality in his own art since he first began to work in stained glass in the mid-1950s. Although landscape and still life have been constant reference points, he has devoted himself almost exclusively to the sacred theme. Pye's main patron is the Catholic Church. His large panels in tempera tell biblical tales in a humble and humane manner. For inspiration he looks to the work of the early Italian Primitives, echoes of whose simple forms and large areas of pure colour are to be found in his own work.

Pye's self-portrait is surprisingly small. He sees it as 'a rather weak compliment to El Greco', whose work he particularly respects for its mysticism. Pye's head, slightly elongated and lowered, evokes the countenance of many of El Greco's saints. The mood of the portrait is calm and contemplative. He paints himself in a blue light, indicated by pale blue brushstrokes which surround his head and highlight his face. The small, luminous gem-like shape below his beard is simply 'a formal device'. The thinned oil colours are those of his tempera paintings. The slightly subdued tones and cropped composition are reminiscent of the Nabis – Vuillard and Bonnard, for example – whose work Pye has always admired.

Born in Winchester, England, 1929. Studied at the National College of Art, Dublin and the Jan van Eyck Akademie, Maastricht. Member of Aosdána. Lives and works in Co Dublin.

Selected Exhibitions	1963 Ritchie Hendriks Gallery, Dublin
	1970 David Hendriks Gallery, Dublin
	1980 *Irish Art 1943-1973*, in association with Rosc Teoranta, Crawford Municipal Art Gallery, Cork
	1980 Gallery 22, Dublin
	1983 Tulfarris Gallery, Blessington, County Wicklow
Collections and	Crawford Municipal Art Gallery, Cork
	Fossa Chapel, Killarney, County Kerry
	Hugh Lane Municipal Gallery of Modern Art, Dublin
	Loughrea Cathedral, County Galway
	St Michael's Church, Dun Laoghaire, County Dublin
Selected Bibliography	Richard Weber, 'Patrick Pye', *Forgnán*, May 1962
	Kate Robinson, 'In this Land of Unbelief', *Hibernia*, October 16, 1980
	Cyril Barrett S.J., 'Patrick Pye' in *Irish Art 1943-1973*, published in association with Rosc Teoranta, Crawford Municipal Art Gallery, Cork, 1980
	Patrick Pye, *Apples and Angels*, Veritas, Dublin, 1980
	Hilary Pyle, 'Patrick Pye: Woman and Serpent, an Evangelist's View' in *Contemporary Irish Art*, ed. Roderic Knowles, Wolfhound Press, Dublin, 1982

Self-Portrait, 1982. Oil on board, 20 x 18.
Signed : 'Pye'.

Thomas Ryan

Thomas Ryan studied and continues to paint in the academic tradition. He believes that the essential skills of a painter must include 'competence in drawing, a painterly ability with regard for tonal values and compositional harmony and balance'. Focusing on these elements, Ryan has, in his considerable output, covered a wide range of subject matter. Portraiture and landscape have been the dominant genres. He also paints still lifes, interiors, animals and flower arrangements. In the tradition of eighteenth- and nineteenth-century Europe, he has executed large-scale historical and commemorative works such as *The Flight of the Earls* and *GPO – 1916*.

Ryan has turned to self-portraiture occasionally 'as an exercise in private inspection'. This portrait, which shows the artist in three-quarter view, is unusually small. Yet the way in which his figure fills the space lends it a grandeur. It is a good example of the manner in which he sometimes infuses the image with a hazy soft-focus. The same effect has been achieved in a recent series of cityscapes, in which the scene is enveloped by a thin violet mist. In this portrait the artist, characteristically, applies his paint quite thinly in parts, revealing the darker layers beneath. With directional brushstrokes he models the form and introduces a gentle gradation of tones. The earth colours of this portrait are a particular favourite with Ryan as is the use of *chiaroscuro*, here relatively subdued.

Born in Limerick, 1929. Studied at the Limerick School of Art and the National College of Art and Design, Dublin. President of the Royal Hibernian Academy. Lives and works in Co Meath.

Selected Exhibitions
1957 Ritchie Hendriks Gallery, Dublin
1967 McLelland Gallery, Belfast
1976 Emmet Gallery, Dublin
1983 Cork Arts Society Gallery, Cork.
1987 Solomon Gallery, Dublin.
Exhibits regularly at the Royal Hibernian Academy.

Collections
Crawford Municipal Art Gallery, Cork
National Gallery of Ireland, Dublin
University of Limerick

Self-Portrait, 1984. Oil on board, 20 x 15.
Signed: 'Thomas Ryan'.
One of two portraits by the artist in the Collection; other painting part of the original Kneafsey Collection.

Una Sealy

Una Sealy is almost exclusively a portrait painter. She likes to paint her sitters in the context of their living or working environments, so that she can convey a truer sense of character. Although she is interested in 'giving a good likeness', she never paints from photographs: 'For the sitter, the portrait still offers more satisfaction than a photograph, perhaps because there is a greater sense of communication between artist and sitter.' In her brightly painted acrylic canvases, individuals and couples sit firmly on simple steel chairs, staring solemnly at the viewer. A bicycle, a plant or a kitchen cupboard are carefully arranged to lead the eye around a complex composition. Similarly, the pattern of an object or a piece of fabric becomes an important compositional device.

Sealy has approached her own portrait in much the same way as she would any other commission. She places herself in her living-room, surrounded by various personal belongings, including a painting and a piece of sculpture. Typically, the scene is viewed from a slightly distorted angle. Here it is as if the artist has used a wide-angle lens or a slightly concave mirror, which would allow her to include more of the room than the human eye sees normally. The use of a mirror is clearly evidenced by the inverted writing on the vacuum cleaner. The space embraces her figure which occupies the centre of the composition. The striped pattern of her jumper the snake-like hose of the vacuum cleaner and the slightly exaggerated kinked leaves of the plants are not merely compositional devices, but represent for the artist 'an openness to the surroundings'. The paintwork is lively and expressive. Brushstrokes move in all directions. Light colours are painted over dark. The striped flesh tones of her face are particularly vibrant. Sealy sits straight backed, her hands placed firmly on her thighs, and regards the viewer with assurance.

Born in Dublin, 1959. Studied at Dun Laoghaire School of Art and Design, Dublin. Lives and works in Co Dublin.

Selected Exhibitions 1980 *Exposure 1*, Bank of Ireland, Dublin
1981 *Exposure 2*, ILAC Centre, Dublin
1985, '86 and '87 *Arnotts Annual Portrait Awards Exhibition*, Dublin

Self-Portrait, 1987. Acrylic on calico, 92 x 92.
Signed: 'Una Sealy' (on reverse).

Noel Sheridan

Noel Sheridan began his working life as an actor and a dancer. In the late 1960s, he combined these skills with sculpture and film sequences in the making of performance art. Both before and since this time he has painted figurative compositions and landscapes. Abstract Expressionism had a strong influence on the paintings which he executed in the late 1950s and has reasserted itself in the brightly coloured west of Ireland landscapes of the late 1980s. The latter relate directly to the emotional content of J.M. Synge's drama, The *Playboy of the Western World*. Sheridan has always questioned the validity of a single viewpoint or image. In a series of paintings from the late 1960s, he presented multiple views of a chair. In a similar manner, *Everyone Should Get Stones* – a published performance work from the early 1970s – focused on different ways in which a stone might be perceived.

His conviction that there can be no definitive representation of reality was reaffirmed by the task of painting a self-portrait. He admits that he would have felt happier in presenting a series of self-studies. In this portrait he depicts himself with the unfocused stare of someone distracted by his thoughts. Unlike many of the landscapes, which are painted in a rich impasto, his portrait consists of thin layers of dry, scumbled paint. The face, built up with small patches of – sometimes complementary – colour, variously absorbs and reflects the light. The predominant greens unify the composition. Sheridan regards this first self-portrait as he does all his paintings: 'an idea in progress, to be developed and improved upon in time'.

Born in Dublin, 1936. Self-taught artist. Member of Aosdána. Lives and works in Dublin.

Selected Exhibitions	1961 Dawson Gallery, Dublin
	1965 Milch Gallery, New York
	1971 Central Street Gallery, Sydney
	1975 State Gallery, Adelaide
	1988 *Playboy Images*, Taylor Galleries, Dublin
Collections	Allied Irish Bank, Dublin
	Hugh Lane Municipal Gallery of Modern Art, Dublin
	Limerick City Gallery of Art
Selected Bibliography	Noel Sheridan, 'Everybody Should Get Stones' in *Contemporary Irish Art*, ed. Roderic Knowles, Wolfhound Press, Dublin, 1982
	Frances Ruane, *The Allied Irish Bank Collection: Twentieth Century Irish Art*, Douglas Hyde Gallery, Dublin, 1986
	Aidan Dunne, 'Tentative Approaches', exhibition review, *Sunday Tribune*, April 10, 1988

Self-Portrait, 1988. Oil on canvas, 61.5 x 51.
Signed: 'N. Sheridan'.

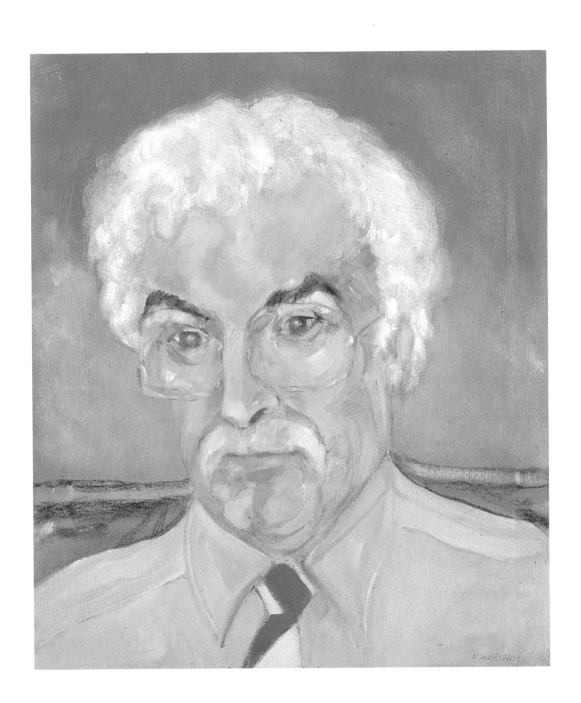

John Shinnors

John Shinnors is keen that his painting should reach as wide an audience as possible. In the early 1970s he began to exhibit his work outdoors and in factories throughout the country. The large triptych, The *Siege of Limerick*, which hangs in the city's General Post Office, and his various Stations of the Cross reflect this concern to extend the audience for contemporary art. His smaller paintings are more private in their symbolism and expression. They represent a fantastical, humorous or sometimes grotesque response to his environment. He works in series – animals, everyday objects, religious themes – with the desire 'to treat these themes in a new and startling way'. Occasionally he makes an art-historical reference, employing the device of a painting within a painting. Pattern is integral to his work, stripes being a particular favourite.

In its treatment of light, Shinnors' self-portrait has much in common with his work dating from the mid-1980s. Vermeer and Rembrandt have been important influences in this respect. Caravaggio's heightened *chiaroscuro* has been a more specific reference point for Shinnors' own dramatic use of light and shade. The artist's face, which fills the whole canvas, looms out of darkness. It is as if a spotlight is beaming onto a small area around the left eye, which looks sideways and down towards the viewer. The other features are concealed and so the viewer is forced to imagine the complete expression. The tones, with the exception of the pale area around the eye, are sombre and densely painted. The deep red, which highlights the forehead as it turns away on the other side, subtly pervades the whole painting. The atmosphere is mysterious and intense.

Born in Limerick, 1950. Studied at Limerick School of Art. Lives and works in Limerick.

Selected Exhibitions	1977 Cummins Gallery, Limerick
	1981 Goodwin Gallery, Limerick
	1981 *Belltable Foursight*, Arts Council touring exhibition,
	1984 Belltable Arts Centre, Limerick
	1987 Taylor Galleries, Dublin
Collections	Arts Council/An Chomhairle Ealaíon, Dublin
	Contemporary Irish Art Society, Dublin
	Guinness Peat Aviation, Shannon
	Irish Management Institute, Dublin
	Limerick Contemporary Art
Selected Bibliography	Patrick J. Murphy, *Belltable Foursight*, catalogue introduction, and John Shinnors, artist's statement, Belltable Arts Centre, Limerick, 1981
	Gerry Dukes, catalogue introduction, Belltable Arts Centre, Limerick, 1984
	Robert O'Byrne, 'Interview with John Shinnors', *Irish Arts Review*, vol. 4, no. 2, Summer 1987

Self-Portrait, 1986. Oil on canvas, 76 x 66.
Signed: 'Shinnors 86'.

Maria Simonds-Gooding

Maria Simonds-Gooding rarely portrays people in her work. Their implied presence, however, is central to the minimal landscapes which she describes in paint, print and plaster. The universal nature of these images is another basic concern : 'The subject-matter, whether it is derived from Ireland, India or other remote parts of the world consists of symbols man has carved out of the land, the unwritten record, the marks and signs, the unerased history that farmers, monks, and shepherds have left behind, such as the field formations and boundaries of ancient times.' Early signs of habitation, such as a *clochán* on the Dingle peninsula or a monk's enclosure on Mount Sinai, are recorded with fine grey lines of fresco pigment on large white plaster blocks. She uses more colour in the oil paintings, which feature large green and hay-stacked fields.

The dominant image of her work is the enclosed field of her self-portrait, a safe intimate place, protected by a wall from the threat of the elements and the surrounding land or sea. In this and other black and white etchings, the textured field shapes are those of the Great Blasket Island, with which the artist closely identifies, having lived beside it for more than twenty years. There is, she finds, a 'very female' womb-like quality to its interior and exterior shapes. Here the artist places herself in the context of her work, using the photo-etch technique to superimpose her own image onto an earlier etching.

Born in India, 1939. Studied at the National College of Art, Dublin, le Centre de Peinture, Paris and the Bath Academy of Art. Member of Aosdána. Lives and works in Co Kerry.

Selected Exhibitions	1965 Brown Thomas Gallery, Dublin
	1978 Betty Parsons Gallery, New York
	1983 Hoshour Gallery, New Mexico
	1985 *Mid-term Retrospective*, Crawford Municipal Art Gallery, Cork
	1985 Taylor Galleries, Dublin
Collections	Allied Irish Bank, Dublin
	Arts Council/An Chomhairle Ealaíon, Dublin
	Hirshorn Museum, Washington
	National Gallery of Modern Art, New Delhi
	Philips Collection, Washington
Selected Bibliography	Charles J. Haughey T.D., 'Forms, Shapes and Spaces – Maria Simonds-Gooding', *Arts in Ireland*, January, 1972
	James Johnson Sweeney, catalogue introduction, Betty Parsons Gallery, New York, 1978
	Aidan Dunne, 'Places', *Magill*, May 16, 1985
	Anthony Cronin, catalogue introduction, Taylor Galleries, Dublin, 1985
	Frances Ruane, *The Allied Irish Bank Collection: Twentieth Century Irish Art*, Douglas Hyde Gallery, Dublin, 1986

Self-Image, 1983. Etching, first state, 48 x 54.5.
Signed: 'Maria Simonds-Gooding'.

Frost/Stars Self Image Maria Simonds-Gooding

Imogen Stuart

Imogen Stuart was first introduced to the idea of religious sculpture while an apprentice of Otto Hitzberger, who had been a successful church sculptor before the Second World War. From him she also learned an appreciation of wood carving and of the of form and consistent integrity of design, has an immediate clarity. Working mainly in wood, she prefers to reveal rather than conceal the process of carving. Rough chisel marks enhance the direct quality of her images. Some of her figures and reliefs are cast in bronze, one of the most recent being a six-foot-high curved figure of the seated Pope John Paul II embracing two kneeling children. In this, as in many of her sculptures, the body expresses more than the face, the features of which are simply indicated. Children, who appear also in her secular sculpture, provide the joyous element which the artist seeks to attain in all of her work.

Stuart enjoys the limits imposed by commissions. The invitation to make a self-portrait posed quite a different set of restraints. Yet she has approached it with characteristic clarity of thought and execution. The bronze gyroscope is, in her own words, 'experimental and not too serious'. In its simple silhouette and lack of visual detail it retains an abstract and 'slightly cool quality'. The two bronze profiles, rotating on a central axis, face in opposite directions. One looks heavenwards, implying the source and goal of her work; the other earth-bound gaze places her sculpture firmly in a living and practical tradition.

Born in Berlin, 1927. Studied with Professor Otto Hitzberger, former Professor of Sculpture at the Hochschule für Bildende Künste, Berlin and attended the Academy of Fine Arts, Munich. Associate of the Royal Hibernian Academy. Member of Aosdána. Lives and works in Dublin.

<table>
<tr><td>Selected Exhibitions</td><td>1959 Joint exhibition with Ian Stuart, Dawson Gallery, Dublin
1973 Retrospective exhibition in conjunction with the Oireachtas, Trinity College, Dublin
1987 Irish Women Artists from the Eighteenth Century to the Present Day, Hugh Lane Municipal Gallery of Modern Art, Dublin
Exhibits at the Royal Hibernian Academy.</td></tr>
<tr><td>Commissions</td><td>Stations of the Cross, Ballintubber Abbey, Co Mayo
Arch of Peace, Cavan
Altar furniture, Honan Chapel, University College Cork
Crucifix, St Patrick's Basilica, Lough Derg, Co Donegal
Monument to Pope John Paul II, Maynooth College, Co Kildare</td></tr>
<tr><td>Selected Bibliography</td><td>Harriet Cooke, 'Harriet Cooke talks to the sculptor Imogen Stuart', Irish Times, May 1, 1973
Maureen Charlton, 'A Sculptor talks about her work', an interview with the artist, Martello, no. 2, Summer 1983
Liam Robinson, 'Imogen – You may have knelt before her work', Irish Press, May 20, 1987
Imogen Stuart, 'Notes on the Life of a Sculptor', Milltown Studies, no. 22, 1988
Christoph Wetzel, 'Imogen Stuart', Humanis: Internationales Forum für Künst und Wissenschaft, Belser Verlag, Stuttgart und Zurich, 1988</td></tr>
</table>

Self-Portrait, 1983. Bronze, 39 x 39.
Signed: 'Imogen 1983'.

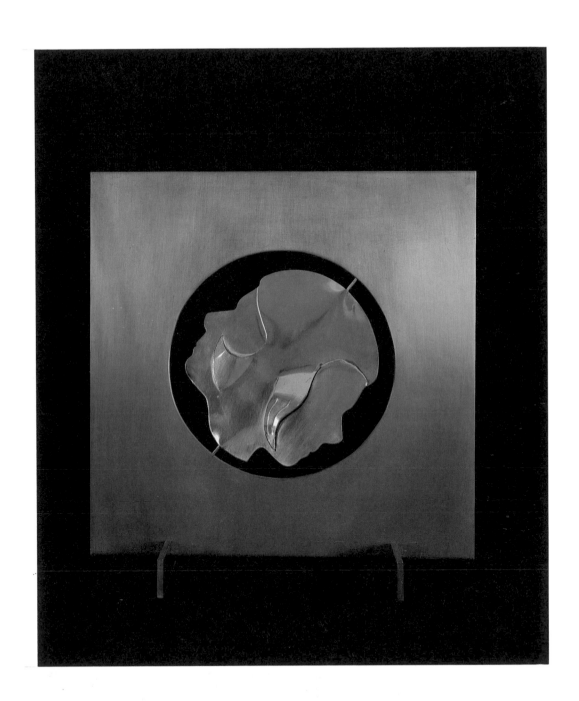

Patrick Tuohy

In his relatively short lifetime, Patrick Tuohy proved to be one of the finest of Irish portrait painters. Technically, he learned much from William Orpen, his teacher at the Metropolitan School of Art in Dublin. However, the sensitivity and compassion with which Tuohy approached his subject-matter were uniquely his. His studies of young children are especially poignant. Having fought alongside Pearse in the General Post Office in 1916, he escaped to Spain where he stayed for eighteen months. His first hand experience of the sombre tones and direct realism of Velazquez and Zurbaran had a profound influence on his own painting. Manet's direct contrasts of light and shade were another important source of inspiration.

Tuohy's self-portrait reveals the serious and intense character that he was reputed to be. He looks outward, his gaze cast slightly down. He appears to be occupied with his own thoughts. Behind him, and painted in quite a different light, is the figure of a woman, thought to be his sister, Bride. Her head has none of the sharpness of his own figure and is probably part of a painting on which he was working at the time. On the other hand, Tuohy is known to have been a slow worker and so it is possible that the self-portrait, which may have included his sister, was left unfinished. The influence of the Spanish painters is evident. Here he has employed the predominantly sombre tones and heightened *chiaroscuro* of Velazquez. The crimson of his neck tie, reflected in both of the faces, was a particular favourite of Tuohy's. Judging from another self-portrait painted before he went to America in 1927, the artist was probably about thirty-three years old when he painted this portrait.

Born in Dublin, 1894. Studied at the Metropolitan School of Art, Dublin. Member of the Royal Hibernian Academy. Died in New York, 1930.

Selected Exhibitions	1929 *Contemporary Irish Art*, Helen Hackett's Gallery, New York 1975 *Irish Art 1900-1950*, in association with Rosc Teoranta, Crawford Municipal Art Gallery, Cork Exhibited regularly at the Royal Hibernian Academy.
Collections	Allied Irish Bank, Dublin Butler Gallery, Kilkenny Crawford Municipal Art Gallery, Cork Hugh Lane Municipal Gallery of Modern Art, Dublin National Gallery of Ireland, Dublin
Selected Bibliography	Thomas MacGreevy, 'Patrick Tuohy, R.H.A. (1894-1930)', *Father Mathew Record*, no. 7, July 1943 Hilary Pyle, 'Patrick Tuohy' in *Irish Art 1900-1950*, published in association with Rosc Teoranta, Crawford Municipal Art Gallery, Cork, 1975 Gearailt Mac Eoin-Johnston, 'Patrick J. Tuohy, R.H.A.', *Martello*, Spring 1985 Frances Ruane, *The Allied Irish Bank Collection: Twentieth Century Irish Art*, Douglas Hyde Gallery, Dublin, 1986 Rosemarie Mulcahy, 'Patrick Tuohy 1894-1930', *GPA Irish Arts Review Yearbook*, 1989

Self-Portrait. Oil on canvas, 93 x 65.
Unsigned.
Purchased from Paul Condon, London.

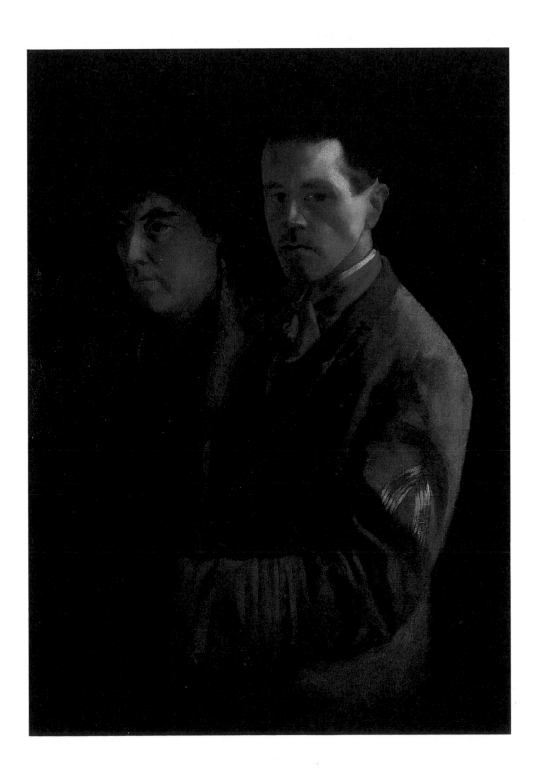

John Turner

John Turner is best known as a portrait painter. While still a student at the Belfast College of Art, he began to revive the painting techniques of the Old Masters. He continues to paint in a realistic style, thus achieving a convincing physical likeness. Amongst his public commissions are his portraits of past Lord Mayors of Belfast which hang in the City Hall. His landscapes and still lifes are painted with a freer hand. In the early years he experimented briefly with a pointillist style and he has, on occasion, produced quite abstract compositions.

Turner has always painted self-portraits. He is particularly fond of this one which was painted over a long period of time. He depicts himself in his home which provides a more intimate setting than the frequently employed monochrome backdrop. It also allows him to experiment with composition, which he enjoys. He turns in three-quarter pose to face the viewer. In the background is a portrait which he painted of his wife before she died. In front of it a bottle and a vase indicate his interest and skill in painting still lifes. The light, sensitively portrayed, clarifies the forms and intensifies colours. This portrait provides an opportunity for a close study of Turner's precise realism.

Born in Belfast, 1916. Studied at the Belfast College of Art, the Slade School of Fine Art, London and the Ruskin School of Drawing and Painting, Oxford. Member of the Royal Ulster Academy.

Selected Exhibitions	1948 C.E.M.A. Gallery, Belfast 1958 *Lewinter-Frankl Collection*, Belfast Museum and Art Gallery Exhibits regularly at the Royal Ulster Academy.
Collections	Armagh County Museum, Armagh Arts Council of Northern Ireland, Belfast City Hall Magee College, Derry Ulster Museum, Belfast
Selected Bibliography	John Hewitt, *Art in Ulster: 1*, Arts Council of Northern Ireland and Blackstaff Press, Belfast, 1977

Self-Portrait, 1980. Oil on canvas, 54 x 36.
Signed: 'John Turner '80'.

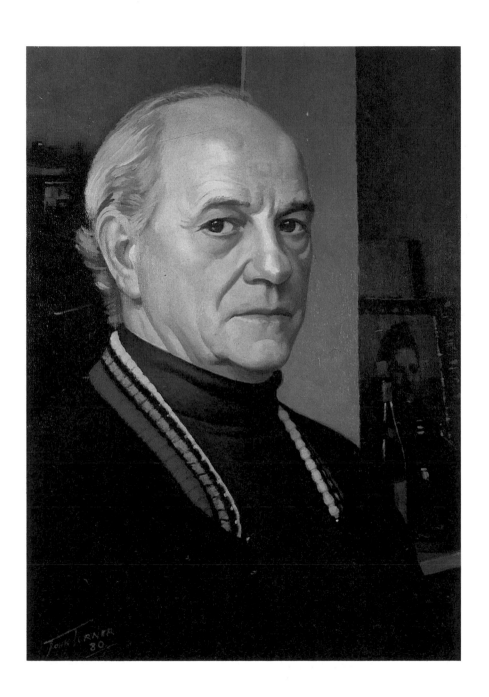

Benedict Tutty

Most of Benedict Tutty's sculpture is commissioned by the Catholic Church. He remains within the mainstream tradition of religious sculpture by maintaining a figurative dimension. However, this is often the medium for a more abstract self-expression. He works on both a large and small scale in metal, stone, wood, terracotta and enamels. Sometimes he combines his media, as in his smaller stations of the cross and his altar furnishings. Colour is essential to his expression; emotive reds and greens are used in an untraditional manner. Forms are simplified and strong. Tutty's work, sympathetic with the earthy, Celtic and sometimes pre-Christian values which he regards as elements vital to the contemporary Christian's understanding, is intended to be both universal and personal.

Tutty sees self-portraiture as a way of confronting and defining the 'unique, original and isolated self'. This self-image may differ substantially from the image which we present to and receive from others. His portrait, in mild steel and terracotta, is characteristic of his work in its combination of figurative and symbolic elements. This produces a paradox 'that is meant to be both poignant and humorous'. Tutty's head, harshly modelled in painted terracotta, emerges from the centre of a crudely welded tracery of painted steel. His eyes have no sight. His mouth is half open. His face is 'the face of the artist emerging' and is at the same time like a death-mask: 'Christ in the sculptural conundrum of 1988'. What could be symbolically seen as a crown of thorns looks more like a garland of greenery. It is supportive rather than condemnatory, suggesting the process of growth necessary for artistic and personal development.

Born in Co Wicklow, 1924. Studied at the Ecole des Métiers d'Art and at Maredsous Abbey, Belgium. Lives and works in Co Limerick.

Selected Exhibitions	1962 *III Biennale Christlicher Künst der Gegenwart*, Salzburg
Collections and Commissions	Beaumount Hospital, Dublin Crawford Municipal Gallery of Art, Cork Limerick City Gallery of Art St John's Hospital, Limerick St Patrick's Training College, Dublin

Self-Portrait. Steel and terracotta, 51 x 51.
Signed: 'Benedict Tutty' (on reverse).

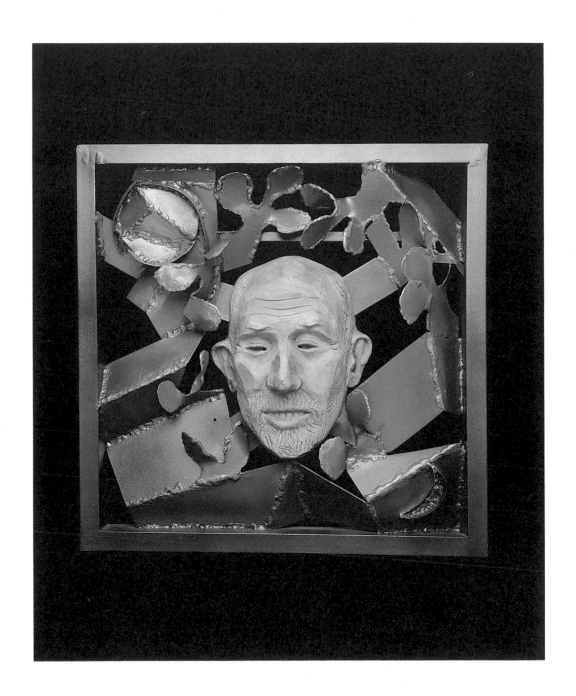

Hilda Van Stockum

Since she was a child, Hilda van Stockum had always wanted to be a portrait painter. She began to paint still lifes so that she could perfect her painting technique, choosing 'the most ordinary well-known objects because of the very light that falls on them'. In doing so she discovered 'the wonderful thing about still life, that it is pure painting. It is entirely in your control ... you are alone with yourself and your composition and you can develop the art of contemplation, which has almost a spiritual signifance.' In her small, smoothly finished paintings, vessels of brass, copper, pewter and glass are carefully arranged on a linen cloth or a wooden table. Individual textures are sensuously conveyed and clearly defined by a bright light.

Van Stockum's self-portrait represents her two main artistic concerns: her early passion for portraiture and the more recent and familiar still lifes. Having painted a number of self-portraits, she finds that the problem of seeing herself objectively remains. She has made her task slightly easier in this instance by including the mirror to contain her reflection. It also extends the space of the portrait, affording a glimpse of a fragment of a painting and a landscape through the door. The delft jug full of brushes, the tube of paint, the palette knife and the book on contemporary Dutch art all tell us more about the artist and her ways of working. In the tradition of her ancestors, the Dutch Old Masters, van Stockum paints on board which gives a particularly smooth finish. She usually works first in tempera, which dries very quickly, and then adds the details in oil. Sometimes she employs a slightly stippled technique, as in the case of her own image in this portrait.

Born in Rotterdam, Holland, 1908. Studied at the Metropolitan School of Art, Dublin and the Academy of Fine Art, Amsterdam. Honorary member of the Royal Hibernian Academy. Lives and works in Hertfordshire.

Selected Exhibitions	1938 *Washington Biennal*, Corcoran Art Gallery, Washington D.C.
	1968 Den Arts Gallery, Ottawa
	1983 Mall Galleries, London
	1984 Tom Caldwell Gallery, Dublin
	1987 Tom Caldwell Gallery, Belfast
	Exhibits regularly at the Royal Hibernian Academy, Dublin.
Collections	National Gallery of Ireland, Dublin
	University of Limerick
Selected Bibliography	Brian Fallon, 'Interview with Hilda van Stockum', *Irish Arts Review*, vol. 2, no. 4

Self-Portrait, 1984. Oil on panel, 60 x 50.
Signed: 'H v S'.

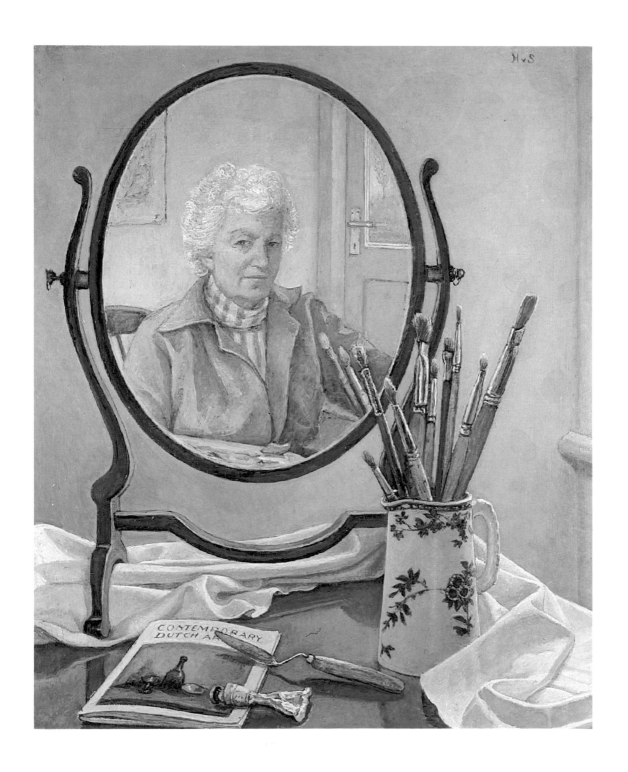

Dairine Vanston

Dairine Vanston, like many Irish artists, studied with André Lhote in Paris during the 1920s. It was during this time that she began to understand and appreciate how light could 'penetrate a painting'. After a period in Costa Rica, she returned to Ireland in the 1940s, recapturing her memories in brightly coloured, luminous watercolours which consisted mostly of landscapes with figures and animals. Initially painting in a cubist manner, she subsequently developed a much freer and more individual style. Colour, not always naturalistic, assumed an increasingly important role in her work. Her simple shapes became rounded and her compositions more lively.

Vanston worked slowly. For this reason she preferred to keep her paintings, so that she could re-work them as she wished. Her self-portrait took thirty-eight years to complete. It was started just as she was beginning to move away from the early cubist influence and was finished two years before her death. The colours are vibrant and idiosyncratic, the light intensely bright. The greens and blues which describe the face and hair are typical of the palette of her South American paintings. She brings her figure forward, setting it at an oblique angle against a flat rectangular form – probably the back of a chair. This, in turn, is separated from the background by a crude black outline, which she often used to emphasize a shape or plane. She sits upright, her expression attentive, her hands loosely clasped. With this rather quirky self-portrait, Vanston reveals her highly personal approach to painting.

Born in Dublin, 1903. Studied at Goldsmith's College, London, the Académie Ranson, Paris and with André Lhote in Paris. Member of Aosdána. Died in Dublin, 1988.

Selected Exhibitions	1987 *Irish Women Artists from the Eighteenth Century to the Present Day*, Hugh Lane Municipal Gallery of Modern Art, Dublin
Collections	National Gallery of Costa Rica
Selected Bibliography	Harriet Cooke, 'Dairine Vanston', interview with the artist, *Irish Times*, September 6, 1972 Brian Kennedy, 'Women Artists and the Modern Movement, 1943-49', in *Irish Women Artists from the Eighteenth Century to the Present Day*, the National Gallery of Ireland and the Douglas Hyde Gallery, Dublin, 1987

Self-Portrait, 1948-86. Watercolour and gouache on paper, 30.5 x 25.5.
Signed: 'D. Vanston. 48-86'.

Barbara Warren

In the early 1950s Barbara Warren lived in Paris where she studied for a brief period under André Lhote. Lhote's cubism looked to Cézanne rather than Picasso for artistic inspiration. Warren also shares Cézanne's concern with colour and tone, allowing them to express the underlying forms of the objects she paints. The result, to use a phrase of Cezanne's, is something 'solid and durable'. Most of her subject-matter – landscapes, seascapes, interiors and still lifes – is derived from the west of Ireland. In these paintings her aim is to create an illusion of three-dimensional space by the way in which she arranges the forms. Hulls of fishing-boats direct the eye towards the expanse of sea beyond. Boggy landscapes, composed of flat patches of colour, are viewed through a window in a corner of a light-filled room.

In her self-portrait, Warren wished to construct the painting so that each shape related to the rectangular composition as a whole. She was attracted by the idea of including a rectangle within a rectangle – hence the painting and the window. She contrasts her own triangular form in the foreground with the rectangular shapes behind, and relieves the overall geometry by introducing the decorative home-made *commedia dell'arte* mask, which she also hoped would act as a talisman. Depth and volume are emphasized by the light and distance glimpsed through the window and the juxtaposition of contrasting colours. Warren found it difficult to maintain her usual objectivity as a landscape painter when approaching her self-portrait. Although satisfied with the painting both as a likeness and as a coherent composition, she regards it as a partial failure 'in that it shows no sign of the struggle involved in its conception and completion'. The systematic, analytical approach, favoured by Cézanne, ironically often appears the freshest and most spontaneous.

Born in Dublin, 1925. Studied at the National College of Art, Dublin, Regent Street Polytechnic, London and with André Lhote in Paris. Member of the Royal Hibernian Academy. Member of Aosdána. Lives and works in Dublin.

Selected Exhibitions
1952 Dublin Painters' Gallery
1960 Dawson Gallery, Dublin
1982 Taylor Galleries, Dublin
1986 Taylor Galleries, Dublin
1987 *Irish Women Artists from the Eighteenth Century to the Present Day*, Hugh Lane Municipal Gallery of Modern Art, Dublin
Exhibits regularly at the Royal Hibernian Academy.

Collections
Algemene Bank Nederland (Ireland) Ltd., Dublin
Limerick City Gallery of Art
St Patrick's College of Education, Dublin
Hugh Lane Municipal Gallery of Modern Art, Dublin
University of Limerick

Self-Portrait, 1984. Oil on canvas, 61 x 51.
Signed: 'B. Warren'.

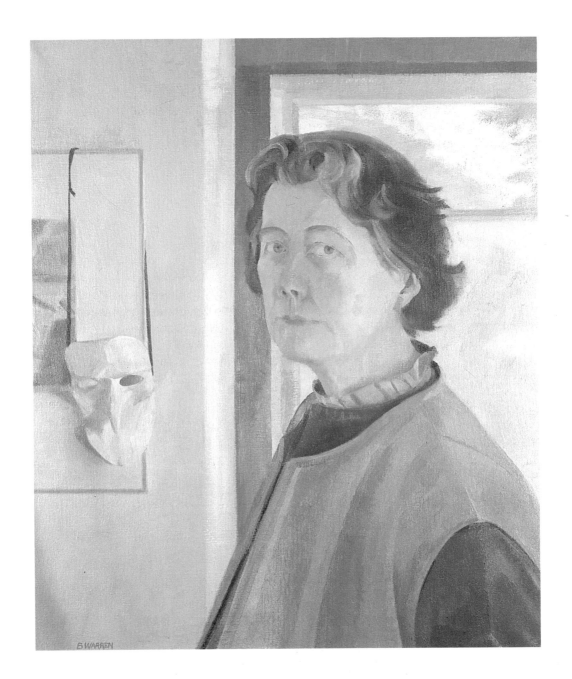

Michael Warren

Michael Warren makes abstract sculpture in steel, stone and wood. The monumental quality which he seeks to attain is 'not so much to do with scale as interproportional relationships'. This interplay of parts is of central importance to the giant columns, obelisks and cruciform shapes as well as the small interlocking forms in bronze and steel. In the early years he worked with painted steel. More recently he has been attracted by the organic nature of wood, particularly by the way in which it expands and contracts according to weather conditions. Most of his wooden sculpture is placed outdoors and so alters slightly with time. Some of these pieces enclose space; others, dictated by gravity, displace it. Abstract concepts dealing with matter and existence are fundamental to Warren's way of working.

The small self-portrait drawing initially seems to have little in common with the large totemic structures in wood or steel. Both are based, however, on the same principles of ratio. In the sculpture, it is a relationship of space to matter; in the drawing, light to line. Working on the principle that we see something only by seeing its opposite, Warren makes a detailed drawing of part of his head; the rest is suggested by empty space. This implication of volume by its absence rather than its presence is central also to his sculpture.

Born in Ireland, 1950. Studied at the Bath Academy of Art, and the Accademia di Belle Arti di Brera, Milan. Lives and works in Co Wexford.

Selected Exhibitions	1980 Round House Gallery, London
	1981 Arts Council of Northern Ireland Gallery, Belfast
	1984 *Rosc '84*, Guinness Hop Store, Dublin
	1984 Solomon Gallery, Dublin
	1988 Douglas Hyde Gallery, Dublin
Collections	Guinness Peat Aviation, Shannon
	Hugh Lane Municipal Gallery of Modern Art, Dublin
	Radio Telefís Eireann, Dublin
	Trinity College, Dublin
	University College Galway
Selected Bibliography	Anne Crookshank, *Michael Warren 1969-80*, catalogue essay, Letatlin, Gorey, 1980
	Rosemarie Mulcahy, `Michael Warren' in *Rosc '84*, Guinness Hop Store, Dublin, 1984
	Michael Warren, 'Art and the Complexity of the World', *Sculptors Society of Ireland Newsletter*, Dublin, vol. 1, no. 3, 1984
	Frances Ruane, 'Michael Warren', *Irish Arts Review*, vol. 2, no. 3, 1985
	John Hutchinson, 'Silence and Necessity: The Sculpture of Michael Warren', catalogue essay, Douglas Hyde Gallery, 1989

Self-Portrait, 1985. Pencil on paper, 48 x 35.
Signed: 'MW '85'.

Alexandra Wejchert

Alexandra Wejchert trained as an architect, an engineer and a fine artist. With clarity and expertise she has combined the skills and techniques of each of these disciplines in the creation of her abstract sculptures. Their angular and curvilinear forms, varying in size and medium, are inspired by the rhythms and harmonies of nature and music. Wejchert is constantly experimenting with new ways of working her materials. Her knowledge of physics and chemistry complements her intuitive knowledge of what is appropriate for a particular piece in a particular location. The bronze forms flow as freely as those in coloured perspex; thin sheets of aluminium are delicately rolled into leaf shapes; fragments of painted wood are arranged in the shape of a flower; a monumental stainless steel structure stands like a bird with wings outstretched.

Wejchert has always been fascinated by the beauty and perfection of the circle. She has incorporated in her serigraphed self-portrait a photograph of herself at work on one of her favourite compositions, based on the circle. Here she is shown placing timber dowels of different lengths at varying angles to create a rectangular relief which, when spray-painted, forms an undulating surface of coloured circles. The circle is repeated in the dot pattern which along with the plain areas of black and yellow, provides an abstract setting for the figure. This portrait is representative of her work as a whole in its juxtaposition of curvilinear and angular forms.

Born in Cracow, Poland, 1921. Studied at the Faculty of Architecture, Warsaw University and at the Academy of Fine Art, Warsaw. Member of Aosdána. Lives and works in Dublin.

Selected Exhibitions	1959 Galeria L'Obelisco, Rome
	1968 Galerie Lambert, Paris
	1969 David Hendriks Gallery, Dublin
	1980 *Irish Art 1943-1973*, in association with Rosc Teoranta, Crawford Municipal Art Gallery
Collections	Arts Council/An Chomhairle Ealaíon, Dublin
	Hugh Lane Municipal Gallery of Modern Art, Dublin
	Peter Stuysevant Collection, Amsterdam
	University College Dublin
	University College Galway
Selected Bibliography	Cyril Barrett S.J., catalogue introduction, Galerie Lambert, Paris, 1968
	Cyril Barrett S.J., 'Alexandra Wejchert' in *Irish Art 1943-1973*, published in association with Rosc Teoranta, Crawford Municipal Art Gallery, 1980
	Louis G. Redstone and Ruth Redstone, *Public Art: New Direction*, McGraw Hill, U.S.A., 1981
	Alexandra Wejchert, 'Rhythm Structures' in *Contemporary Irish Art*, ed. Roderic Knowles, Wolfhound Press, Dublin, 1982
	Frances Ruane, *The Allied Irish Bank Collection: Twentieth Century Irish Art*, Douglas Hyde Gallery, Dublin, 1986

Self-Portrait, 1985. Serigraph 1/20, 59 x 85.
Signed: 'Alexandra Wejchert '85'.

Self-Portraits – A Selected Bibliography

BONAFOUX, PASCAL: *Portraits of the Artist: The Self-Portrait in Painting*, Rizzoli, New York, 1985

GASSER, MANUEL: *Self-Portraits from the Fifteenth Century to the Present Day*, Weidenfeld and Nicolson, London, 1963

GOLDSCHEIDER, LUDWIG: *Five Hundred Self-Portraits*, George Allen and Unwin, London, 1937

GOTTLIEB, CARLA: *Self-Portraiture from Ancient Egypt to World War 2*, Dutton, New York, 1987

KINNEIR, JOAN, ed.: *The Artist by Himself: self-portrait drawings from youth to old age*, Granada Publishing, London, 1980

LUCIE-SMITH, EDWARD and KELLY, SEAN, eds.: *The Self-Portrait: a modern view*, Sarema, London, 1987

QUICK, MICHAEL: introduction, *Artists By Themselves: Artists' Portraits from the National Academy of Design*, National Academy of Design, New York, 1983

CATALOGUES

As We See Ourselves: Artists' Self-Portraits, Heckscher Museum, Huntington, New York, 1979

Painters by Painters, a selection from the Uffizzi Self-Portrait Collection, National Academy of Design, 1988

Staging the Self: self-portrait photography 1840s-1890s, Plymouth Arts Centre, 1986

ARTICLES

ROSE, BARBARA: 'Self-Portrait: theme with a 1000 faces', *Art in America*, vol. 63, January 1975

GRACE SILL, GERTRUDE: 'The Face in the Mirror', *Connoisseur*, vol. 216, no. 894, 1986

SILVERMAN, HUGH J.: 'Cézanne's Mirror Stage', *Journal of Aesthetics and Art Criticism*, vol. 4, no. 4, 1982